Motion Illustratio__

Motion Illustration

How to Use Animation Techniques
to Make Illustrations Move

Adam Osgood

BLOOMSBURY VISUAL ARTS
LONDON • NEW YORK • OXFORD • NEW DELHI • SYDNEY

BLOOMSBURY VISUAL ARTS
Bloomsbury Publishing Plc
50 Bedford Square, London, WC1B 3DP, UK
1385 Broadway, New York, NY 10018, USA
29 Earlsfort Terrace, Dublin 2, Ireland

BLOOMSBURY, BLOOMSBURY VISUAL ARTS and the Diana logo are trademarks of
Bloomsbury Publishing Plc

First published in Great Britain 2024

For legal purposes the Acknowledgments on p. 192 constitute
an extension of this copyright page.

Cover design by Louise Dugdale
Cover illustration: Yukai Du

A catalogue record for this book is available from the British Library.

A catalog record for this book is available from the Library of Congress.

ISBN: PB: 978-1-3503-2314-8
 ePDF: 978-1-3503-2316-2
 eBook: 978-1-3503-2315-5

Typeset by Integra Software Services Pvt. Ltd.
Printed and bound in India

To find out more about our authors and books visit www.bloomsbury.com
and sign up for our newsletters.

For my parents, Christie and Gary. Thank you both for encouraging and supporting my lifelong interest in illustration and animation, and never questioning whether a career in the arts was possible.

Contents

Chapter One

Heritage of Motion Illustration 1

Chapter Two

What Makes an Engaging Motion Illustration? 37

Chapter Three

Common Themes and Motifs 47

Chapter Four

Contemporary Practice 67

Chapter Five

Technical Considerations 143

Chapter Six

Exercises and Projects 151

Introduction

About this Book

Over the last decade, motion illustration has exploded from a novelty that only a handful of innovative illustrators played with, to a staple of the contemporary illustration portfolio. Today's illustrators create charming looping GIFs, sophisticated digital animations, and clever lo-fi videos.

Through a discussion of history, tools, media, experimentation, and commerce, this book illuminates the growing area of motion illustration.

While much has already been written on the separate topics of illustration, animation, and motion graphics, this book is wholly devoted to motion from the illustrator's perspective. Collected within these pages are examples from illustrators across the globe who create animated content for comics, advertisements, games, music videos, and more.

For many illustrators, the idea of animation can be overwhelming, but this book shows that motion illustration can take many forms and be accessible at any skill level. Whether you are a seasoned professional, a student, or an educator, this book is written as a resource to inspire you to integrate animation techniques into your illustration practice.

A Global Community of Illustrators

This book features artwork from illustrators representing nineteen different countries. The discovery method began over a decade ago by actively following practitioners in the illustration, animation, and motion graphics fields. Some illustrators and projects were discovered from write-ups in relevant media. Others were found through networking and word-of-mouth. Industry-recognized illustration competitions were referenced to round out the list. The final selection was carefully curated to showcase the widest variety possible of technique, style, method, and application from illustrators worldwide. To demonstrate illustration's global reach, each artist is listed with their country of origin and country of residence. I share my deepest gratitude with the illustrators who contributed their work and time to this book as we begin to document a history for this nascent artform.

A Note about Language

Professionals and academics use various terms to describe illustration that is animated. The most popular include "motion-based illustration," "moving illustration," and "kinetic illustration." Within this book, the term **motion illustration** will be used. This

is an intentional choice that functions both as an abbreviated variation and puts "motion illustration" on the same level as its graphic design counterpart, "motion graphics."

Additionally, the term **cartoon animation** is explicitly used to reference the "animation industry" that produces narrative animation for entertainment and advertising purposes (i.e., a Pixar film, a Saturday morning cartoon, or an animated commercial for children's cereal). In everyday language, these examples are often described simply as "animation," but this distinction is necessary to avoid confusion as the word "animation" is needed to describe the quality of movement.

Speaking of Animation …

Language derived from filmmaking is used to describe the stories, design, and animation techniques used in time-based works. These projects may be described in terms of scenes, shots, and frames:

- **Scene:** This usually refers to a single location within a story that may be shown from many different camera angles. A story may take place exclusively within one scene or might require multiple scenes.
- **Shot:** Within a scene, each individual camera angle is a shot. Each shot will usually require a separate background painting to depict the environment. Most films and videos use multiple shots, while GIFs generally tell a complete story with just one.
- **Frame:** An animation is made from a sequence of frames that create the illusion of movement when shown in succession. This book shows frames pulled from animations to demonstrate the movement. In motion illustration, an individual frame will typically use composition and object arrangement to tell a complete story, much like traditional illustration.

This book contains a **Glossary** for any specific terms that aren't part of common language. Glossary terms are highlighted in bold throughout the text.

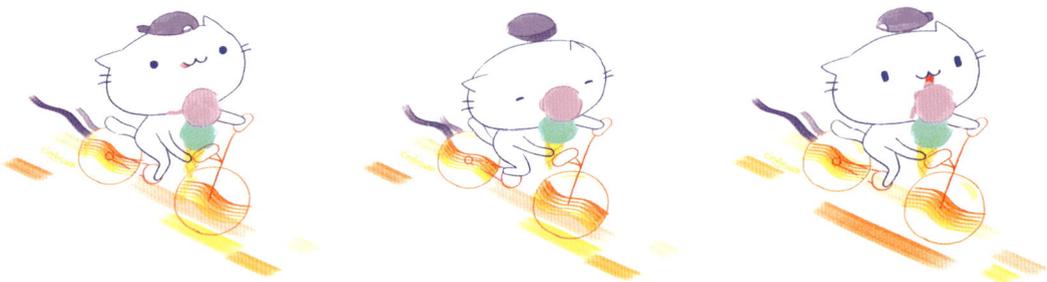

Figure 0.1 Cindy Suen is a pioneer of motion illustration, creating animated GIFs and videos that bring her charming characters to life. These three frames from "Ice Cream Bike Ride" use impressionistic streaks of color to create the illusion that the bike is moving forward.

A Working Definition for Motion Illustration

While curating the projects in this book, I often wondered, "is this motion illustration?" The borders between motion illustration, cartoon animation, and motion graphics are blurry, and these disciplines will likely to continue overlapping so long as artists have access to approachable digital tools. Most of us are familiar with animation and motion graphics, and these artforms have rich histories of practice and research. We have experience with Saturday morning cartoons, big-budget animated films, motion graphic title sequences, web banner ads, and so on. Likewise, the established illustration discipline has a well-documented history and cultural awareness via editorial cartoons, product packaging, comic books, etc. Compared with these mature fields, however, motion illustration is still in its infancy, without a clear definition.

What is Motion Illustration?

- Is it an animation made by someone who identifies as an illustrator?
- Is it an animated GIF commissioned for *The New York Times*?
- Is it a short film made up of a sequence of illustrations?
- Is it an iPad game that feels like a children's book?

To aid us in defining motion illustration, let us first define "illustration." At its most basic, illustration might be described as *an image that conveys an idea*. This broad definition explains the origins of illustration in the larger context of global art history (i.e., cave painting, hieroglyphics, illuminated manuscripts, etc.). However, this can easily be confused with work in related disciplines, such as the fine arts. The contemporary illustrator is often known for their professional practice, creating work on commission for clients to earn a living. With this in mind, we will adopt a more specific definition: **Illustration is an image that conveys an idea *and* is made for commercial purpose.** This definition shouldn't exclude illustrators who create personal work and experiment with media outside of their client work, as these explorations are often the fuel for growth within a portfolio and lead to wonderful and unexpected opportunities. In fact, many of the images included in this book come from passion projects.

Based on this definition, motion illustration should meet these criteria:

- **Visualize an idea, concept, or story within a single composition.** Illustrations should have clear visual communication and be image-centric. We might consider each page, panel, or shot as a single composition for sequential applications like picture books, comics, and videos with many images.

- **Exist for some commercial purpose.** Usually, works will be commissioned for publishing, advertising, or entertainment. However, this can include images made for self-promotion, as well as those made by illustrators to explore personal voice.
- **Include animation in a supporting role.** The animation may help draw attention to the idea, enhance the mood, and/or add visual interest. However, the image should maintain its visual clarity without animation.

These criteria reflect the research undertaken for this book: a survey of more than 150 contemporary illustration portfolios and analysis of the commonalities within their animated work. Importantly, these criteria do not define motion illustration in terms of visual style, media technique, software, file types, end-use/application, or platform for delivery (although we will see in **Chapter 3: Common Themes and Motifs** how there are some common threads). Motion illustration doesn't even need to be digital. Outside

SELF-DIRECTED WORK AS CREATIVE FUEL

Chris Sickels, the illustrator behind Red Nose Studio, creates personal work to explore ideas and approaches he can use in his commercial work.

Describing his animated video, *The Optimist* (see Figure 0.2), he says, "Self-directed work helps me create artwork that has potential to push into realms that maybe a commercial job can't afford. *The Optimist* was inspired by watching my 4-year-old daughter play with a Jack-in-the-Box. It dawned on me that if you take out those last few notes, the music continuously loops. Then you start to think how potentially dreadful that could be. So this piece was inspired by observation and freethinking instead of a creative brief … In this case, I was free to 'play,' chasing an idea without having expectations of it having to be successful. Curious exploration like this generally leads to growth in one form or another that then ends up in my commercial work. This short speaks about being a persistent optimist, to keep at it, and make the best with the situation at hand."

Figure 0.2 Three frames from an animated video called *The Optimist* (2019) depict a character perpetually winding a Jack-in-the-Box that never opens. This personal project from Red Nose Studio elicits a ceaseless sense of anticipation in the viewer.

of the screen, illustrators experiment with physical media, like lenticular images, flip-books, and paper puppets, to make their illustrations move.

There are dangers in defining something new. What if the definition excludes relevant work? What if the definition shapes or restricts future works? My hope is that these criteria will function only as a starting point for further study and that the illustration community will be reflective and flexible as the artform continues to mature.

Blurred Disciplines

As noted, motion illustration shares many qualities with cartoon animation and motion graphics. All three can involve a combination of image-making, commercial purpose, and movement. Accordingly, there is significant overlap and inconsistency between how artists who create motion illustration self-identify, using various combinations of the words *illustrator, animator, motion designer, digital artist*, and so on.

We have already established some criteria for what motion illustration is. To deepen this definition and understand how motion fits into the larger world of art and design, it is useful to contextualize it with cartoon animation and motion graphics. From a technical perspective, all three are specialized forms of animation. Table 0.1 explains their similarities and differences, using *purpose, format, style*, and *advantage* for comparison.

This table is merely an organizational tool and is not meant to silo artists into a single manner of working. Practitioners in all three areas are capable of, and often do, create multidisciplinary work. However, the practitioner's core identity and specialized training will likely lead to particular strengths in approach. Illustrators are typically independent creators who spend years developing a singular visual voice. On the other hand, animators and motion designers often work as parts of larger teams and must be able to work in various styles, depending on the needs of the production. They usually have a specialization (like 3D modeling, 2D character animation, or visual effects).

Because the illustrator spends significant time making images, their superpower is in picture-making and visual communication. They will feel just as comfortable telling a story in one image as they are in a sequence of many images, and are adept at making an animation that functions just as well when it is static as when it is moving. Since illustrators are known for their own signature style, clients will often seek them out specifically to pair with a matching project.

Table 0.1 Animation

	From the Latin verb *animare*, meaning "to give life," animation is an umbrella term used to describe the art of making inanimate objects appear to move. For our purposes, animation specifically describes a sequence of images that, when played in order, create the illusion of movement. Animation could describe artifacts as varied as a children's cartoon, an animated GIF viewed on a webpage, the special effects in a blockbuster film, the kinetic typography in a lyric video, an ultra-realistic character in a video game, etc.		
Area	**Cartoon Animation** The animation industry is typically referred to as "animation," but we will use the term cartoon animation. This might be a film, television show, video clip, or advert featuring characters performing a narrative story. The production may utilize various techniques, including hand-drawn frame animation, 3D computer-generated imagery, stop-motion animation, etc.	**Motion Illustration** Part of the greater illustration discipline and sharing qualities with cartoon animation and motion graphics. It applies new media approaches, like motion and interactivity, to projects traditionally created by illustrators, such as comics, picture books, editorial illustrations, etc. It might be narrative-driven, like cartoon animation, or focused on intricate motion design.	**Motion Graphics** Often associated with graphic design, motion graphics combines elements like image, type, and video through motion. Applications are diverse, including logo builds, user interface, title design, advertisements, infographics, web animation, etc. This area may also be described as "motion design."
Purpose	Often made for entertainment purposes, although it may also explain, inform, or advertise. It is generally a singular piece of art made for consumption, i.e., the viewer will direct their full attention towards watching an animated cartoon. (However, interactive experiences and gaming are often associated with the animation industry.)	Many types of illustration, such as editorial or advertising assignments, are designed to co-exist with text and serve a supplementary role within the larger whole. However, when motion illustration is used within a comic strip or game, it may stand on its own as a singular piece of art.	Because motion graphics is such a broad field, the purpose could be as complex as making an app more intuitive through subtle icon animation to being a simple decoration. The motion designer treats movement and timing with the same care as the visual elements they work with and aim to create a strong viewer/user experience.
Format	Film or video with a linear narrative that unspools over time. Understanding the story's full meaning requires the viewer to watch the entire piece.	An image that immediately communicates its story or concept to the viewer. (In the context of longer pieces like short films or games, we might apply this idea to a single shot or level design.)	The formats can be as broad as the outcomes, such as linear or interactive, short or long, instructive or abstract, etc.
Style	The motion is performance-based, using character animation to visually act-out a story.	The image is dominant. Animation plays a supporting role to add visual interest and help the viewer understand the illustration more clearly.	Animation is used to move typography, graphics, and video.
Advantage	Believable character performance for storytelling.	Strong visual communication with refined visual aesthetics.	Carefully designed motion and integration of typography.

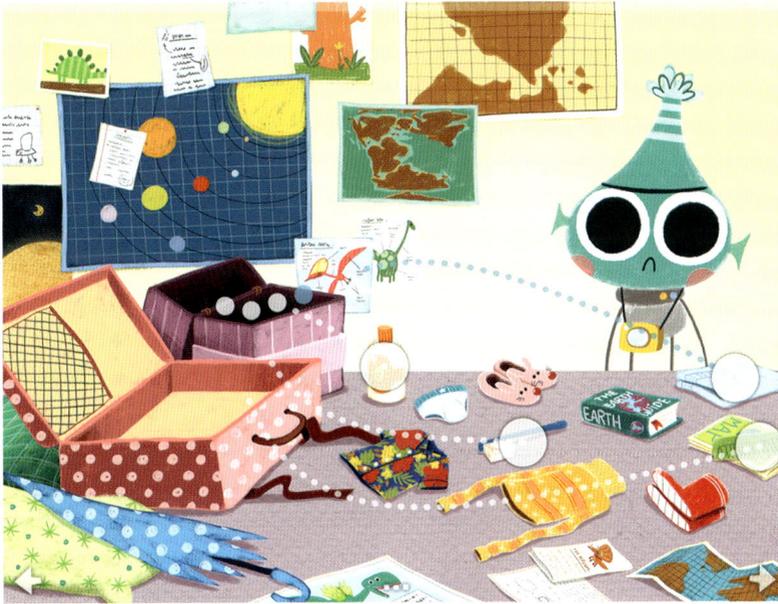

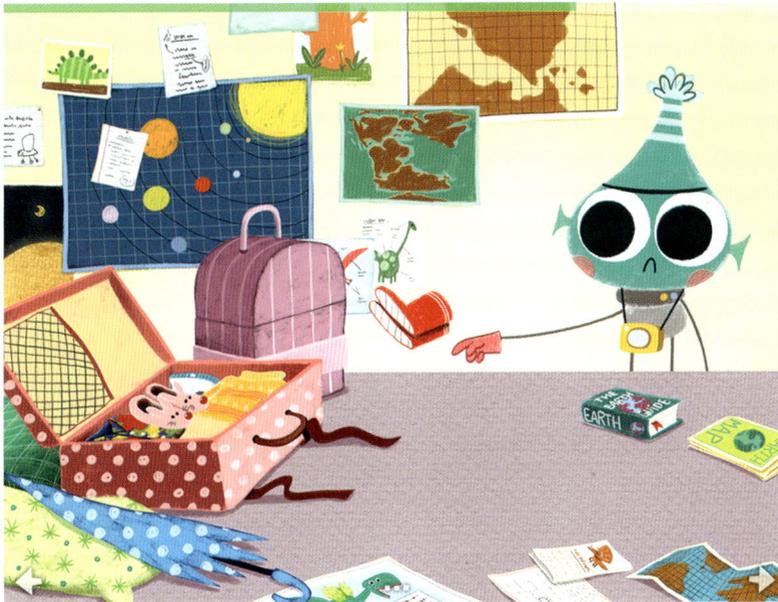

Figure 0.3 New media formats, like interactive picture book apps, blur traditional art markets. These two frames from an interactive sequence in Chiquimedia's *Mortimer and the Dinosaurs* (2019), illustrated by Màriam Ben-Arab, ask the reader to "pack" Morti's suitcase by dragging his clothing with their finger.

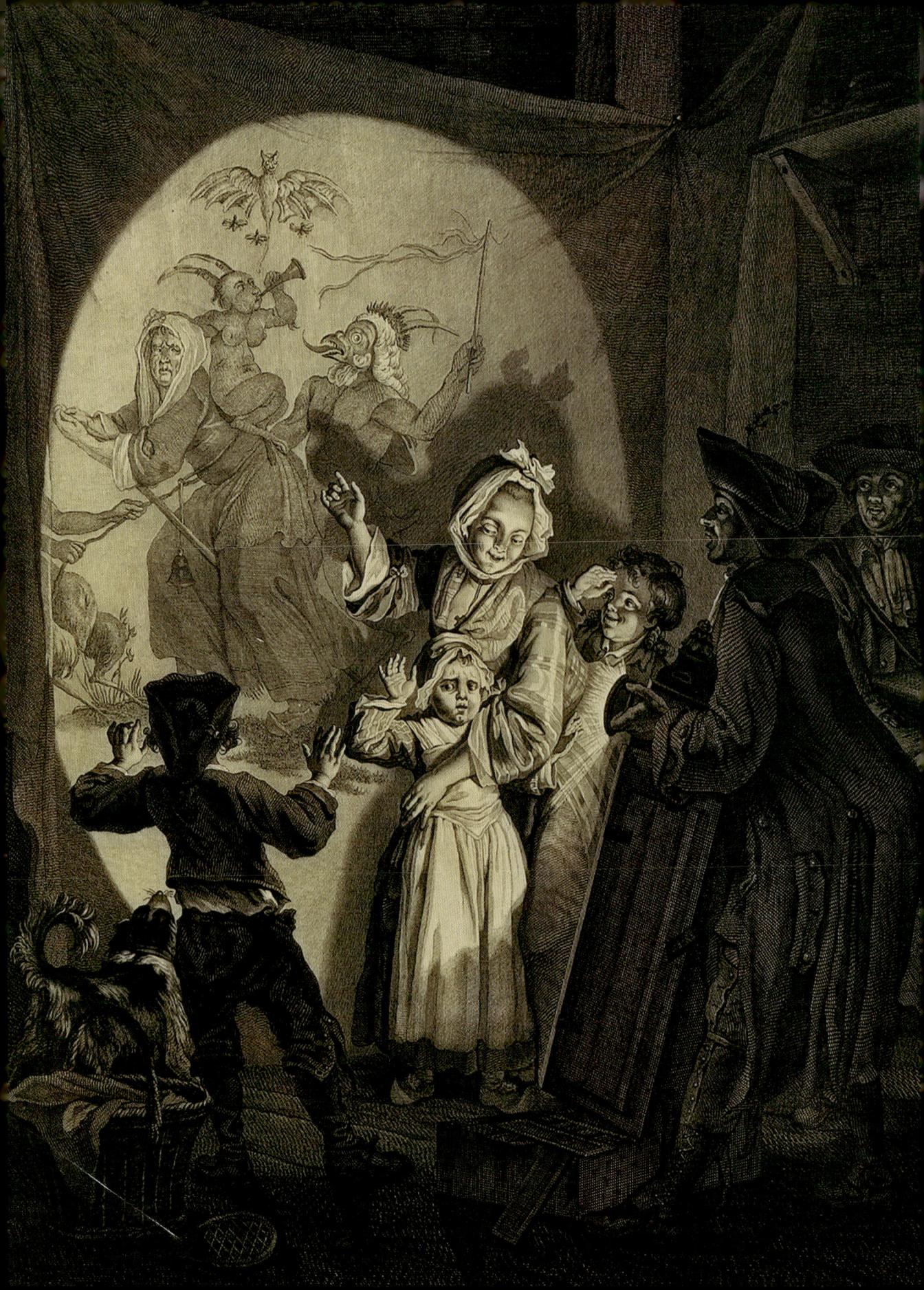

CHAPTER 1

Heritage of Motion Illustration

Contemporary artists blend illustration, animation, graphic design, and motion design in a collage of digital and analog media, blurring the lines between these disciplines. For instance:

- Annie Wong and Red Nose Studio both use stop-motion animation to create illustrations, a technique with a storied history in the cartoon animation industry.
- Yukai Du, Lily Padula, and Emory Allen animate fluid graphic shapes with a similar style used by motion designers.
- Wesley Bedrosian, Richard Borge, and Andy Potts create computer-generated 3D illustrations with software typically used in big-budget animated films, special effects, and AAA gaming.
- Chris Piascik and Alyssa Nassner integrate hand-drawn typography in their illustration work, leaning on their talents as graphic designers.

Chris Piascik is emblematic of the multidisciplinary motion illustrator. His work references a deep history of cartoon animation and graphic design, such as his "Fork Yeah" GIF (see Figure 1.1). Like many of his type-centered images, this looping animation features an attention-grabbing phrase and perfectly suits the way GIFs are used as a response in chats and text messages. He fluidly animates the word "fork" into the composition with a bouncy squash and stretch animation, followed by a write-on effect of "yeah." He combines hand-lettering with illustration of a fork that bounces into the scene, piercing the "F."

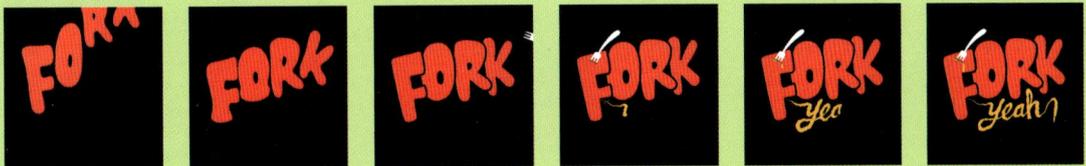

Figure 1.1 These six frames from Chris Piascik's "Fork Yeah" GIF show how his bouncy animated lettering combines elements of graphic design with cartoon animation.

Piascik's works often draw on techniques from the history of cartoon animation, like the rubber hose style used on the arms in his "Ghost Morph" GIF (see Figure 1.2). The wavy, amorphous, stretchy animation recalls early cartoons like Sullivan and Messmer's *Felix the Cat* or Fleischer Studios's *Popeye the Sailor*. This looping GIF portrays a series of characters wildly morphing into one another as they scream and wail. Two of the wackiest transitions show a character's nose turning into a ghost, which is swallowed by the subsequent character. Piascik's oddball looping GIFs make the most of our social media culture's appetite for quirky, bite-size, shareable animated content.

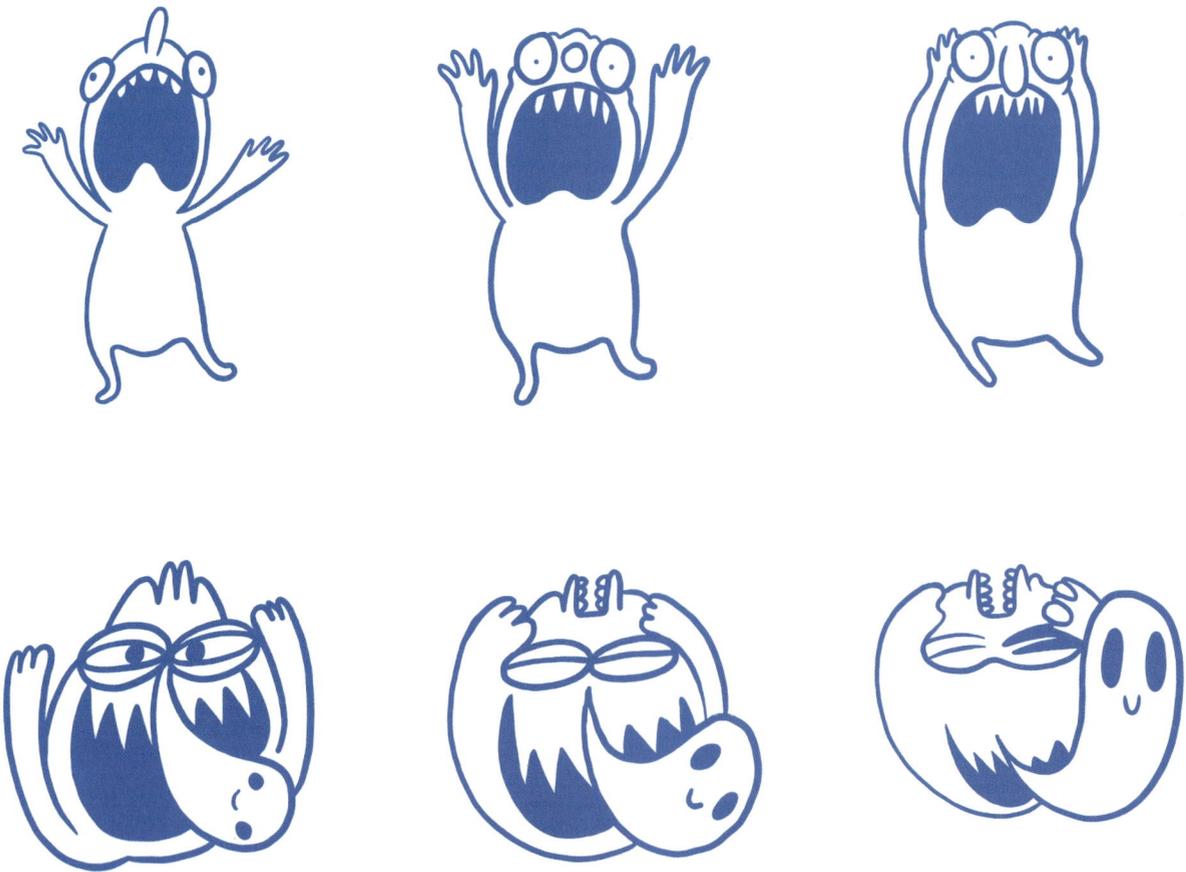

Figure 1.2 These frames from "Ghost Morph" show how Chris Piascik uses a rubbery animation style to playfully transform a sequence of characters into one another.

Computer-generated (CG) technology developed for visual effects and gaming also finds its way into the world of illustration through the adoption of advanced digital tools. For instance, Wesley Bedrosian uses 3D modeling workflows to experiment dynamically with lighting, camera angle, and pose to maximize visual communication (see Figures 1.3 and 1.4). Bedrosian's work will be discussed in greater detail in **Chapter 4.**

How did we get to this interdisciplinary moment? This chapter traces the intertwining histories of illustration, animation, graphic design, and computer science to the points of their convergence toward motion illustration.

Figure 1.3 Wesley Bedrosian's illustration of Rupert Murdoch was digitally sculpted with Pixologic Zbrush, a software used in the gaming and entertainment industries. Bedrosian captures every sag and wrinkle in high-definition detail, using a red backlight to catch the skin's texture while imbuing the portrait with a demonic spirit. The figure is posed with his head looking slightly up and away from the camera, giving him an air of superiority, while his eyes leer directly at the viewer.

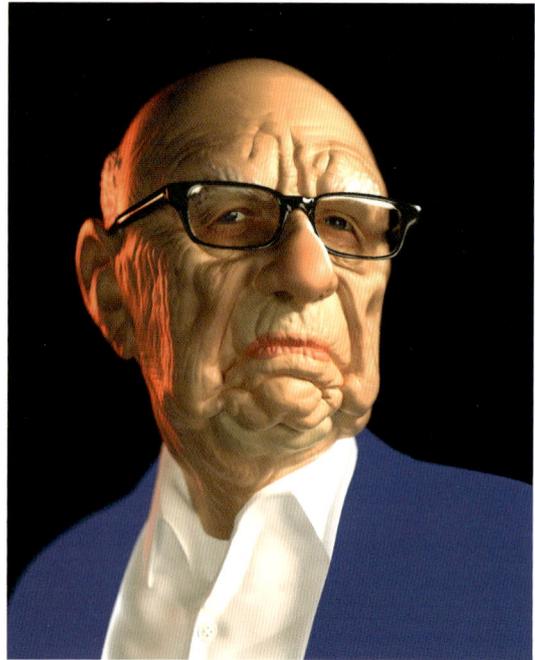

Figure 1.4 One key benefit of 3D modeling is the ability to experiment with different lighting and framing. This screengrab, taken during the sculpting process of Wesley Bedrosian's *Rupert Murdoch* portrait, shows the structure of the 3D mesh and how meaningful lighting and camera placement will be to the conceptual understanding of the final portrait.

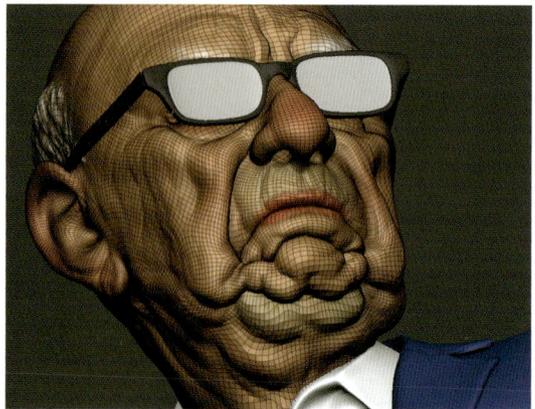

First, we will examine how technology has played a role in how illustrators create and share their work. Key inventions, art movements, and world events will be discussed as they relate to the way today's illustrator uses motion. Later, we will consider how the accessibility of digital tools allows anyone with a personal computer to create animated content. Finally, we will examine how the animated GIF was co-opted during the early years of social media to create a market for motion illustration.

This chapter focuses specifically on technology and interdisciplinarity, but does not present an exhaustive history of illustration or its related disciplines. For greater depth

and context, *History of Illustration* by Susan Doyle, Jaleen Grove, and Whitney Sherman; *A New History of Animation* by Maureen Furniss; and *The Language of New Media* by Lev Manovich all offer comprehensive discussions of their respective disciplines. Additional readings and resources can be found in the appendix.

Illustration, Technology, and Communication

Illustrators have always adapted to new technology to create and publish art. At its essence, illustration history is a story about the relationship between new technology and expanded forms of communication. As such, motion illustration, born at the intersection of digital technology and digital communication, is a logical branch in illustration's epic, global lineage. This section broadly discusses how early systems of visual communication led to writing, paper, books, printing methods, and mass publishing; informing contemporary illustration markets and allowing the opportunity for illustrators to integrate motion within their practices.

Recording and Communicating Ideas

Cave paintings are often named as the earliest form of illustration, visually communicating information 64,000 years ago. They depicted aspects of life at the time with scenes of hunting, warfare, and ceremony. Research suggests that the non-figurative markings paired with the images may be a proto-writing system, functioning as a record for animal behavior (Bacon 2023). Although we do not know how accessible these paintings were or who could read them, their purpose was likely a communication medium: to record history, share information, or perhaps even entertain.

Some of these proto illustrations might also be understood as forbears to animation. For instance, the paintings discovered on the walls of the Chauvet-Pont d'Arc cave in France depict multiple lionesses drawn overlapping one another (see Figure 1.5). From one perspective, we might understand this as a group of many lions. Another interpretation may be that the duplication of their forms animates them leaping toward their prey. Because these cave images would be illuminated with fire light, it is likely that the Paleolithic people would only see portions of the wall at a time, and the flickering light might aid in the illusion of movement and introduce a sequential narrative structure (Zorich 2014).

Advancing thousands of years, the development of the written language allows people to record and communicate complex information. Writing begins as pictographic script—symbolic images representing words and ideas. Some of the first known evidence of writing comes from Sumerian script on clay tablets in Ancient Mesopotamia around 3400 BCE (Brown 2021). Egyptian hieroglyphic script emerged about the same time, approximately 3200 BCE. Early writing was used for bureaucratic purposes, like food rationing and business agreements, as well as to tell stories about royalty and religion.

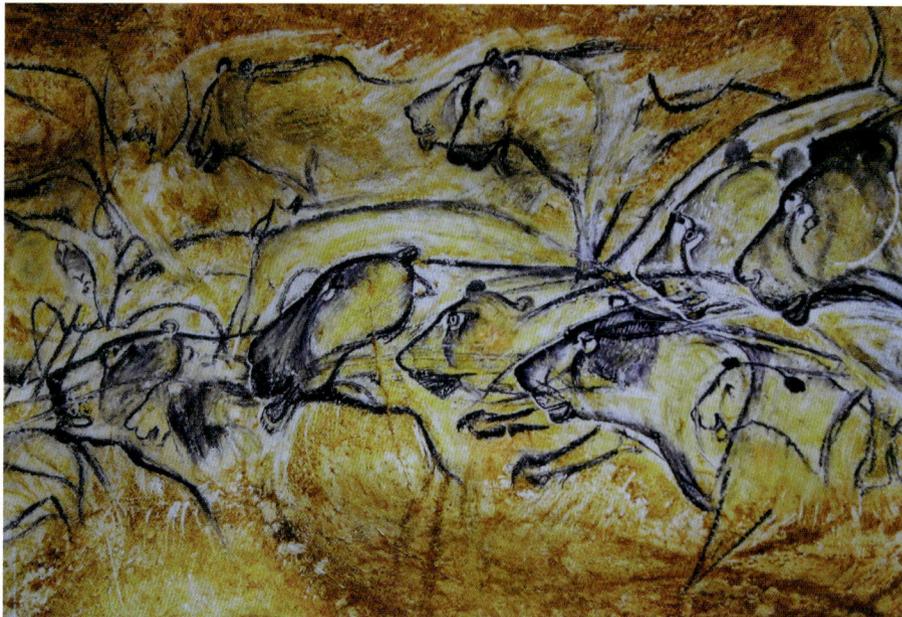

Figure 1.5 This photograph shows paintings of lionesses on the walls of the Chauvet-Pont d'Arc cave in southern France. The overlapping figures suggest movement or animation. Thousands of years later, Étienne Jules Marey would experiment with multiple exposures of a single action in his photographs from the 1800s, and artist Marcel Duchamp would famously paint overlapping action in *Nude Descending a Staircase, No. 2* (1912).

Paper, Printing, and Publishing

Along with writing, the invention of lightweight, portable materials, like papyrus (Egypt, 3000 BCE), parchment (Pergamum, 1500 BCE), and paper (China, 105 CE), were transformative as a medium for recording and sharing information. Hand-rendered illustrations began appearing in Western manuscripts and books around the seventh century. Illuminated manuscripts were produced with rich illustrations and ornate lettering to document and convey religious messages for many faiths. These were hand-copied texts produced in monasteries or by highly skilled artisans for academic and devotional use.

The Chinese invention of printmaking techniques in the eighth century, like wood-blocks and moveable type, allowed text and image to be duplicated. The woodblock led to the commercial mass production of books in China as early as the tenth century. Subjects included religious texts, fiction, and self-improvement, and often included illus-trations for decorative and instructional purposes (Doyle, Grove and Sherman 2019). Through trade, papermaking and printmaking processes propagated to empires world-wide and were adapted to meet local cultural needs. For instance, beginning in 1600s Japan, Ukiyo-e prints used a sophisticated woodblock process to reproduce intricate illustrations in lush colors (see Figure 1.6).

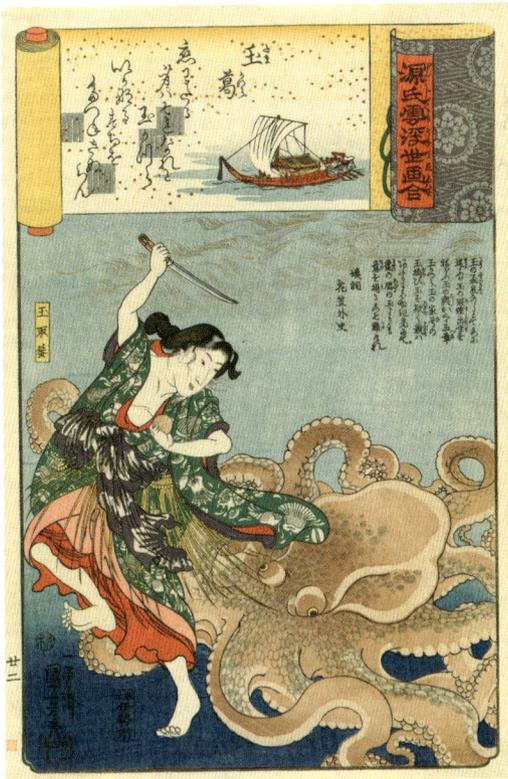

Figure 1.6 Japanese Ukiyo-e prints depict stories with opulent color applications. This print by Utagawa Kuniyoshi from 1845, "A Lovely Garland," illustrates a scene from a medieval tale where a beautiful diver battles an octopus on her journey to recover a jewel stolen by the sea king. The dynamic visual storytelling in Ukiyo-e prints would inspire manga comic books and later Japanese animation.

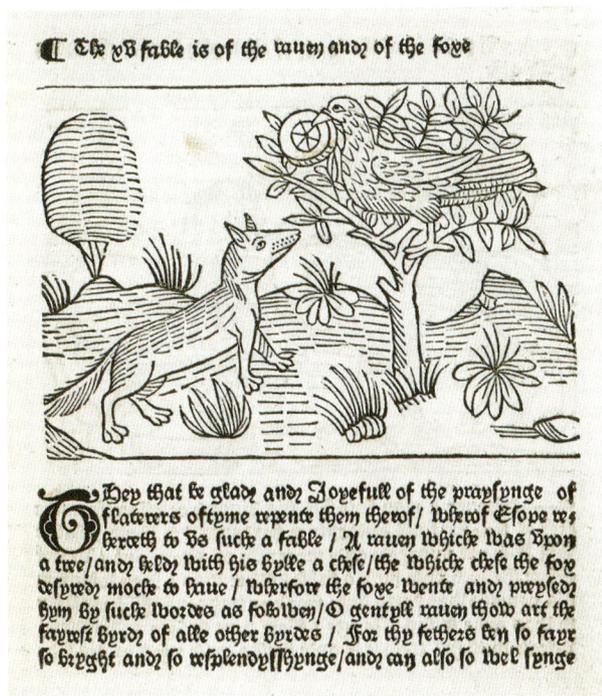

Figure 1.7 This detail from William Caxton's 1484 edition of *Aesop's Fables* tells the story of "The Raven and the Fox" with a woodcut illustration and printed text. Published with the newly introduced printing press, children's books like these would be widely distributed, embedding cultural awareness of folktales, fairytales, legends, and fables; as well as helping to form the picture book industry. Consider how today's interactive storybooks are built on this simple foundation.

Around 1450, German goldsmith Johannes Gutenberg combined existing printmaking techniques with the innovation of reproducible metal type to mass-produce prints with speed, revolutionizing the distribution of information and planting the seeds for today's global news network (Roos 2019). For the literate, printed illustrations aided in understanding complex subjects like anatomy. For those who could not read, printed illustrations made information accessible, democratizing knowledge.

Spread of News Media and Advertising

During the 1800s, upgrades in printing technology—like improved presses, paper, and color printing techniques—added speed, accuracy, and quality to printed material, allowing the mass production of widely circulated, low-cost, and disposable illustrated publications such as *The Penny Magazine, Punch, Harper's Monthly*, and *Collier's*. These publications used illustration to educate, entertain, and sway public opinion through caricature, satire, and political commentary, thus establishing the practices of editorial illustration and comics.

Meanwhile, advertising developed from the expanding consumer culture enabled by industrialization and had a symbiotic relationship with print media; printers funded technological advancements in part through hefty advertising fees (Baker Library Historical Collections n.d.). Illustrators made ads for print publications, posters, and branded collectibles to sell products and services, beginning an enduring collaboration with the advertising market.

The popularity of newspapers, magazines, and books, combined with improvements in printing and the public's voracious appetite for illustration, led to a period known as the Golden Age of Illustration from the 1850s to the 1930s. Innovations in photographic reproduction processes, like color halftone, made it possible to duplicate illustrations made in any media, reducing the need for illustrators to be trained in printmaking processes like wood engraving or metal etching. For instance, see how J. C. Leyendecker's lush oil painting technique is translated to print advertising in Figures 1.8 and 1.9.

At the height of the Golden Age, the most popular illustrators like Arthur Rackham, N. C. Wyeth, Maxfield Parrish, and Norman Rockwell were household names, earning substantial fees for their images. Artists would also be known for their richly illustrated children's books, such as John Tenniel (*Alice's Adventures in Wonderland*, 1865), Randolph Caldecott (*The House that Jack Built*, 1865), and Beatrix Potter (*The Tale of Peter Rabbit*, 1902).

Print technologies would similarly lead to the beginning of comics. The first comic strip, "The Yellow Kid and His New Phonograph," was created by Richard Outcault in 1895 and published in the *New York World*. This was followed by a series of popular comic strips, such as Winsor McCay's *Little Nemo in Slumberland* (1905), Hergé's *The Adventures of Tintin* (1929), as well as superhero comic books like Joe Schuster's *Superman*, first appearing in *Action Comics* (1938).

New Directions

The Golden Age of Illustration ended around the 1930s when photography began to replace illustrations as the preferred method of visual storytelling. Of course, illustration is still alive and well, doing what photos cannot: depicting the illustrator's point of view

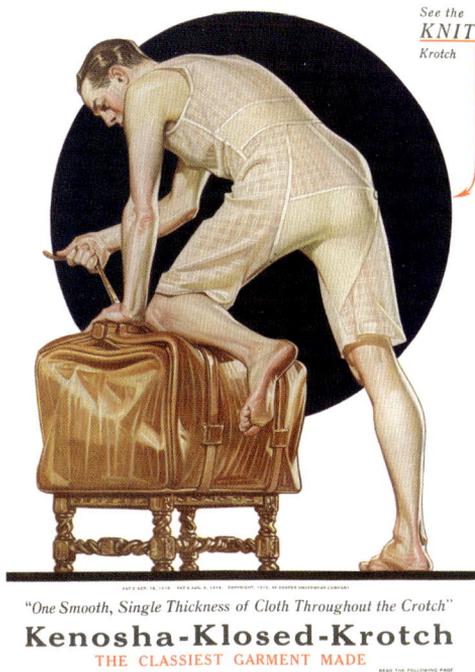

"One Smooth, Single Thickness of Cloth Throughout the Crotch"

Kenosha-Klosed-Krotch
THE CLASSIEST GARMENT MADE

Figure 1.8 J. C. Leyendecker's illustrated print advertisement for the Cooper Underwear Company's "Kenosha-Klosed-Krotch" (1916). The ad's overt sensuality shamelessly grabs the viewer's attention, an advertising ploy still used today in TV spots and social media adverts.

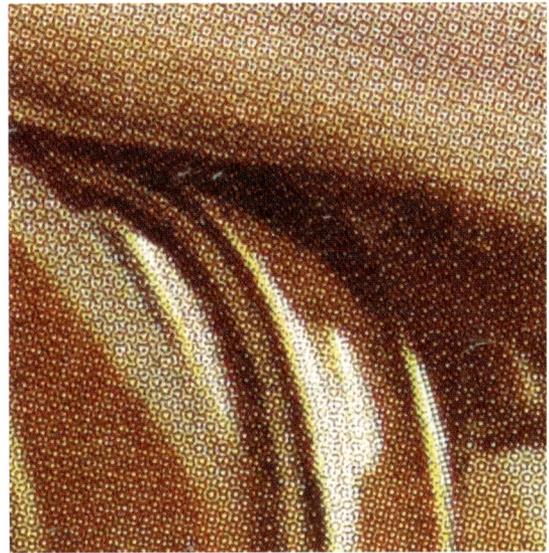

Figure 1.9 This detail of the "Kenosha-Klosed-Krotch" advert shows how Leyendecker's traditional brush strokes are reproduced through halftone color printing via arrays of colored dots that blend in the viewer's eye to produce full tonal range. This technological advance in printing is much like the dithering patterns used in digital media decades later when file formats like the GIF were developed to display full-color imagery on computer screens.

through stylized, thematic, and conceptual imagery. Adapting to competition from the camera has led to diverse illustration marketplaces with specialties in advertising, publishing, package design, surface design, comics, fantasy art, entertainment design, and more.

Meanwhile, the introduction of accessible digital tools and online distribution in the 1980s and 1990s have only further democratized the artform, reducing the need for traditional materials and providing a free publishing platform to every artist. Illustrators have historically adapted and thrived with new technology; motion illustration is an exciting new direction.

Connections with Film, Graphic Design, and Technology

Understanding how the illustration discipline developed through invention, we can now turn our attention to the events that have intersected through history to form the creative tools, distribution channels, viewing devices, and social tastes at the foundation

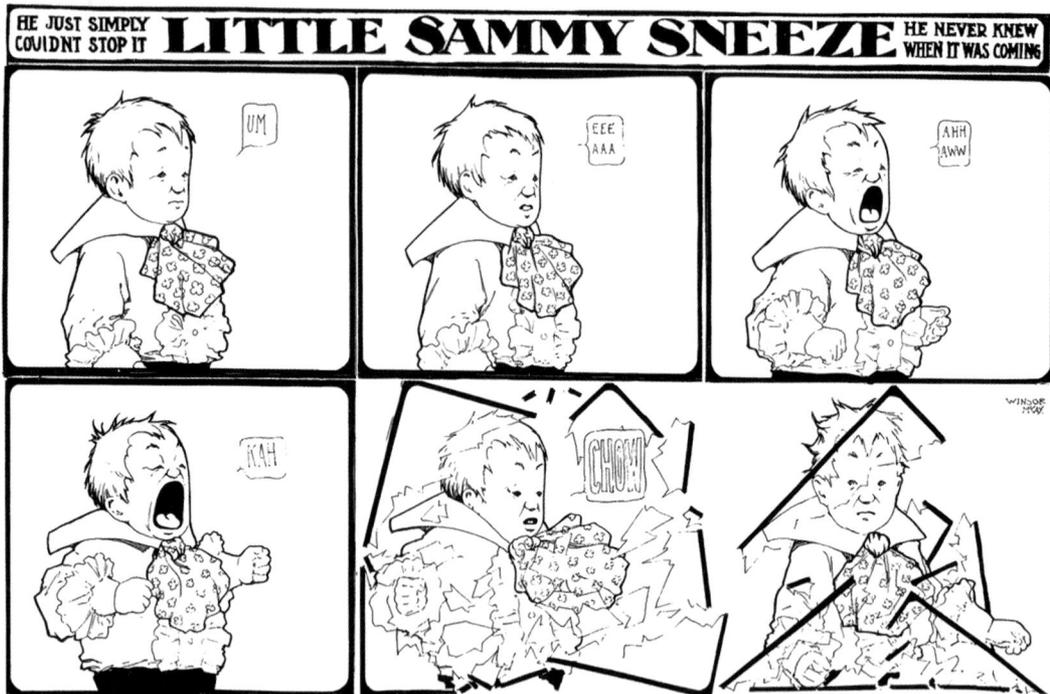

Figure 1.10 Cartoonist Winsor McCay plays with the viewer's expectations in this Little Sammy Sneeze comic strip, illustrated for the *New York Herald* (1905). Subverting comic conventions, the panel borders break to show the intensity of Sammy's sneeze. The grid panel layout feels almost like a film strip, foretelling McCay's innovative work in animation.

of motion illustration. While this section progresses somewhat chronologically, it is not a straightforward timeline. Instead, it aims to reveal connections between distinct areas of study, including art movements, film, cartoon animation, motion graphics, and computer technology.

Ancestors of Animation (1600–1900)

In the early 1600s, Dutch scientist Christiaan Huygens invented the "Magic Lantern," which projected a single image onto a screen or wall (see Figure 1.11). This device was used to entertain audiences with fantastical images, effectively functioning as early cinema. In the 1800s, handheld parlor toys like the Thaumatrope (1827), Phenakisti-scope wheel (1832), and Zoetrope (1834) made animation accessible to the public and are analog forebears to the looping GIF (see Figure 1.12). These simple devices created the illusion of movement through the rapid playback of sequenced illustrations.

Today's digital imaging technology also began in the 1800s via unrelated inventions from around the globe. These innovations provide the foundation for digital illustra-tion tools and publishing platforms. For instance, French weaver Joseph Jacquard's loom (1804) used punch cards to automate complex patterns in textiles. These punch cards

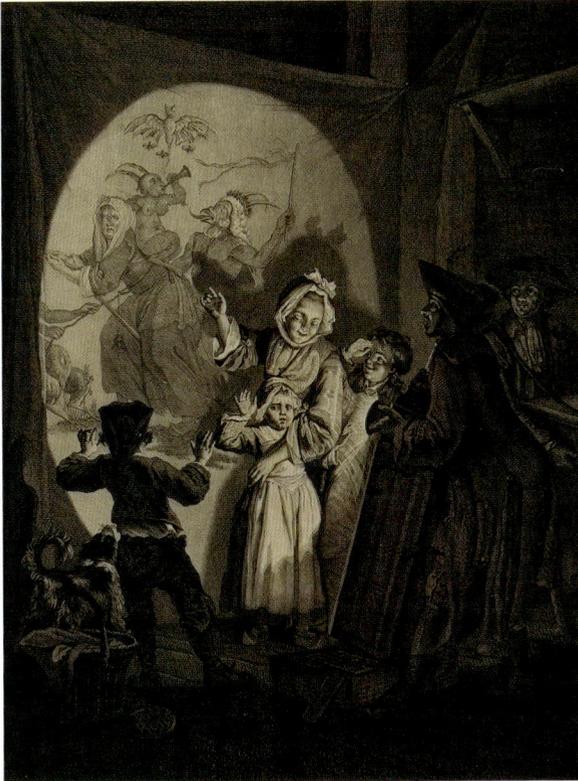

Figure 1.11 This illustration of a "Magic Lantern" show, by French engraver Jean Ouvrier (1725–1784), shows how a single image would be projected for groups of people as entertainment. This invention involves the illustrator at the very beginning of cinema.

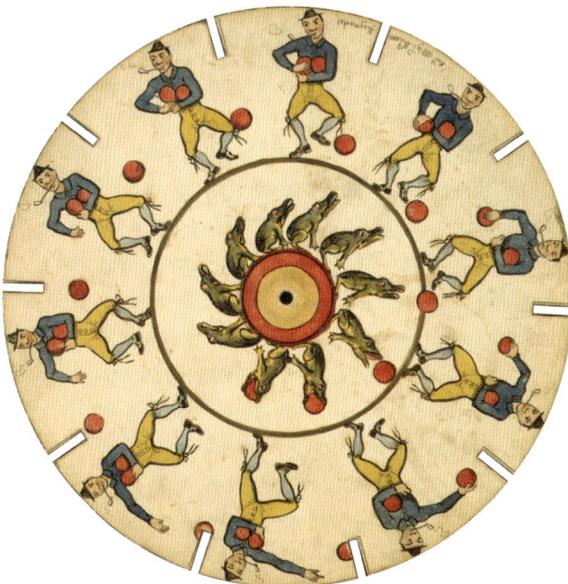

Figure 1.12 A phenakistiscope published in *McLean's Optical Illusions*, London, 1833. The disc is meant to be observed through a mirror. The sequence of discrete images transforms into continuous animation by spinning it rapidly and peering through its cutout slits.

would later be used as storage media for mechanical computers, like English inventor Charles Babbage's "Analytical Engine" (1837). Later innovations would pave the way for displaying images on screen, like German inventor Paul Nipkow's "Nipkow disc" (1884), a mechanical image scanning device that would later be used in the first televisions; or Ferdinand Braun's Cathode Ray Tube (1897), a vacuum tube that could display images on a phosphorescent screen; leading to Japanese engineer Kenjiro Takayanagi's electronic television receiver (1926).

A fascination with movement

Innovations in cameras and photography provided the foundation for motion pictures. Early technology, like the camera obscura, referenced as early as the fourth century BCE in China, allowed a camera's view to be projected onto a surface. However, French inventor Nicéphore Niépce is credited with the invention of photography, with his experiments in the early 1800s that allowed an image to be fixed to a surface with chemicals. His 1827 heliograph is the earliest known photograph.

In the 1870s–90s, the works of French scientist Étienne Jules Marey and British-American photographer Eadweard Muybridge formed the foundation for cinematography with their studies of human and animal locomotion, which required the development of cameras that could shoot a sequence of photos. Additionally, their photographic catalogs have been referenced extensively by animators as an aid for understanding the discrete poses that make up everyday movements like walking and running (see Figure 1.13).

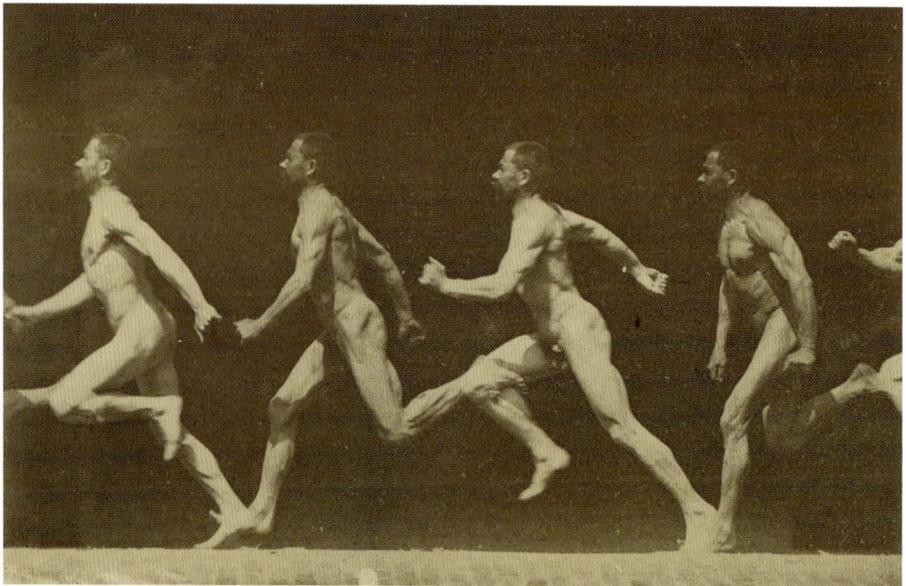

Figure 1.13 French physiologist Étienne Jules Marey used his "chronophotographic gun" to create a single photograph with multiple exposures, elucidating human locomotion (photo circa 1894). His photographs, and those of his contemporary Eadweard Muybridge, helped animators understand how to draw believable movement.

A meeting between Muybridge and American inventor Thomas Edison inspired the first motion-picture camera, the Kinetograph, which William Dickson further developed in 1891 during his employment with Edison. This device captured images on a roll of perforated film, to be played back on a Kinetoscope to a single viewer. After viewing an exhibition of the Kinetoscope in Paris, the Lumiére Brothers developed an improved camera and projector system, the Cinématograph. In 1895, they debuted the invention with a public screening (Furniss 2007: 14).

These advances in motion-picture cameras allowed for narrative filmmaking and, not long after, the introduction of special effects. In 1902, illusionist Georges Méliès used stop-motion techniques in the live-action film, *A Trip to the Moon* (1902), playfully integrating double exposures, split screens, and dissolves to visualize this fantasy narrative (Furniss 2007: 5).

Exciting special effects would continue development throughout the twentieth century, such as the stop-motion animation and optical compositing in *King Kong* (1933), color film traveling mattes in *The Thief of Baghdad* (1940), and the optical slit-scan technique in *2001: A Space Odyssey* (1968). While digital tools would eventually replace these analog techniques, they were important stepping-stones toward the special effects technology developed for the film industry, which in turn led to the commercial animation software used by today's motion illustrators.

Inventing Animation (1900–1950)

In the early 1900s, cartoonists begin experimenting with animation on film. French cartoonist Emile Cohl's *Fantasmagorie* (1908) is one of the earliest known examples of cartoon animation. American cartoonist Winsor McCay, discussed previously for his printed comics, pushed the boundaries of early cartoon animation with his detailed drawings in *Little Nemo* (1911), *Gertie the Dinosaur* (1914), and *The Sinking of the Lusitania* (1918). Cutting his teeth on sequential storytelling in printed media, McCay's interest in animation was a natural step forward. Known for imaginative characters and meticulous environments, his works would inspire the next generation of animators (see Figure 1.14).

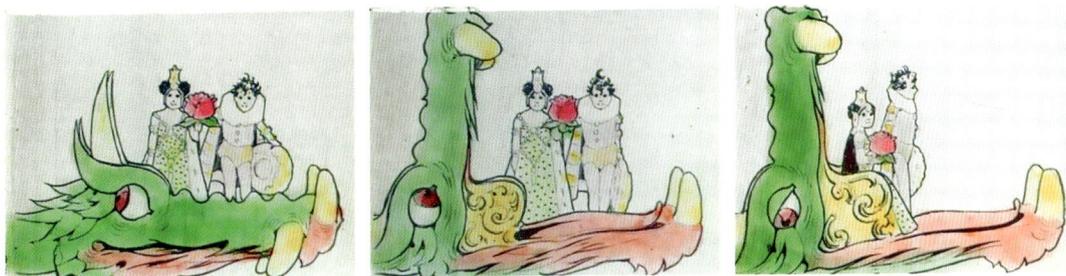

Figure 1.14 Winsor McCay's *Little Nemo* (1911) is one of the earliest known animated films, created before cel animation became the standard production method for most of the twentieth century. Pre-dating color photography, each frame of this film print was meticulously hand-tinted, resulting in variation in tone as the animation proceeds.

Cartoon competition drives innovation

Technical innovations from the 1910s through the 1930s would define the look and feel of cartoon animation and launch a new industry through the formation of animation studios. Many critical developments in animation come from intense competition between American studios, who raced to one-up each other with novelty to attract audiences. Some of the most important and enduring inventions include:

- **Cels:** Earl Hurd's 1914 invention of cel animation allowed for the reuse of backgrounds. This technique would be used for most of the century, only to be replaced by computer processes in the 1990s.
- **Rotoscope:** Max Fleischer patented the Rotoscope in 1915, allowing an image to be traced from live-action film. He used rotoscoping in the *Out of the Inkwell* series (1918) starring Ko-Ko the Clown.
- **Celebrity:** While not technically an invention, Pat Sullivan's *Felix the Cat* (1919) would become the first celebrity animated character, debuting in 1919. Felix was a sensation and would be cross-promoted on merchandise and toys.
- **Audio:** Lee De Forest's Phonofilm sound-on-film system would be used by Fleischer Studios in *Song Car-Tunes* (1924), the first animated film with recorded sound. Audio technology would be refined through Pat Powers' newer Cinephone system, used in Disney's *Steamboat Willie* (1928).
- **Color:** Ub Iwerks' short *Fiddlesticks* (1930) is the first animated film to use color, with Technicolor's two-strip process. Walt Disney Productions had an exclusive contract to use Technicolor's superior three-strip process, which allowed for a wider range of colors. They released their first color film, *Flowers and Trees*, in 1932.
- **Multiplane Camera:** Ub Iwerks is typically credited as the inventor of the multiplane camera in 1933, which allowed painted background elements on glass shelves to be moved independently, creating the illusion of depth or **parallax** motion. However, Lotte Reiniger used a similar device several years earlier in *The Adventures of Prince Achmed* (1926). Bill Garity developed the most well-known version for Disney, first used in *The Old Mill* (1937).

Experimental approaches

In addition to cartoonists, fine artists and filmmakers developed many important visualization techniques through their experimentation with film. For instance, Walter Ruttmann animated swaths of shape and color, timed to music, in abstract films like *Lichtspiel: Opus I* (1921). Fernand Leger edited together random footage clips against a jittery musical composition in "Le Ballet Mécanique" (1924), delighting in the materiality and implied meaning of the image sequence. Marcel Duchamp experimented with optical illusion in "Anémic cinéma" (1926), where he filmed spinning discs with spiral patterns and text. In the 1930s, Oskar Fischinger interpreted music with fluid, abstract animation in his impressionistic films, while Norman McLaren would draw and paint directly onto film stock. These early explorations would inspire generations of designers and animators to use abstraction, montage, and illusion for storytelling purposes.

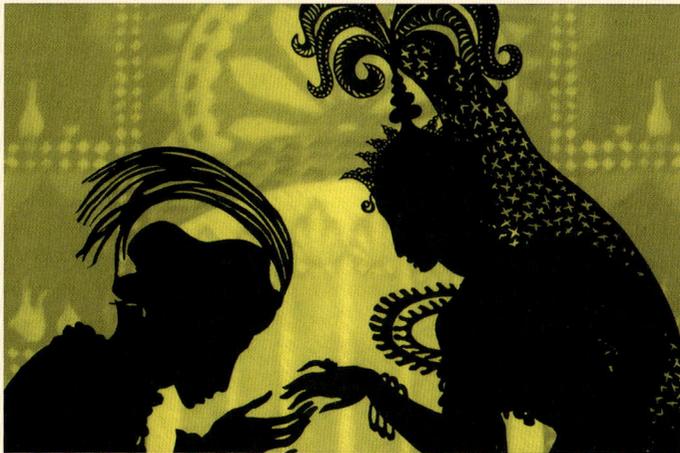

Figure 1.15 German animation director Lotte Reiniger's *The Adventures of Prince Achmed* (1926) used a unique paper puppet animation technique, resembling the dramatic visual style of traditional Indonesian shadow puppets. Her beautiful character designs feature strong silhouettes balanced with fine costume details.

Cartoon animation is certainly not exclusive to Americans as a storytelling medium. Indeed, the first full-length animated film, the lost *El Apóstol* (1917), was made in Argentina by Quirino Cristiani. In Germany, director Lotte Reiniger's *The Adventures of Prince Achmed* (1926) used a **cutout** puppet approach to animation (see Figure 1.15). In Russia, animator Ladislas Starevich used **stop-motion** to animate 3D puppets in his feature-length *Reynard the Fox* (1937). In China, the Wan Brothers released the first Asian feature-length animated film, *Princess Iron Fire* (1941), and followed it up with their masterpiece *Havoc in Heaven* (1961). In Italy, Anton Gino Domeneghini would direct the lush 2D feature, *La Rosa di Bagdad* (1949), inspired by fairytale films from Walt Disney Productions. In Britain, directors John Halas and Joy Batchelor would adapt George Orwell's satiric allegory, *Animal Farm* (1954). Many of these films are cultural touchstones in their home countries and have influenced animators internationally.

Golden age of cartoon animation

Starting with the implementation of sound in the mid-1920s, cartoon animation enjoyed a renaissance with high-quality films, shorts, and television shows which set a lasting standard in the industry. Disney's *Snow White and the Seven Dwarfs* (1937) was the first feature-length cel-animated film, created by the talented crew known as the "Nine Old Men," who would establish the **basic principles of animation**. Warner Bros. would also foster the talents of many prominent animators, including Chuck Jones, Friz Freleng, and Tex Avery, with the production of their *Looney Tunes* and *Merrie Melodies* film series.

During the Golden Age of Animation, notable illustrators were also hired to work on cartoons, producing concept art, character designs, and background paintings. For instance, Kay Nielsen (Danish, 1886–1957), Gustaf Tenggren (Swedish–American,

1896–1970), Tyrus Wong (Chinese-American, 1910–2016), Eyvind Earle (American, 1916–2000), and Mary Blair (American, 1911–1978) were hired as production designers at Disney, lending their unique illustrative voices to classic films such as *Snow White* (1937), *Fantasia* (1940), *Bambi* (1942), *Cinderella* (1950), and *Sleeping Beauty* (1959).

Bold Shapes and Colors (1905–1970)

Outside of film and animation, artists embraced technology following the Industrial Revolution and rejected the overwhelming decoration and shallow ornamentation of the past. Modernist art movements flourished throughout Europe and America during the first half of the twentieth century, like Constructivism, Futurism, Purism, Cubism, and De Stijl. Artists such as Le Corbusier (Swiss-French, 1887–1965), El Lissitzky (Russian, 1890–1941), Herbert Bayer (Austrian, 1900–1985), and Robert Delaunay (French 1885–1941) embraced formal design elements with bold shapes and colors taking center stage.

Modernist impact on the graphic arts

Lissitzky is one of the main figures of the Constructivist movement, influencing the spread of design formalism across the world and profoundly impacting the field of graphic design. Lissitzky would experiment with abstract minimalism in his paintings, like *Der Prolog* (1923), which shows his graphic sensibilities in the harmonious balance of shape, line, value, and form (see Figure 1.16).

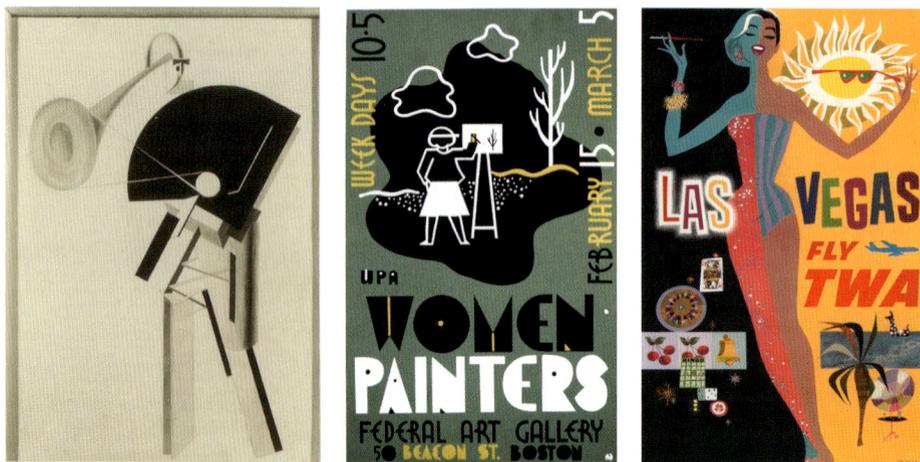

Figure 1.16 The minimalist shape-language and balanced compositions in Modernist art, visible in El Lissitzky's painting *Der Prolog* (1923), helped bring formalist design to commercial graphic design and animation.

Figure 1.17 This poster was commissioned by the United States' Works Progress Administration (WPA) in 1938 as part of a massive program to sustain artists during the Great Depression. The program supported the creation of about 2,000 WPA posters, which are known for their minimalist abstract styles, undoubtedly inspired by Modernist art movements.

Figure 1.18 David Klein illustrated this travel poster for TWA in 1962. Its streamlined shape-language and bold application of color show an evolution of the Modernist aesthetic in the graphic arts. This visual approach was pervasive in the 1960s and visible in cartoon animation—for example, compare this female figure to character designs for Wilma and Betty from *The Flintstones* (1960).

The abstract influences of Modernism would be embraced by graphic artists globally. For instance, in the United States, designers commissioned by the WPA would use Modernist aesthetics in their poster designs. The 1938 poster in Figure 1.17 uses a stark 4-color palette along with curvaceous shapes, hard angles, and thin lines to depict an abstracted figure painting in the park. The intentional use of negative space cushions the composition, drawing the viewer's eye toward the central illustration.

Posters and other advertisements like these would change the public's visual taste, with graphic shapes, expressive colors, and minimalist designs becoming the standard for graphic design and cartoon animation. Figure 1.18 shows a 1962 Trans World Airlines (TWA) poster illustrating a female figure enjoying the day and night pleasures found in Las Vegas. The illustrator's abstraction of the figure, with lively shape-language and eye-catching palette, is an evolution of the ideals started by the Modernist movements fifty years earlier while embracing new movements like Pop Art.

Modern cartoon style

After becoming popular in the graphic arts, Modernism's formalist design aesthetic permeated the cartoon animation industry. United Productions of America (UPA) was founded in 1946 by former Disney employees and is considered the initiator of the modern cartoon style. Their animated short, *Gerald McBoing Boing* (1951), was a sensation that sent ripples across the global animation industry with its snappy motion and minimalist aesthetic, bucking the Golden Age's march towards naturalism. Aware of the Modern art movements, UPA's sparse production design elicits a whimsical mood with pattern, texture, abstracted shapes, and offset registration (see Figure 1.19).

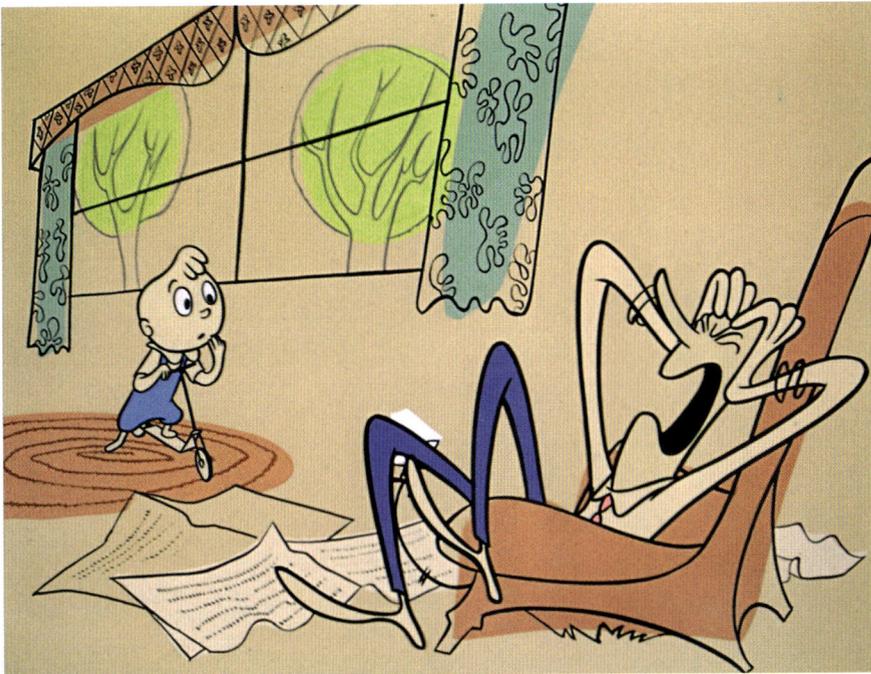

Figure 1.19 This still frame from *Gerald McBoing Boing* (1951) shows how the artists at UPA collaged line, shape, color, and texture to create a bold new style in post-war animation. UPA's Modern look would be imitated by animators across the world, making a lasting impact on cartoon animation.

This Modern style would stimulate a new direction in animated shorts and advertisements worldwide, for instance, in the work of the animators at Yugoslavia's Zagreb Film studio. Known as the "Zagreb School of Animation," these artists produced a significant body of work from the 1950s to the 1980s, known for their avant-garde visual stylization and mature storytelling. Speaking to an interviewer in 2009, Zagreb director Vatroslav Mimica said, "we understood that Disney was not everything, and that we could express ourselves differently ... we left the rubber figurines based on circles, and discovered the triangle, the square, and the other possibilities of modern graphics" (Grgic 2009). Mimica's award-winning 1958 animated short, *Samac (The Lonely)*, used the Modern geometric approach to great effect, distorting and warping the protagonist's body to visualize his losing battle with industrialization.

Outside of UPA and Zagreb, many other studios embraced this new style, such as Italy's *An Oscar for Signor Rossi* (1960) by Bruno Bozzetto Productions; Hungary's *Uhuka, Who Watches TV All Day* (1969) by Gyula Macskássy and György Várnai; and France's *Un Atome Qui Vous Veut Du Bien* (1960) by Henri Gruel.

Moving towards the psychedelic 1970s, modern cartoons opened the door for exciting new animation styles that embraced multimedia collage, like Heinz Edelmann's art direction for *Yellow Submarine* (1968), Terry Gilliam's animation for *Monty Python's Flying Circus* (1969), or René Laloux's *Fantastic Planet* (1973). The influence of Modernism is still alive, evident in the snappy animation and graphic sensibilities of today's illustrators such as Igor Bastidas, Andrea Chronopoulos, and Yukai Du.

Explosion of Screen Culture (1950–1980)

The relationship between people and screens changed forever with the public's massive and rapid adoption of television in the second half of the twentieth century. Serving millions of new viewers, nascent television networks began producing programs and broadcasting widely in the late 1940s, shifting the public's media consumption away from radio.

Animation was part of television culture from the beginning, with the American production of *Crusader Rabbit* in 1950 being the first animated series made specifically for broadcast. This paved the way for enduringly popular shows like *Hergé's Adventures of Tintin* (1957) in France, Jay Ward Production's *Rocky and his Friends* (1959) and Hannah-Barbera's *The Flintstones* (1960) in the US, and Osamu Tezuka's *Astro Boy* (1963) in Japan. Unlike the rich cartoon animation often seen in film, these television shows utilized **limited animation** techniques such as camera movements, stock footage, and looping cycles that allowed the animation to be produced more quickly and cheaply. This approach made a lasting impact on artists, evident in the loops and "camera movements" seen in contemporary motion illustration.

Television also ushered in a new era of motion-based advertising. Animation studios around the world would produce high-quality animated commercials for consumer brands in the 1960s and 1970s, experimenting with new visual styles and disseminating them to the public. The legacy of these animated television spots can be traced to today's commercial marketing campaigns that continue to use animation and motion graphics to sell products.

Computer imaging and gaming

Along with television, advances in digital computing would create a path towards personal computers, design software, and the internet—necessary tools for today's illustrator. First designed as a flight simulator in 1951 for the US Navy and Airforce, MIT's Whirlwind computer could display real-time text and graphics using the cathode-ray tube (CRT) for its digital display (Carlson 2017). In 1963, computer scientist Ivan Sutherland wrote Sketchpad, a computer program that introduced the concept of **Computer Aided Drafting (CAD)** software, which could be used for technical and artistic purposes (Ross 2022). The year 1966 would see the beginning of 3D imaging, with MAGI's SynthaVision, which simulated nuclear radiation exposure. Its technique of "**raytracing**" was adapted to trace light rather than radiation, and would be used in 3D animation (Carlson 2017).

The rapid development of digital computing also initiated gaming culture. Programmer Steve Russell worked with a group at MIT to create *Spacewar!* (1962), one of the first video games (Bellis 2019). Other early games from this period include *OXO* (1952), *Tennis for Two* (1958), and *Pong* (1972). These early games were built around simple graphics, with large pixels visualized in pure black and white. For instance, *Spacewar!* depicts two small white space shuttle icons which can be "piloted" by the player against a black field littered with white pixel stars (see Figure 1.20). While these binary graphics

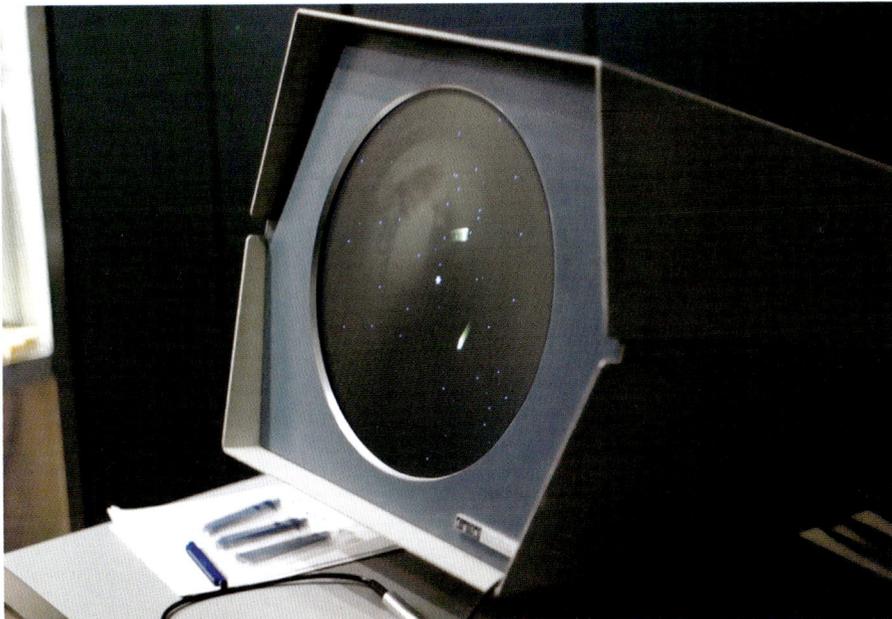

Figure 1.20 Computer game *Spacewar!* (1962) running on a PDP-1 (Programmed Data Processor-1) at the Computer History Museum in Mountain View, California. Its CRT display was initially developed for military radar applications and could plot points on a grid of 1024 × 1024 (PDP-1 2022).

appear rudimentary to our modern eyes, early games like *Spacewar!* fueled interest in computing that led to more sophisticated digital graphics for games, television, film, and the web.

Motion graphics emerges as a new artform

Like a puzzle finally coming together, decades of experimental film, the Modern design aesthetic, new technology, and the burgeoning media culture of the 1950s provided graphic designers with the tools and motivation to explore motion graphics. Combining techniques of print graphics with animation and sound, many of the features of motion graphics are prevalent in motion illustration. Both disciplines, born from long histories in print, bring special attention to formal design and conceptual thinking into the animated medium.

Motion graphics would develop as a specialized discipline through title sequences in blockbuster films. Saul Bass's titles for Otto Preminger's *The Man with the Golden Arm* (1955) were pivotal in establishing motion design. An American graphic designer known for his minimalist film posters and iconic corporate logos, Bass uses a staccato animation style with spare white stripes on a black background, synched perfectly to Elmer Bernstein's jazz score (see Figure 1.21). He would create many influential title sequences for films like *Vertigo* (1958), *North by Northwest* (1959), and *Psycho* (1960). Bass's minimalist, abstract approach makes his motion graphics effective. Rather than

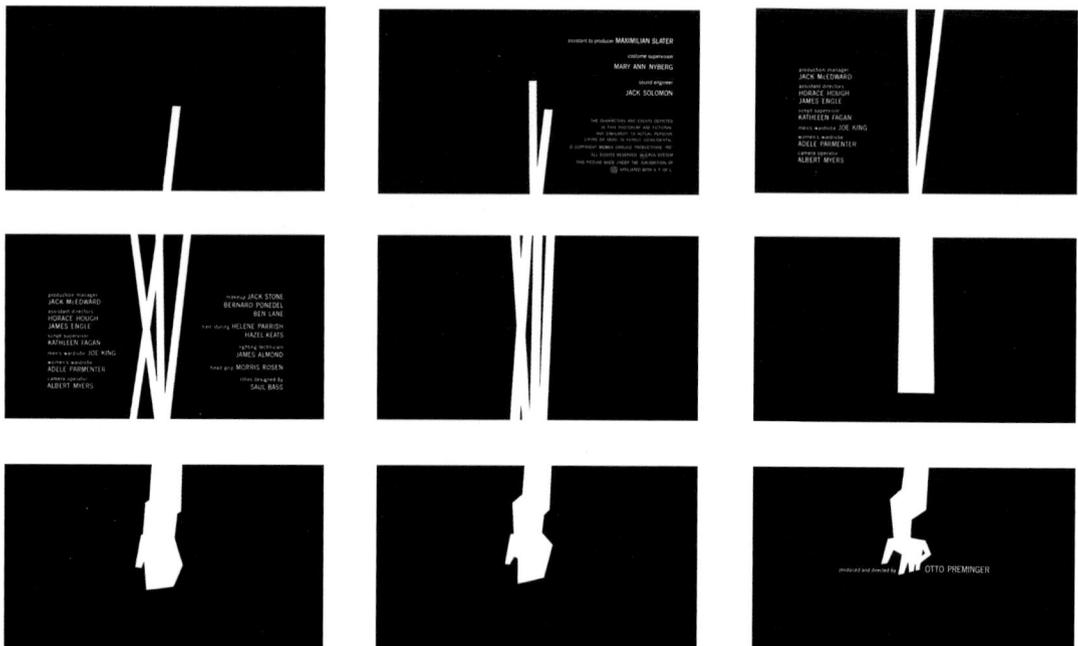

Figure 1.21 Otto Preminger's *The Man with the Golden Arm* (1955) tells the taboo story of heroin addiction. Saul Bass's opening titles symbolize the drug use with a disembodied arm. This sequence of frames shows a series of white stripes building at harsh angles, morphing into a solid rectangle, then transforming into a twisted arm.

telling a comprehensive story, he cleverly combines image and sound to evoke a specific mood within the viewer.

Artists of the day, such as Harry Smith, Jordan Belson, James Whitney, John Whitney, and Lillian Schwartz, integrated new technology in their experiments with abstract visual effects. Some of these techniques would find commercial applications. For instance, John Whitney collaborated with Saul Bass on the memorable title sequence for Alfred Hitchcock's *Vertigo* (1958) and later founded Motion Graphics Inc. in 1960 to produce title sequences for TV and film.

Experimental filmmakers would also continue manipulating film with analog techniques, such as in Stan Brakhage's *Mothlight* (1963), where he taped parts of moths, twigs, and leaves directly onto the film. Brakhage's mixed-media approach to working with film would inspire the next generation of motion designers, like Kyle Cooper, whose titles for *Seven* (1995) utilize scratches, double exposures, and rapid cuts to set up the movie's dark tone for the viewer.

ANIME'S GLOBAL INFLUENCE

The distinctive aesthetics, ethereal fantasy, and epic storytelling of Japanese **manga** and **anime** have captured the imagination of illustrators around the globe for generations. With roots in the rich storytelling of Ukiyo-e prints, the term manga was first used to describe Santō Kyōden's picture book, *Shiji no Yukikai (Four Seasons)*, in 1798, leading a wave of comic book circulation in Japan. By the 1910s, animators like Ōten Shimokawa, Jun'ichi Kōuchi, and Seitaro Kitayam were producing animated shorts. Influenced by Western cartoons, such as Fleischer Studios' Betty Boop, the "fathers of anime" sparked the development of a youthful, expressive shape-language that would become ubiquitous in Japanese media.

Manga exploded after World War II through the work of popular comics, like Osamu Tezuka's *Astro Boy* and Machiko Hasegawa's *Sazae-san*, and would be adapted for the screen in popular animated series, like *Astro Boy* (1963), *Lupin III* (1971), and *Mazinger Z* (1977). Japanese animation would transcend children's cartoons through the work of directors like Hayao Miyazaki, whose whimsical imagery and sensitive storytelling bring images to life in *My Neighbor Totoro* (1988), *Princess Mononoke* (1997), and *Spirited Away* (2001); or Katsuhiro Otomo's *Akira* (1988) and Mamoru Oshii's *Ghost in the Shell* (1995), both considered cyberpunk masterpieces. The meticulous craftsmanship in these films is evident in the detailed character designs, dynamic special effects animation, and fine background paintings.

Exports of Japanese manga and anime, such as *Speed Racer* (1967), *Lone Wolf and Cub* (1970), *Sailor Moon* (1991), and *Pokémon* (1996), would become global sensations. Their mature themes and deep storylines would influence popular Western media, like *Sin City* (1991), *The Powerpuff Girls* (1998), *W.I.T.C.H.* (2004), and *Steven Universe* (2013). With the confluence of art and social sharing, anime has made a lasting impression on motion illustration.

Modern Computing (1970–2000)

Up until this point, advances in computing were fueled by science, healthcare, and the military. However, the 1970s saw a new development: digital technology developed specifically as a tool for entertainment media. Breakthroughs in **computer-generated imagery (CGI)** would become a staple in the film industry, fuel the growth of the gaming industry, and lead to the design software used by illustrators today.

Hungarian-British animator Peter Foldes was a computer animation pioneer, implementing a digital **keyframe animation** method in his short films *Metadata* (1971) and *La Faim* (1973), funded by the National Film Board of Canada. Foldes created these with a computer application written by Nestor Burtnyk, which would automatically create the in-between animations from keyframe drawings made by an animator (see Figure 1.22). This type of automated **"tweening"** is now standard in digital animation software.

In Hollywood, CGI would be used for the first time in a feature-length film by Information International, Inc., who created the 2D digital animation in *Westworld* (1973), and the 3D animation in *Futureworld* (1976). In the 1980s, Lucasfilm's computer animation division, led by Ed Catmull, developed groundbreaking tools for artists to create photorealistic 3D imagery. Animator Jon Lasseter would experiment with this

Figure 1.22 Peter Foldes's short *La Faim* (1973) was made with a digital keyframe animation program. In this sequence, the gluttonous protagonist gorges a massive meal. Foldes drew the main poses of the arms and mouths, and the computer program generated the in-between poses to complete the movement.

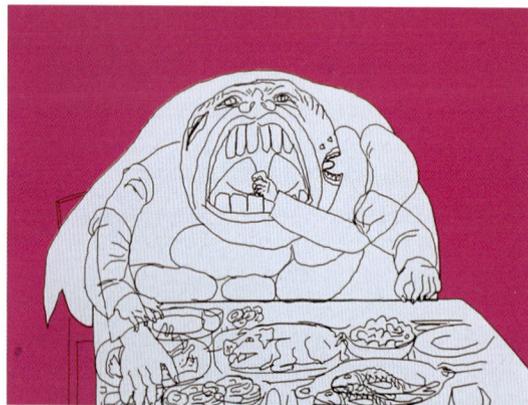

technology in his short film *The Adventures of Andre and Wally B.* (1984). This part of Lucasfilm's graphics group would become the animation studio Pixar, which produced the first full-length 3D animated film, *Toy Story* (1995). The other part would become Industrial Light & Magic, whose innovations in special effects, like the first photorealistic CGI character in *Young Sherlock Holmes* (1985), the metallic morphing effect in *Terminator 2: Judgment Day* (1991), and the lifelike organic dinosaurs in *Jurassic Park* (1993), would forever change the film industry.

CG technology would also be developed into commercial 3D animation software and special effects packages from Wavefront Technologies, Alias, Side Effects, Softimage, and Autodesk. These software packages allowed smaller studios to produce work for advertising and television, eventually becoming accessible to independent animators.

Personal computers and gaming culture

Technological advances in the 1970s, like Intel's first microprocessor, allowed the invention of personal computers, arcade gaming, and at-home gaming systems. In 1972, Magnavox released the Odyssey, the first commercial home video game console, which used interchangeable circuit cards to play different games. This was followed by consoles from competitors, like the Atari 2600 and ColecoVision. Arcade games, like *Pong* (1972), *Space Invaders* (1978), and *Pac-Man* (1980), could be played in public at restaurants, bars, and bowling alleys, embedding gaming into popular culture.

While oversaturation and low-quality games led to a gaming market crash, personal computers (PC) began to grow in popularity, like the Commodore 64 and Apple II, which allowed for more complex games, and the ability for inventive users to code their own games. The Apple II, in particular, helped transform the computer from a hobbyist tool to a standard home appliance with its consumer-friendly design boasting color imaging and sound, expanding the gaming audience and inspiring a new generation of coders. Titles like *The Oregon Trail* (1971), *Colossal Cave Adventure* (1975), and the *Zork Trilogy* (1980–82) showed how gaming could be used to tell non-linear stories, while *SimCity* (1989) and *Populous* (1989) popularized the simulation genre.

Game designer Roberta Williams helped bring non-linear narrative games into the mainstream with titles like *Mystery House* (1979) and *King's Quest* (1984). *Mystery House* was the first PC game to feature graphics, which Williams created with the VersaWriter, a peripheral that helped trace images into a digital format (Lemelson-MIT n.d.). The graphics in *King's Quest* were a marked improvement in computer graphics, showing depth and perspective with layered environments that the player could explore by moving the playable character, Sir Grahame (see Figure 1.23).

Gaming consoles became popular again with the release of the 8-Bit Nintendo Entertainment System (NES) in 1983, launching popular franchises like *Super Mario Bros.* and *The Legend of Zelda*. Sega's 16-bit Genesis console, released in 1989, boasted more colorful graphics and started the console wars, pitting their *Sonic the Hedgehog* against the improved 16-bit Super NES. In the 1990s, consoles like the Sony PlayStation and Nintendo 64 would integrate 3D graphics to create games with explorable worlds, beginning an industry-wide pursuit towards photorealistic CG graphics. The culture of gaming has opened new roles for digital artists to be involved in their creation, while their popularity has influenced the styles, medium, and storytelling used by today's illustrators.

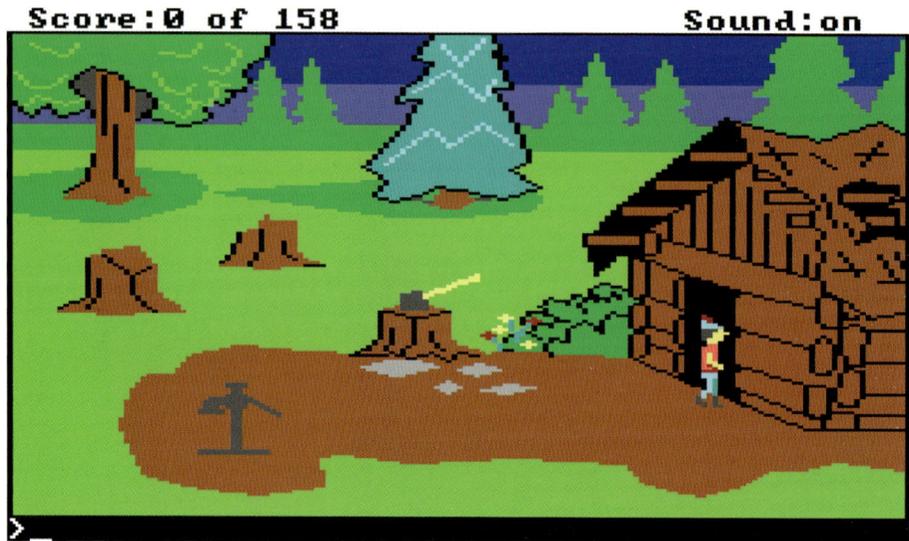

Figure 1.23 Screenshot from Roberta William's *King's Quest* (1984) from Sierra Online. The detailed graphics of computer games in the 1980s made full use of limited color palettes and minimal screen resolution, depicting complete environments with perspective and animated characters; a significant step forward from the two-color graphics of early games like *Spacewar!*

Accessibility and democratization of digital tools

Along with developments in visual effects and gaming, affordable computers and intuitive software democratized digital tools across the entire illustration field. In 1973, Xerox's Alto computer introduced the first Graphical User Interface (GUI), which allowed users to interact with icons and a desktop metaphor, although this expensive machine was only accessible to universities and research institutions (Sirk 2020). Apple would integrate a desktop-inspired GUI in their consumer-friendly 1984 Macintosh computer, which was becoming a favored platform for digital artists. Around this time, digital drawing systems, such as 1983's KoalaPad and Wacom's 1984 cordless stylus, would allow artists to draw naturally with computers. Artist Andy Warhol famously demonstrated digital drawing on a Commodore Amiga in 1985, where he manipulated a photograph of singer Debbie Harry in front of an audience at the Lincoln Center.

Design software would be developed to aid specific tasks in graphic design, digital drawing, and photo manipulation. These include vector drawing tools like Aldus Free-Hand (1988), Adobe Illustrator (1988), and Corel Draw (1989); as well as image-editing and painting software like Adobe Photoshop (1990), Jasc Paint Shop (1990), and Corel Photo-Paint (1992). These applications would become standard tools for the illustrator, who could speed up traditional processes with digital art.

New software developments would also bring video and animation tools to the consumer, with Adobe Premiere (1991), CoSA's After Effects (1993), and FutureSplash Animator (1995). FutureSplash was acquired by Macromedia and renamed Flash in 1996, allowing artists to animate vector drawings in a portable, web-friendly file format. Flash was a phenomenon, used by independent artists and web designers to

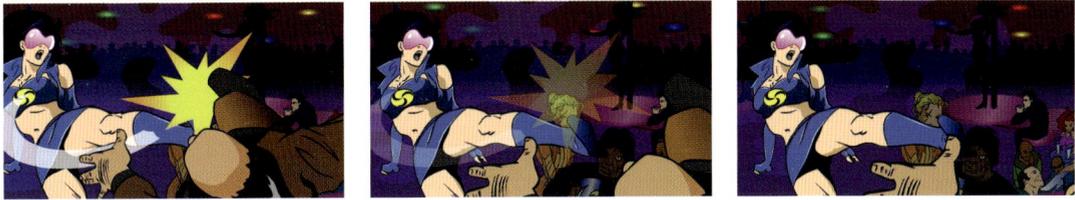

Figure 1.24 Three frames from a shot in Visionary Media's *WhirlGirl* (1997) show the title character kicking an adversary out of the frame. The limited animation moves a static illustration of WhirlGirl from left to right, with an energy burst appearing and then fading out at the point of contact. Made with Macromedia Flash, projects like *WhirlGirl* are illustration-dominant, with simple keyframe animation supporting the narrative.

create animations with sound and interactivity for the web. Several high-profile cartoon projects used Flash, such as *The Goddamn George Liquor Program* (1997), produced for Microsoft's fledgling MSN; and Visionary Media's *WhirlGirl* (1997), which was made for the premium TV network Showtime (see Figure 1.24). In addition, projects like the *Homestar Runner* web series and the user-uploaded entertainment site Newgrounds were destinations for Flash-animated content in the early 2000s. While Flash would eventually be replaced by newer technology like HTML5 and JSON, its influence on indie animation is enormous.

The World Wide Web (1990–2000)

Of all cultural movements and technological achievements, the invention of the World Wide Web is perhaps the most crucial singular factor that led to illustrators embracing motion. Developed at CERN by British computer scientist Tim Berners-Lee in 1989, the introduction of the web made the internet easily accessible to the general public via modems and web browsers. The Web has fundamentally changed how people interact with media, and how artists and illustrators create, publish, share, and distribute their work.

To aid in the transfer of images across any brand of hardware, computer scientist Steve Wilhite developed the **Graphics Interchange Format (GIF)** in 1987 for Compuserve (Boissoneault 2017). The GIF was designed for portability across slow modems of the time, boasting small file sizes and the ability to hold multiple animation frames. The intention was that GIFs would be used to share information, like weather maps and stock charts (Mak 2022), but as we know it became a favored vehicle for humor and a way to decorate personal web pages with animated banners, backgrounds, and "under construction" signs (Romano 2017).

By 1995, the internet had become a global sensation, and illustrators would use the web to publish portfolios of their work, as well as to distribute their own stories through webcomics and animations.

Memes go viral

First defined by biologist Richard Dawkins in his 1976 book, *The Selfish Gene*, the meme is a unit of culture that can be transmitted to others via image, writing, speech, gesture, and so on. In the internet age, the meme has taken the form of an image that might

be funny, odd, thought-provoking, or satirical, which can be easily shared via email or social channels. The most effective memes have viral spread—they are so hilarious, relatable, or outrageous that they must be shared across personal networks.

"The Dancing Baby" was one of the first viral internet memes, which spread by email in 1996 by several independent actors. Michael Girard originated "Baby" as a demo for Autodesk's 3D Studio Max software to demonstrate that pre-animated movements could be transferred across 3D models (see Figure 1.25). Multiple animators, including Robert

Figure 1.25 Frames from "The Dancing Baby"™ animated GIF ©1996 Autodesk.

Lurye and John Chadwick, worked on the dance moves, which were applied to a 3D model by Tony Morrill. LucasArts animator Ron Lussier found the animation files and posted "Dancing Baby" as an AVI movie online, which would later be converted to a GIF by developer John Woodell and shared further. The "Baby" animation was a sensation, appearing on major news networks and featuring as a recurring gag on the hit TV show *Ally McBeal* (1997). "The Dancing Baby's" tangled history, mixed authorship, and global reach represent how contemporary digital tools have enabled meme culture.

Social Media, Streaming Video, and Smartphones (2000–Now)

We finally reach the intersection of art, culture, and technology, where motion illustration is born through the introduction of social media, streaming video, and smartphones.

Virtual networks, like Friendster (2003), MySpace (2003), and Facebook (2004), began as platforms to connect with friends and find dates, but have mutated into an omnipresent global communication hub for politics, social issues, and pop culture. Illustrators have adopted newer platforms like Instagram, Twitter, and Tumblr to share work, discover other artists, and communicate with followers. Social media has created a direct path to contact influential artists, art directors, and potential collaborators, and has completely changed how illustrators promote their work.

Streaming video revolution

Concurrent with the introduction of social media, improvements in internet speed, from broadband and advanced wireless networks, allowed streaming video to completely transform the media landscape. Video platforms emerged, such as Vimeo (2004), Daily Motion (2005), and YouTube (2005), offering anyone with an internet connection a simple way to upload and publish videos. Independent animators immediately jumped on these video platforms to upload their short films, such as Jason Windsor's *End of Ze World* (2003), David Firth's *Salad Fingers* (2004), and Jason Steele's *Charlie the Unicorn* (2005). These were massive hits, captivating viewers with uniquely weird content tailor-made for the age of meme culture.

Firth's *Salad Fingers* was made in Flash, using limited animation techniques to tell its dark and strange story (see Figure 1.26). Firth described the value of streaming services in an interview with *Vice*, "You could just post stuff straight to the site without anyone having to approve it, which was a really different system to before. Usually you'd have to email someone and ask if they'd put something on their website, and then they'd watch it and say no" (Garland 2018). The combination of animation software, meme culture, and video sharing allowed a single artist to animate and distribute their work while reaching new audiences with original ideas.

Portable computer devices, apps, and casual gaming

The introduction of the Apple iPhone in 2007 and App Store in 2008 transformed how people interact with the internet. Its innovative design combined a large touchscreen with on-demand access to apps, turning phones into powerful pocket-sized computers

Figure 1.26 A screenshot from *Salad Fingers 3: Nettles* (2004). David Firth's *Salad Fingers* web series was created in Macromedia Flash using limited animation techniques. Initially distributed on a media site called Newgrounds, *Salad Fingers* was later uploaded to YouTube, where it became a viral sensation.

Figure 1.27 Playdead's *Limbo* (2010) has an illustrative visual style, placing silhouetted characters against gauzy background paintings to emphasize the dark, introspective story. The shadows are at once dangerous and mysterious, allowing the player to fill in the blanks.

capable of playing games, accessing social media, and creating art. The concept of app stores would be imitated by competitors like Google and Microsoft, along with similar touchscreen phones.

Using technology developed for the iPhone, Apple also helped modernize the PC market with the introduction of the iPad in 2010, creating a new taste for tablet computers. However, the 2015 release of the Apple Pencil would turn the iPad into a digital drawing tool that became immediately popular with illustrators. Apps like Savage Interactive's Procreate and Adobe Fresco featured easy-to-use brushes that simulate

traditional painting and drawing media. Earlier tablet competitors, like the Samsung Galaxy Tab (2010) and Microsoft Surface (2012), also offered an integrated stylus for illustrators to draw directly on the screen.

This new app economy allowed independent developers to distribute their own software, creating a market for casual handheld games. Titles like *Angry Birds* (2009), *Candy Crush* (2012), and *Temple Run* (2014) combined fun graphics with clever play mechanics to make gaming accessible to the general public. Without the pressures of the gaming industry, the app economy allowed indie developers to experiment with sophisticated new visual styles, like Playdead's *Limbo* (2010) and UsTwo's *Monument Valley* (2014), which feel like illustrations in motion (see Figure 1.27). Additionally, new gaming concepts, like dating simulators, visual novels, and children's book apps, would combine text-based narratives with lush illustrations.

Fertile grounds for motion illustration

With a smartphone in everyone's pocket, social media offered a new promotional channel for illustrators, who could now post images, GIFs, and videos directly to interested viewers. In particular, Tumblr was an active space for illustrators in the early 2010s, allowing followers to repost content while boosting savvy digital artists into celebrity status. Other social media platforms followed suit by adding integrated GIF and video support, like Twitter in 2014 and Facebook in 2015. Through self-directed work, illustrators helped create a market for web-based advertising and editorial projects featuring animation. Look, for instance, at the greater visibility of GIFs in *The New York Times*, which included only three animated GIFs in their 2013 "Year in Illustration," while in 2017, they featured a whopping fifteen.

Social media would prove a valuable tool for advertisers to connect directly with consumers, where brands partnered with illustrators to create clever, silly, and transfixing motion illustrations designed specifically to engage potential consumers. Today's illustrator needs to design content for social media that captures the viewer's attention and stops them from scrolling. New trends in digital communication also created a demand for new kinds of illustration, such as animated stickers and emojis, which people can use to visually express their feelings online (see Figure 1.28).

Figure 1.28 Static frames from Annie Wong's *Emotional Weather GIF Sticker Set*. Created in Wong's signature clay-animation style, these cute emojis can be used in chat applications or placed on top of photos to express the user's feelings.

Looking Forward: Evolving Illustration Marketplaces

Motion illustration is still very young. It is encouraging to see recognition from notable organizations, such as the Society of Illustrators, American Illustration, and Communication Arts, who now feature animation categories in their competitions. As we move forward, it will be exciting to observe how illustrators and their clients continue to experiment with motion.

Following historical trends, new technologies will likely affect both the tools artists use to make their work and the platforms they use to share it. Illustration and animation software will certainly become easier to use and offer new ways to create. For instance, artificial intelligence programs already offer anyone with an internet connection the ability to create images in infinite visual styles from text prompts (notably, AI tools are trained from the work of millions of images without the consent of their authors). How will advanced tools like AI impact the jobs which illustrators count on to make a living, and what new opportunities will they present?

Other technologies, like virtual reality and cryptocurrency, offer new opportunities for illustrators to make and sell art. For instance, non-fungible tokens (NFT) allow for the trading of digital art as a financial asset (see Ardhira Putra's animated video NFT in Figure 1.29).

Perhaps the future of illustration will also see a return to the past. Inundated with screens and technology, illustrators are already returning to tactile, traditional materials. The public, in turn, is embracing the analog, evidenced by the revival of vinyl albums in the 2010s and physical books following the pandemic.

What will all this mean for the motion illustrator? Unfortunately, we don't have a crystal ball, but many of the illustrators interviewed for this book offered the same advice: don't worry about trends—create because you love creating.

Figure 1.29 Three frames from Ardhira Putra's *Yellow Cosmic* NFT (2021). This video loops infinitely as objects and textures float upward. Putra's signature pastiche of anime and retro gaming is instantly recognizable and collectible in the NFT marketplace.

Cindy Suen (Hong Kong/US)

cindysuen.tumblr.com

Working out of the United States, Hong Kong native Cindy Suen is a pioneer of motion illustration. She has created and shared animated content for over a decade with a client list that includes Google, Disney, and Hallmark. Suen's work is characterized by bold, colorful shapes and irresistibly cute subject matter—often depicting cats and anthropomorphized objects in whimsical situations. Her early explorations with looping GIFs and social media have helped define motion illustration.

During the height of the social network Tumblr's popularity in 2014, Suen's looping GIFs caught the eye of Tumblr's strategy team, who hired her as one of the first artists in their Creatrs Network, which linked content creators with corporate campaigns. While social media advertising campaigns are now a standard part of the online browsing experience, at the time advertisers were still fumbling through how best to use these new platforms to engage with consumers. The major innovation of social media advertising was to leverage the popularity of talented "creators" like Suen and generate branded content that didn't feel like an advertisement. In this new form of commercial illustration, the client benefits from the artist's existing network, and the artist benefits from the campaign's global reach. Through the Creatrs program, Suen created animated GIFs on commission for major brands like Apple Music, NBC's *The Voice*, and the CW's *Crazy Ex-Girlfriend*. Suen's illustrations perfectly suit this advertising style, creating an emotional connection between the consumer and her friendly animated characters.

Suen's early work during the Tumblr heyday is characterized by a colorful, lineless visual style applied to looping GIFs of characters enjoying food—or in this case, *being* food! The GIF depicted in Figure 1.30 is a strong example of this, illustrating a happy cat made of toast. The looping animation portrays "Toasty Cat" galloping forward, as the slices of bread rhythmically pop up and down. Note

Figure 1.30 Three frames from Cindy Suen's "Toasty Cat." This GIF is emblematic of Suen's bold and whimsical visual style.

Figure 1.31 Cindy Suen's "Sushi Cat" GIF is shown here as five keyframes, illustrating a cat rolling onto its back and completing a transformation into a sushi roll.

how the complementary blue/orange color scheme and strong value contrast demand attention. Besides the aesthetic qualities, the minimal color palette is ideal for keeping the file size of the GIF small, which was especially important with the slower internet speeds of the 2010s. The fluid motion, as featured in much of Suen's portfolio, is visually appealing and hypnotic in the repetition of its loop. The combination of bright colors and motion makes an immediate impact on small screens where viewers may be scrolling through dozens of images.

Suen's sense of humor and wonder in the content she illustrates is part of the charm in her work. Many of her GIFs illustrate some sort of metamorphosis or transformation that could only function in the animated medium. Figure 1.31 depicts keyframes from one of Suen's most popular images, "Sushi Cat," showing off her unique take on animated loops and youthful aesthetic. This image combines two subjects that are beloved in the youth culture, sushi and cats, and morphs them into a new super subject that is both surprising and impossibly adorable. In the GIF, we see the cat lean over onto its back, then curl up into a sushi roll, with the black pattern on its back becoming the seaweed wrap. After a few moments as sushi, the roll transforms back into the cat, completing the loop. Just as she achieved with "Toasty Cat," Suen imbues "Sushi Cat" with a hypnotic quality that rewards the viewer for watching the loop several times.

Like many illustrators, Suen creates personal work to generate new ideas and explore different ways of making. For

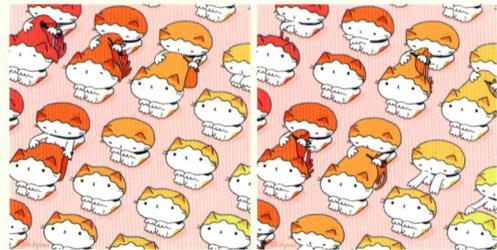

Figure 1.32 Two frames from Cindy Suen's "Barber Cats" GIF illustrate an array of cats giving each other haircuts.

instance, her "Barber Cats" GIF (Figure 1.32) uses a more complex visual style with detailed character designs and a denser composition than we see in "Toasty Cat" or "Sushi Cat." Here, Suen animates believable movement as each cat lifts the long hair of the friend sitting in front of them, snips the hair away, then patiently awaits their own haircut. The animation is repeated across the entire array of cats in a gentle wave formation of infinite haircuts. Originally published in 2017, Suen reissued this animation in 2021 as her first NFT, exploring how motion illustration can have a second life with new platforms.

Since 2018, Suen has been experimenting with 3D tools to create new works, both in the digital and physical realms. Her 3D works translate the bold colors and soft shapes of her 2D illustrations into fully animated CG characters, like "Tamago Cat" (Figure 1.33), who is featured in many videos and was made into a plush toy. Of course, physical products aren't new for Suen, who has placed many illustrations on merchandise for sale on Society6's print-on-demand online shop. Still, there is something especially exciting about

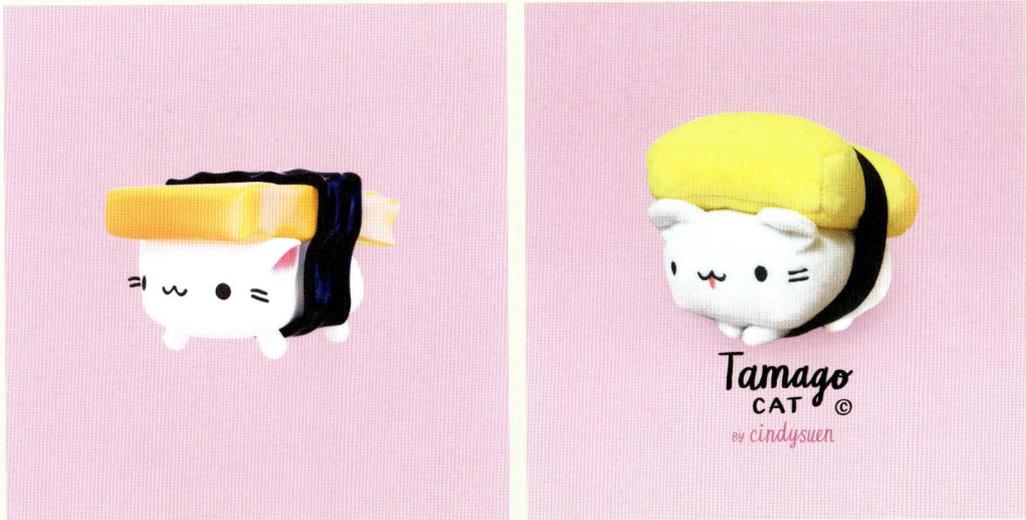

Figure 1.33 Cindy Suen's "Tamago Cat" was created both as a computer-generated 3D animation and produced into a plush toy.

the physicality of the "Tamago Cat" plush that brings her illustration to life in a tangible way.

In addition to single-character designs for use as GIFs and stickers, Suen makes 3D animated videos with a complete sense of space and implied story. For example, Figure 1.34 shows three frames from an animated video inspired by Edward Hopper's painting *Nighthawks* (1942). In Suen's *Night Sushi*, the viewer sees a familiar view of a city diner with a moon shining overhead. The camera moves forward toward the diner's window, giving the viewer a closer look at the conveyor belt moving sushi along the bar. In a smooth, continuous motion, the camera tracks to the left for a close-up of the chef and happy customers, then pulls out to show the whole diner again. Suen cleverly exploits the dimensional qualities of 3D artwork, using the camera movement to show something familiar in a

faithful recreation of Hopper's masterpiece, and then evoking surprise when the camera moves forward to show the details of her fantastical, whimsical world.

While much of Suen's early body of work uses a GIF format, many of her recent explorations are released as videos. These take advantage of today's speedy internet connections and feed the demand for streaming video content. Her new work with 3D art makes it clear that motion illustration is still a developing field and exemplifies how illustrators can break boundaries to borrow sensibilities from other art practices, continuing the evolution of what motion illustration *is* and *can be*. Suen's distinct visual voice is recognizable across media and demonstrates how a single independent illustrator can create a complete multimedia brand with today's technology and distribution channels.

You're one of the first illustrators I became aware of who used GIFs, and I always come back to your work when I think of motion illustration. How did you get started incorporating animation into your work?

I have been obsessed with making art since I was a little kid. I doodled in class, signed up for all the art lessons, and tried to turn every school project into an art project. I remember making my first animation experiment in middle school with my mini notebook, where I drew a stick figure dancing through the pages. I would constantly flip the pages to check the animation every time I had a new page drawn. Later, I decided to go to art school. Originally, I planned to study illustration, but when I found out I could major in motion media, I remembered my first animation experiment, and was immediately hooked. It was fascinating to learn that I could make my illustrations move. During that time, Tumblr was the most common place where artists shared their art online, and GIFs were popular within the platform back then, so I started making GIFs all the time, hoping to become a better artist and develop a following online.

In the early 2010s, Tumblr was one of the most popular social media sites, and your work got a lot of traction there. What influence (if any) do you think social media has had on your art and career?

Tumblr had a huge influence on me back then. I found a lot of like-minded artists who were always making new art and posting GIFs there. Being surrounded by the Tumblr community was a great motivation to keep me making new art to push myself to be a better artist. Tumblr also allowed me to meet a few of my online artist friends in person. Nowadays, I try to put my art on as many social media sites

as possible, hoping that it would be easier for my art to reach a greater audience. I must also admit that posting on social media has been a great help in getting me work. Art directors and potential clients would see my work online and reach out to me to work on projects with them.

Your work was featured in some of the first social media campaigns that mixed viral meme-culture with advertising clients like Subway, Kit Kat, and Fox. How did these projects come to be? What was it like adapting your visual approach to commercial projects?

I was very lucky to get a chance to work with these advertising clients. I believe they found me through my online portfolio and social media sites. They liked the work that I showed in my portfolio and commissioned me to make work for them in a similar style. Back then, I was still starting out as an artist, and I tended to make more frame-by-frame hand-drawn animations in Photoshop, so I didn't do too much adapting when making commercial work other than using the brand's color palettes.

For better and worse, social media has changed a lot over the past several years. What do you think its current state means for creators, and especially illustrators?

Social media has its pros and cons for creators. It's the perfect place to share your art online to develop a following, get motivated by other artists, and get noticed by potential clients. However, there is also a giant pool of talent out there, and it isn't always easy to stand out. To stay relevant, one must post regularly, make good work consistently, make good friends online, and stay up-to-date with the latest trends.

You've made a prolific number of GIFs— what qualities do you think viewers like the best in a GIF?

It's easiest to get somebody's attention when they can relate. It could be something that they love, like sushi. I drew an ikura sushi that got a lot of likes, where each ikura takes turns turning into a cat head. I think it's also the unexpected aspect that the viewers liked. Or other times, I make GIFs to celebrate certain occasions, which usually would relate to viewers if I release the GIFs at the right time, like during Halloween, Christmas, New Year, etc.

What tools do you use to create your animated work? Is there any technology you are experimenting with or eager to try?

I usually use Adobe Photoshop for frame-by-frame hand-drawn animation, Adobe Illustrator and Adobe After Effects for vector animation and compositing, Blender for 3D animation, and Spark AR for making Instagram filters. Lately, I have been playing around with Adobe Substance, testing out their materials on the app.

Are there any motion illustrators or animators who inspire you?

I'm always inspired by the work of other artists, but lately I really like the work of Silvia Puff (@ puffypuffpuff_ on Instagram), Sam Lyon, who goes by jellygummies online, and Ardhira Putra. I also love Disney's traditional hand-drawn animations.

Do you have any predictions for where the discipline of illustration is headed? What should illustrators be preparing for?

I think illustrators should be prepared to equip themselves with the skillset to animate and edit videos, as videos tend to be social media's favorite medium nowadays.

Do you have any advice for illustrators looking to get started with motion?

My advice would be to keep practicing your art, create lots of personal projects, try to learn something new every once in a while, and don't be afraid to share your work online.

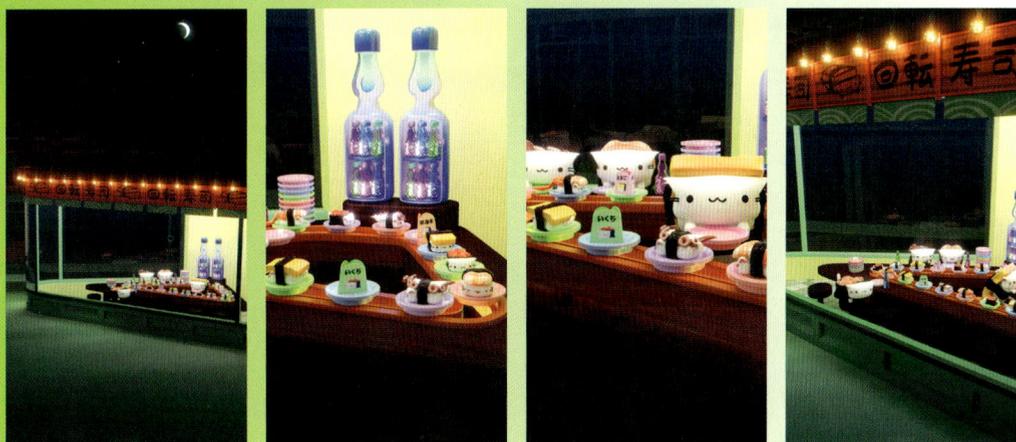

Figure 1.34 Cindy Suen's *Night Sushi* video uses a dramatic camera movement to reveal narrative details. Her "Tamago Cat" character portrays the chef.

What Makes an Engaging Motion Illustration?

Animation can be included within or applied on top of an illustration in any number of ways. A few examples include:

- A decorative effect, such as film grain, is layered on top of an illustration.
- Character animation brings the figures in the illustration to life.
- A scrolling background creates a sensation of movement.

Today's technology makes it easy to add motion to any image. Professional software like Adobe Photoshop and Procreate for iPad offers approachable animation tools that any illustrator can use with some practice. Additionally, many easy-to-use phone apps, like Motionleap by Lightricks, enable the casual user to apply preset animation effects. Even outside of the design space, most social media apps offer the option to add animated stickers and animated filters to static images, essentially turning them into animated content (see Instagram story stickers, for example).

While adding animated filters and effects to images is fun, the illustrator has a secret power: the ability to design an image with motion in mind. This chapter will examine how motion is used in several illustration projects and consider what makes them powerful and engaging. We will specifically discuss how illustrators use motion as a tool to enhance storytelling in their work. We will also look at novel approaches to animation and consider the visually addictive quality of animated loops to answer the question: what makes an engaging motion illustration?

Motion Supports Narrative

The strongest examples of motion illustration go beyond adding animation for the sake of animation. Just as an illustrator can carefully control all the aesthetic choices within their images, they may also apply the same control to the motion. In these projects, animation is thoughtfully considered as an additional tool used to support the concept or story.

A great place to look for thoughtfully designed motion is in the portfolios of editorial illustrators, who are often asked to illustrate a static and motion version of the same

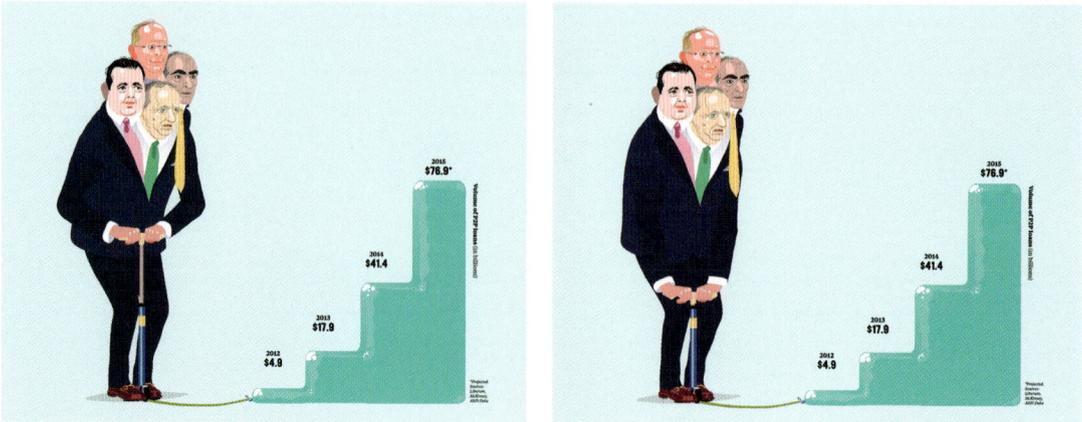

Figure 2.1 Two frames from Stephen Vuillemin's GIF for *Bloomberg Business* show the key poses of the figure's pumping action.

image for the print and digital editions of their publications. (You can read more about editorial illustration in **Chapter 4: Contemporary Practice**.) Often, these images need to convey a complex message through **visual metaphor**. The skillful integration of motion can support visual messaging by drawing the viewer's focus to the key action of the illustration.

In Stephen Vuillemin's editorial illustration for *Bloomberg Business* (Figure 2.1), the housing crisis is depicted as a many-headed monster that is literally inflating the lending bubble, represented by a balloon. This illustration was designed to function both in the print and digital editions of the publication, and it works wonderfully in each mode. In the static image made for print, Vuillemin visualizes the concept completely, with a dynamically posed figure and balanced composition.

The digital version is presented as an animated GIF, adding animation to the four-headed man, who actively pushes the bicycle pump up and down, "inflating" the balloon slightly on each pump. This animation reiterates the visual metaphor of how banks inflated the housing market, directly supporting the illustration's narrative. While the illustration functions perfectly in its static form, the added motion draws the viewer's attention to the focal point, taking advantage of the properties of digital screens.

In addition to the primary "inflating" action, the illustration features secondary action with the movement of the characters' heads and a subtle draping motion of the yellow tie. This additional animation adds believability to the illustration, breathing life into the characters and making them feel real to the viewer. Vuillemin deftly controls the "volume" of the animation, making sure that the pumping action is "loud" and the secondary character animation is "quiet." Just as the illustrator will control the visual hierarchy within the image, it is essential to control the kinetic hierarchy so that the viewer is not overwhelmed.

In Lily Padula's 3-minute animated short *Contagion*, produced for National Public Radio (US), we see more examples of motion that illustrates storytelling. This short, made from an excerpted audio clip from the podcast *Invisibilia*, explains how our facial

expressions and moods are transmittable to those around us. Its approach to animation feels to the viewer like a series of editorial illustrations that visually communicate the podcasters' script, connected with smooth animated transitions.

Figure 2.2 shows a few frames from a shot illustrating the spoken phrase, "She was talking very quickly and energetically." In this shot, Padula depicts an abstract human figure with oversize facial features. The animation is erratic, with rapid mouth movement and orange "words" flying out. Secondary animation of the figure's eyebrows "rippling" and a scribbly animated zig-zag over her eyes clearly convey the "energetic" mood from the script.

Motion illustration also features in entertainment media. In *The Nib's* animated series, well-known political cartoonists collaborated with animators to create short videos that lampoon current events. In "Fake News" (2017), illustrated by Mark Kaufman, Donald Trump's administration stages a phony news program to feed him information (see Figure 2.3). After this frenzied activity, the staffers are exhausted. Kaufman's caricature of Kellyanne Conway hugs herself as she rocks back and forth, realizing that tomorrow will bring more madness. The video relies on the same strong visual narrative, spot-on likenesses, and subversive humor one would expect from a political cartoon. However, the animation by Augenblick Studios adds believable performances to Kaufman's illustrations, reiterating the story beats through nuanced character acting. Additionally, the time-based narrative allows Kaufman to stuff the story with gag after gag, maintaining the viewer's interest with a cavalcade of humor.

Figure 2.2 Three frames illustrate a "fast talker" from NPR's short *Contagion*, animated by Lily Padula.

Figure 2.3 These two frames from *The Nib's* 2017 "Fake News" animated segment, by illustrator Mark Kaufman, show Donald Trump's exhausted staff unwinding after a hectic day in the White House. A harried Kellyanne Conway wavers, "great job, everyone," as the character animation emphasizes the stressed-out poses and expressions of each staffer.

Motion is Used in a Novel Way

In addition to using animation to support the narrative, theme, or concept; it is worthwhile to evaluate what qualities and values animation and screen-based viewing can bring to a project. How can motion be used in new and daring ways that attract and engage viewers? Consider these questions:

- What type of devices or screens might a viewer engage with motion illustration?
- What are the inherent qualities of these screens and devices?
- What opportunities do these qualities offer the illustrator?
- What tools, techniques, and media formats can be used to create motion illustration?
- What emerging technologies can be adapted for illustration?

While not all motion illustration has to exist on a screen (consider the modest flipbook), one of the benefits of screen-based viewing is the possibility of interactivity. Illustrators have already experimented with interactive media for games, apps, virtual reality, webcomics, and so on. Interactivity allows for intriguing options, such as open-ended stories and immersive experiences.

The children's book format saw a wave of illustrators and publishing companies experimenting with interactive apps in the 2010s after the initial popularity of tablet computers. These interactive picture books allow the reader to directly engage with visual storytelling by pressing, sliding, and dragging objects to move the narrative forward. For example, Chiquimedia's app *Mortimer and the Dinosaurs* (2019) is a story-game designed to enable children to participate actively in the narration of the story.

Using a page format, just like a printed picture book, Màriam Ben-Arab's illustrations depict complete narratives with richly detailed environments. Figure 2.4 shows keyframes from a page where the reader must drag a grouchy Morti out of his busted spaceship. Character animations show Morti's facial expression and body language change to a peppy stride as he goes forward to the next page. The interactive format merges the qualities of illustrated picture books, animated cartoons, and video games into a single app.

Figure 2.4 Three frames from an interactive sequence in *Mortimer and the Dinosaurs* (2019) by Chiquimedia. Illustrator Màriam Ben-Arab's friendly, colorful, and tactile paintings come to life via reader interaction.

Figure 2.5 Screenshots of three pages from Emily Carroll's webcomic *Margot's Room*, shown in a web browser. Each page breaks the rules of traditional printed comics, with webpages that scroll horizontally and vertically. The different layouts support the sensation of time passing and invite the viewer into the abstract thoughts of the narrator.

Comic illustrators have also embraced digital media to tell complex interactive stories that could not easily fit on the printed page. In Emily Carroll's webcomic *Margot's Room* (2011), the reader is presented with a single illustration of a dark room where a violent act has occurred and must play detective to discover what happened (see Figure 2.5). Five different objects, including a mirror, a doll, and the moon, are clickable and lead to other parts of the story. The objects can be clicked in any order, meaning each reader will have a slightly different experience depending on which pages they encounter first, immersing the viewer as an active participant in the narrative.

Along with the comic's open-exploration format, each page has a different layout. Some are horizontal, some are vertical, some are short, and some are long. The reader's role as explorer is reiterated through these diverse layouts that require the viewer to navigate each differently. While *Margot's Room* does not technically feature animation through video files or GIFs, the reader essentially becomes the animator by clicking and scrolling through the web pages, creating movement.

Beyond novel ways for viewing illustrated works, we can also look at inventive new ways for creating. Illustrators are known for developing a unique visual voice, with cohesive aesthetic choices visible across their entire bodies of work. Many illustrators who work with motion also have a unique kinetic style.

Jakub Javora is an illustrator and animator known for his painterly animation style, which celebrates tactile brush strokes. He experiments with high-tech solutions to create his work, often combining hand-painted digital art with animation software to create the illusion of paintings come to life. Figure 2.6 shows two frames from an animation of a Lynx by Javora, which is packaged as a sample with the innovative EbSynth software by Secret Weapons. With EbSynth, the user can input frames from live-action video, along with at least one sample painting, and the software will synthesize a complete animation that looks like the painting. In this sample, Javora's impressionistic painting style is synthesized over footage of an actual lynx, resulting in lifelike animation that captures every nuance of the cat's movement.

Conversely, artist Aubrey Longley-Cook takes a low-tech approach with his beautifully hand-crafted GIF animations, with frames assembled from actual embroidery and

Figure 2.6 Two sample frames from Jakub Javora's "Lynx" video, an experiment using the EbSynth software to apply an impressionistic painting style to live-action footage.

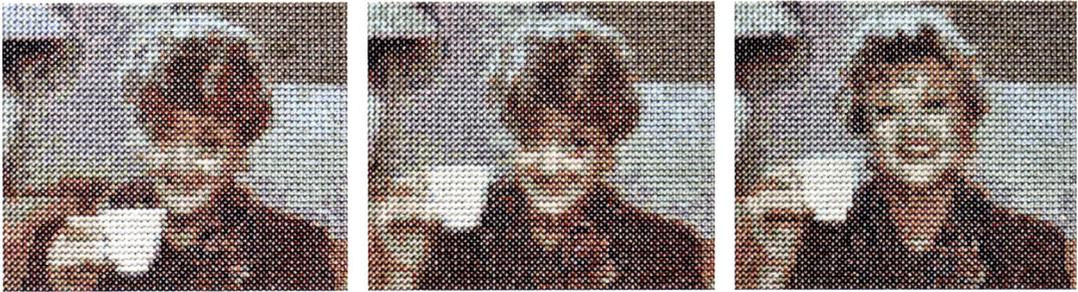

Figure 2.7 Three frames from Aubrey Longley-Cook's "TEA." Each frame is cross-stitched by hand, and then digitized into the final animated GIF format.

cross-stitch. His remarkably original GIFs play with the contrast of handmade craft and the advanced digital animation format. With these works, the computer is not used as a creation tool; it is only used to assemble the artwork into the final GIF format.

In Longley-Cook's animated GIF "TEA," he recreates a moment from the television show *Murder She Wrote*, depicting actress Angela Lansbury raising her teacup to the viewer through a sequence of cross-stitched images (see Figure 2.7). Longley-Cook's delicate handmade craft complements the elderly sleuth's mild disposition. The large stitches almost feel like pixel art, with the dabs of color optically blending into a full-color image of Lansbury, playfully nodding to the GIF's beginnings on low-resolution monitors. Longley-Cook's multimedia approach shows how artists can combine existing ideas and techniques in new ways to create something novel.

Animation is Mesmerizing

Like the viral "Dancing Baby" video, illustrators often create wild, clever, surprising, beautiful, and strange imagery that is hard to look away from. Often the animation uses seamless transitions, exciting visual effects, fluid motion, and/or repetition to capture the viewer's attention. The most successful of these illustrations inspire viewers to share the GIFs and videos across their social media channels.

Illustrator Yukai Du is known for her fluid animation style, which she employs in looping GIFs and full video clips. Figure 2.8 shows frames from Du's GIF "Flow," which is emblematic of her illustrative voice. It combines her metamorphosizing animation style and her trademark geometric shapes and patterns. In this GIF, a hand waves back and forth, breaking apart into flowing ribbons that emphasize the motion. The geometric shapes in the background slowly rotate and change size, adding delicious secondary animation. With no clear beginning or end, the looping nature of the GIF hypnotizes the viewer.

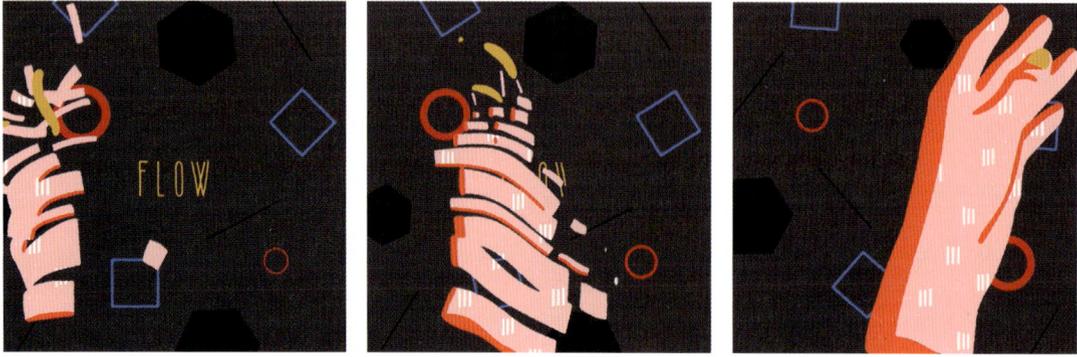

Figure 2.8 Three frames from Yukai Du's "Flow" GIF show how a naturistic hand breaks apart into flowing ribbons as it waves back and forth.

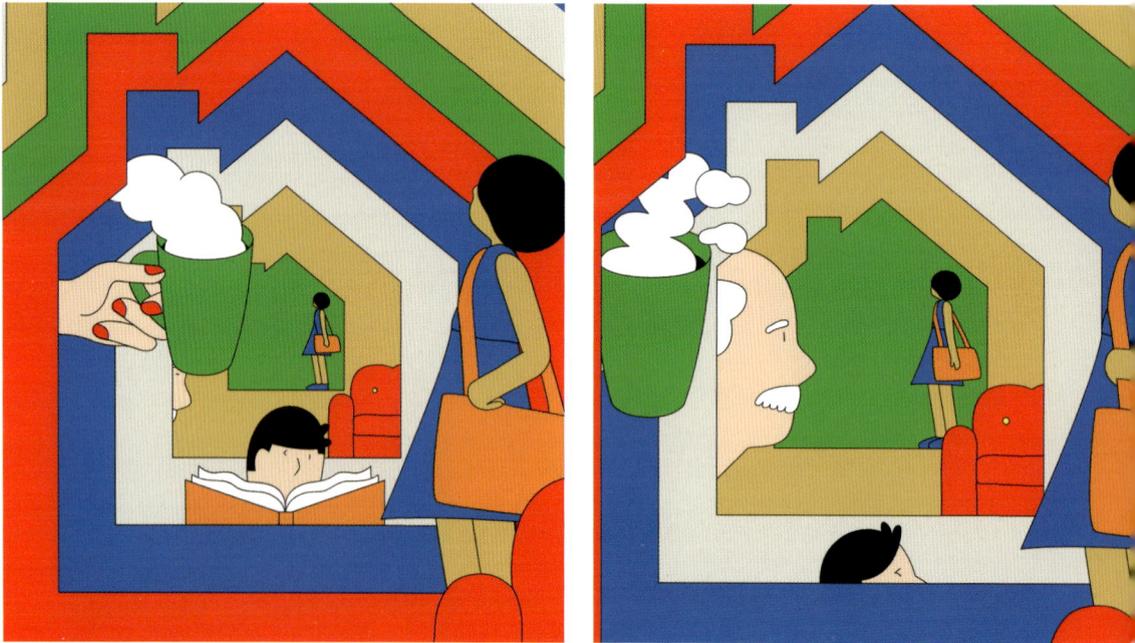

Figure 2.9 Four frames from Igor Bastidas's "The New American Dream Home Is One You Never Have to Leave" for *The New York Times*. This mesmerizing animation infinitely repeats expanding house shapes, creating a psychedelic striped effect.

The hypnotizing effect of a well-designed loop is evident in Igor Bastidas's editorial GIF "The New American Dream Home Is One You Never Have to Leave" for *The New York Times* (Figure 2.9). His graphic linework and primary color palette give the illustration a retro psychedelic feeling, complemented by a zooming effect that recalls 1960s motion graphics. The perpetual stream of homes expands towards the viewer, peppered with characters and objects, like a coffee mug and a reading child, that add specificity to the homey concept. Bastidas's well-crafted secondary animations give the reader many details to discover, encouraging extended viewing. For instance, the coffee's steam follows the laws of physics, fracturing into small clouds as the cup is yanked out of the composition. Like Yukai Du's "Flow," the clever construction of this animation tantalizes the viewer. The infinite repetition of movement is mesmerizing, grabbing the viewer's interest and keeping it.

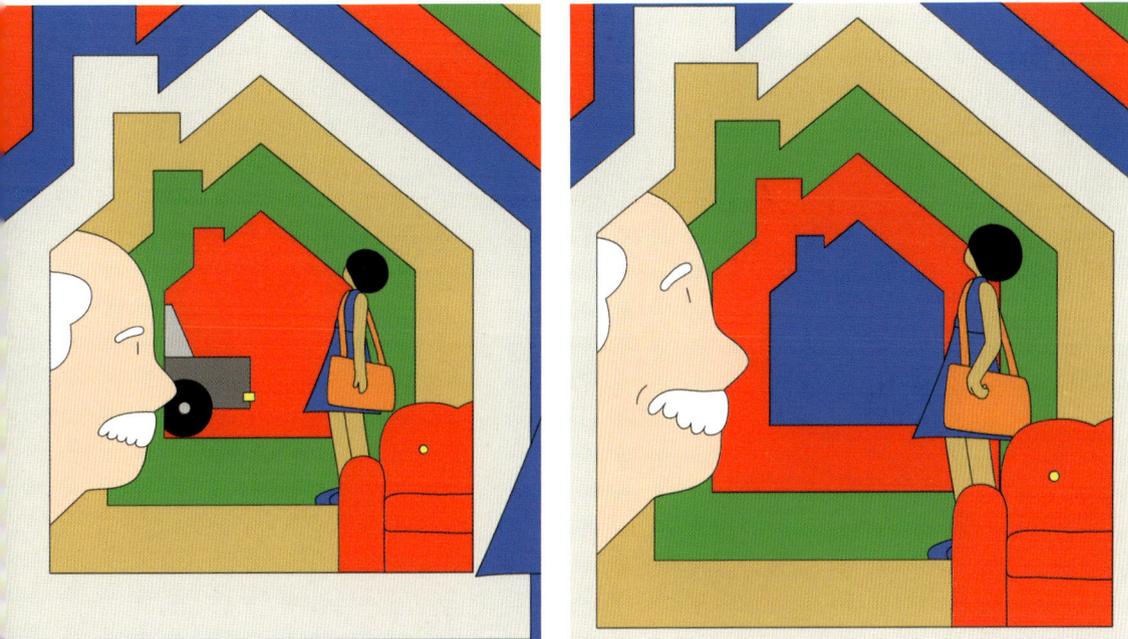

CHAPTER 3

Common Themes and Motifs

We have already seen how illustrators use a variety of different media approaches and stylistic qualities to create engaging work for many purposes, such as editorial, advertising, publishing, and entertainment. This chapter carefully examines works from contemporary motion illustrators, looking for commonalities in aesthetic style and approach to animation. These will be described as **visual motifs** and **kinetic motifs**.

These motifs add depth to the definition of motion illustration and may also serve as inspirational sparks when adding motion to your illustration projects. Most illustrators use different combinations of these recurring motifs to support their unique approaches to illustration. The results can be as diverse as the handmade 3D sculptures of Red Nose Studio, the CG visual effects used by Yoshi Sodeoka, or the fluid illustrated lettering of Chris Piascik. While the application of these motifs is not required for something to be motion illustration, all the projects in this book use at least one of them.

Visual Motifs

These are aesthetic design decisions frequently used in motion illustration:

- **Solid composition:** Objects are arranged intentionally to direct the viewer's eye in dynamic compositions that maintain their integrity during motion.
- **Selective color palette:** Controlled palettes emphasize mood and feeling over naturalistic representation.
- **Tactility:** A noticeably hand-drawn or handmade aesthetic permeates the illustration through texture, visible brush strokes, and handmade techniques.

Kinetic Motifs

These are animation approaches that support visual narratives and concepts:

- **Simple loops:** Animation is limited to simple looping motions, such as a character waving their hand or the tires on a car rotating.
- **Scrolling backgrounds and camera moves:** The impression of a journey, time passing, or action is conveyed with camera movements and scrolling backgrounds.
- **Atmospheric and ambient effects:** Illustrations are designed around naturalistic environmental animations like falling rain, crackling fire, or lighting shifts.
- **Textural effects:** Animated textures, patterns, and CG visual effects are used abstractly to add visual interest.
- **Metamorphosis:** Objects, characters, and words transform into one another for storytelling purposes.

Figure 3.1 Two keyframes from "Chain E-Mail" for *The New Yorker* by Igor Bastidas. In this GIF, a man runs perpetually forward through an endless hallway of envelopes. Bastidas uses several motifs, including **selective color palette, simple loops**, and **camera moves**.

12 PRINCIPLES OF ANIMATION

Separate from the **visual motifs** and **kinetic motifs** used here to describe motion illustration, the **12 Principles of Animation** were introduced by legendary Disney animators Ollie Johnston and Frank Thomas in their book, *The Illusion of Life* (1981). These principles were developed in the pursuit of believable character animation, with specific attention to visual design, timing, and physics. They are:

1. Squash and Stretch

2. Anticipation

3. Staging

4. Straight-Ahead Action and Pose-to-Pose

5. Follow Through and Overlapping Action

6. Slow In and Slow Out

7. Arc

8. Secondary Action

9. Timing

10. Exaggeration

11. Solid Drawing

12. Appeal

Many of the illustrators in this book, especially those who use hand-drawn frame animation techniques, utilize these principles. For artists interested in animation, these are worth further study and have been discussed comprehensively in other texts and online videos.

Visual Motifs

Solid Composition

Objects are arranged intentionally to direct the viewer's eye in dynamic compositions that maintain their integrity during motion.

A complete idea is visually communicated within each composition without the necessity of animation. The motion plays a supporting role, drawing attention to the narrative and/or adding visual interest. The compositions must be designed carefully to maintain balance and image hierarchy as the illustration changes with animation.

When commissioned for editorial purposes, motion illustrations often take the form of animated GIFs, which require a static print and an animated digital version. For example, Richard Borge's "Strong Dollar," for the *Wall Street Journal*, depicts a strongman lifting the American dollar, causing international currencies to drop (see Figure 3.2). Any frame from this GIF would function well as the printed version, as Borge carefully balances the negative and positive space throughout the motion.

Red Nose Studio achieves a similar result in thoughtfully designed illustrations for *Scientific American*'s "Truth, Lies, & Uncertainty" issue. In "Lies," illustrator Chris Sickels uses the flow of the snake's body to direct the viewer's eye across the composition toward the boy reading in the corner (see Figure 3.3). He integrates small character animations, like the snake's flicking tongue and boy's kicking feet, to bring the image

Figure 3.2 Two keyframes from Richard Borge's animated GIF for *The Wall Street Journal* article "Emerging Markets Have a Dollar Problem" show how the composition maintains balance during animation.

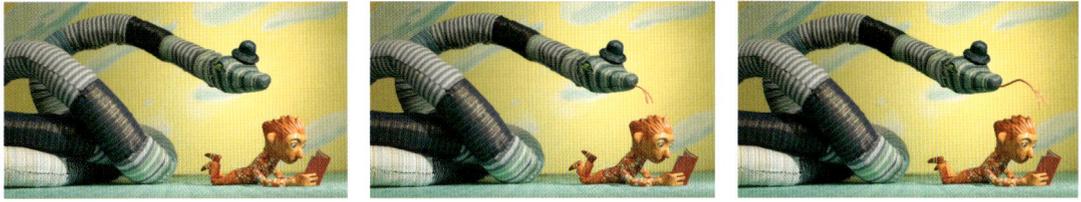

Figure 3.3 Three frames from a video by Red Nose Studio for *Scientific American's* "Truth, Lies, & Uncertainty" issue. The carefully designed composition can communicate its entire message without motion, while the subtle character animations bring the image to life.

Figure 3.4 A still frame from the video game *Limbo* (2010) by Playdead shows off the stark black-and-white graphic style, which maintains its integrity during play.

to life without disturbing the composition. On the web, this illustration is shown as an animated video, but the printed edition features a full spread with integrated typography. Sickels intentionally leaves resting space in the upper right of the image for the designer to place the headline.

In the entertainment space, this motif can be seen in still frames from television shows, movies, and video games. Playdead's *Limbo* (2010) is a 2D platform game with strong art direction (see Figure 3.4). Its black-and-white graphics transport the viewer into a dream state, overlaying silhouetted platforms against gauzy atmospheric paintings. The player can pause the game at any moment, and the still image feels like an intentionally designed illustration with gorgeous framing, evocative mood, and clear visual communication.

Selective Color Palette

Controlled palettes emphasize mood and feeling over naturalistic representation.

Color palettes are carefully chosen to convey a specific mood to the viewer. Evocative palettes may suggest time, place, culture, era, subject matter, emotion, and/or theme. Palettes reference color theory to create strong contrast and attract attention, especially on crowded social channels. Additionally, limited color palettes may aid GIF optimization, allowing only 256 unique colors in each image.

Cindy Suen's 3D computer-generated "Watermelon Smoothie" video depicts one of her charming cat characters preparing smoothies (see Figure 3.5). Suen's restrained palette of luminous candy-colored pinks transport the viewer into a deliciously sweet

Figure 3.5 Two frames from Cindy Suen's "Watermelon Smoothie" video show a cat scooping watermelon into a glass cup. The animated video is illustrated with a sweet color palette.

Figure 3.6 This screenshot of Lucas Pope's game *Return of the Obra Dinn* (2018) shows how the game is rendered in only two pure colors. Its dithering pattern creates the illusion of tonality while referencing vintage gaming graphics.

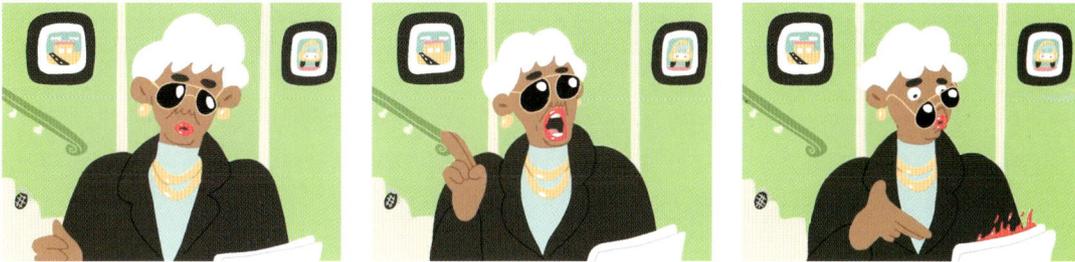

Figure 3.7 Three frames from a video by Henry Bonsu depicting his recurring Granny character with a selective green/brown color palette.

state of mind. The red/green complementary palette pairs a refreshing green with fruity pinks, creating a vibrant contrast.

In Lucas Pope's game *Return of the Obra Dinn* (2018), the entire game is visualized in two solid colors, emulating the look of early computer games from the 1980s, with their limited graphic capabilities (see Figure 3.6). The player can switch to different color settings, referencing the look and feel of vintage gaming systems, such as its default dark green/light blue "Macintosh Palette" palette, blue/cyan "Commodore 1084" palette, or brown/gold "Zenith ZVM 1240" palette. Pope uses a dithering pattern to create a range of value between the dark and light tones, resulting in images with depth and form.

Henry Bonsu's illustrations typically use minimal electric color palettes, which stand out in the social feeds where he posts them. Figure 3.7 depicts frames from a GIF of his Granny character setting some papers on fire. The split-complementary palette unifies a highly saturated celery green and aqua against warm brown and neutral oatmeal. Granny's vibrant red lipstick and the burning flames sizzle against the cool tones. The unified palette attracts the viewer when navigating a sea of photos and videos on social media.

Tactility

A noticeably hand-drawn or handmade aesthetic permeates the illustration through texture, visible brush strokes, and handmade techniques.

Tactility often adds a human touch to images made for the screen, making digital art more personal and relatable for the viewer. The different aesthetic approaches often relate directly to the unique visual voice illustrators are known for in the industry. Historically, these tactile visual approaches have proven challenging to recreate in cartoon animation, which often demands a streamlined stylistic approach to aid in the intensive frame-by-frame production.

Figure 3.8 shows three frames from Rob Wilson's experimental cut-paper animation of a man floating in a pool. The artwork uses confident, gestural mark-making and DIY videography on an iPhone. The layers of paper cast shadows, showing off the piece's depth. Its tactility makes us feel like we are with Wilson in his studio as we watch the video. This sensation of personal connection makes his work relatable and appealing.

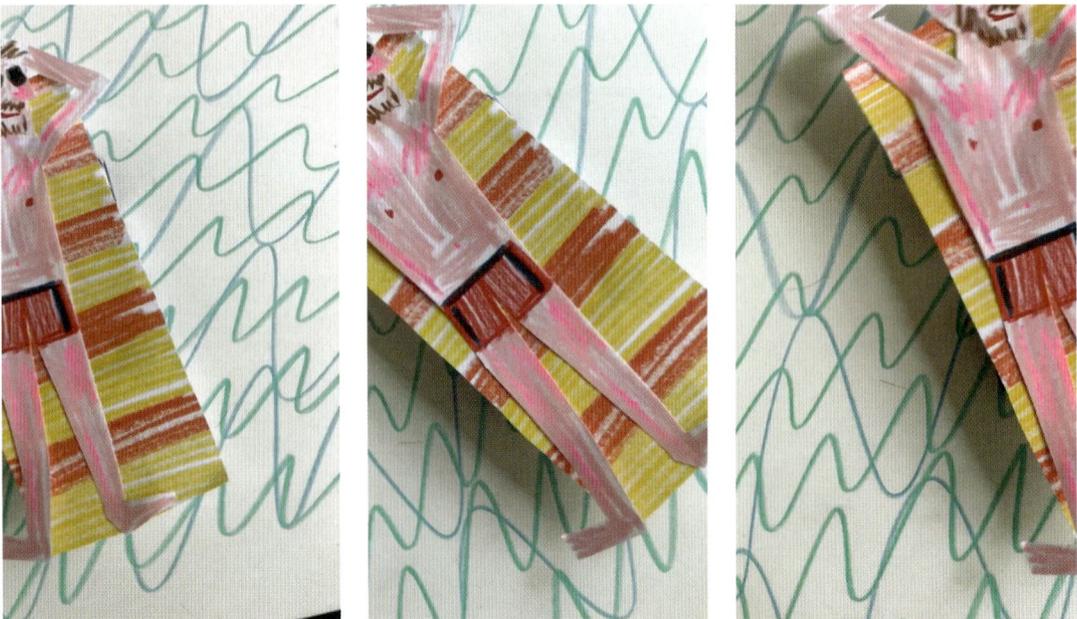

Figure 3.8 Three frames from Rob Wilson's "Floating" cut-paper animation. Filmed with an iPhone, Wilson moves his camera in a waving motion above a cut-paper illustration to make it look like the character is floating in a pool.

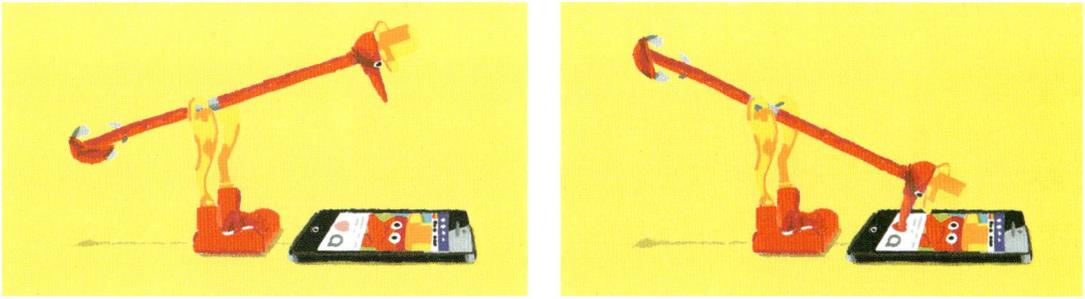

Figure 3.9 Two frames from Luis Mazón's illustration for the article "Norms and Etiquette for Technological Boys" in *O Magazine*. The illustration's subtle textures lend the digital work a sense of humanity.

Figure 3.10 Three frames from one of Jakub Javora's experimental *Medieval Knights* videos show his gestural mark-making style.

Stimulated by realistic brush settings in design software, many contemporary illustrators often create digital work with a tactile sensation. Luis Mazón's work celebrates the unpredictable textures of traditional artwork with gestural mark-making. At first glance, his GIF for *O Magazine*'s "Norms and Etiquette for Technological Boys" may appear as clean vector art, but closer inspection reveals incomplete lines and chewy edges that give a sensation of wet-on-wet gouache painting (see Figure 3.9). The solid areas of color have subtle tonal variations as if the pigments had settled non-uniformly. The tactility of Mazón's digital work provides a needed contrast from the slick screens that most motion illustration is viewed on.

Jakub Javora creates digital animations with the aesthetic quality of impressionistic paintings. He uses advanced software to synthesize digital art with live-action video to create lifelike animations with luscious mark-making. Figure 3.10 shows three frames from one of the experimental videos in his *Medieval Knights* series. As the actor turns his head, Javora's dabs of color and expressive brush strokes follow the figure. The result captures the nuanced facial expressions of the actor, giving the sensation of an oil painting come to life.

Kinetic Motifs

Simple Loops

Animation is limited to simple looping motions, such as a character waving their hand or the tires on a car rotating.

Rather than creating complete character performances, animation is limited to simple gestural motions. The limited movement is often intended to loop, creating a mesmerizing sensation for the viewer while simplifying the drawing process for the illustrator. For a character, this might function as a gesture, like a waving hand, kicking leg, or winking eye. Simple loops may also be used in the animation of an object, such as the movement of a vehicle, the rotation of a fan blade, or glow of a light.

Andrea Chronopoulos uses a solid composition and selective color palette to illustrate a man playing table tennis in one of his images for Pocko's #peaceofmind social campaign (see Figure 3.11). The man's body stays static as he plays, while a simple gestural motion of his arm moves back and forth with the paddle. He hits the ping-pong ball, which bounces against the wall, table, and back to the man. Chronopoulos integrates secondary animation of the cat's head following the ball's position, and an action-packed starburst accentuates the hit against the wall. These secondary actions support the narrative and activate the whole composition.

Figure 3.11 Three frames from "#peaceofmind" by Andrea Chronopoulos for Pocko use simple looping animations to depict a man playing table tennis.

Figure 3.12 These four frames from Stephanie Hofmann's "Bird Lady" animated GIF show the movement of a bird flying out of the woman's mouth and exiting the shot on the right. A random pattern of blue dots in the background appears as falling rain when animated.

Figure 3.13 Three frames from an animated GIF made by Ellen Porteus for the 2018 *PBS Radio Festival Campaign*. She combines food and musical imagery to support the campaign's "Feast Your Ears" theme.

In Figure 3.12, Stephanie Hofmann uses a tactile watercolor and digital cut-paper aesthetic to illustrate a bird flying out of the mouth of a fashionable woman. This example shows how a successful animation can feature a figure that does not move at all. In "Bird Lady," the woman is static, with the movement reserved for the bird that "flies" horizontally across the composition. The bird is designed as a simple digital puppet with separate layers for the body and two wings, which Hofmann manipulates to create the illusion of flapping. Secondary motion adds additional context and humor to the piece, like the movement of the fox stole's eyes and atmospheric animation of rain falling in the background.

Loops do not have to involve a character and can show the activity of inanimate objects instead. For example, Ellen Porteus's animation for PBS depicts a hybrid radio-toaster with looping animation that "pops" the toast up and down (see Figure 3.13). Made for PBS's 2018 *Radio Festival Campaign*, Porteus creates a visual metaphor to support its "Feast Your Ears" theme. When the toast comes up, Porteus applies a motion blur to show its rapid vertical movement. In the "down" position, the toaster's button is fully depressed, making the shot believable to the viewer.

Scrolling Backgrounds and Camera Moves

The impression of a journey, time passing, or action is conveyed with camera movements and scrolling backgrounds.

Infinitely scrolling backgrounds and dynamic camera movements can convey a journey, the impression of passing time, or the action of a figure/object. The animation may be as simple as a long horizontal painting "panning" across the camera, or as complex as a CG scene made of 3D models. Some artists create a parallax camera effect, moving background layers at varying speeds to create a sense of depth and perspective.

In Ardhira Putra's *Morning Breeze* video, a man bicycles through a beach city, illustrated in a vintage style that evokes retro arcade games (see Figure 3.14). The background is constructed with 3D models and styled to appear as a graphic 2D animation. As the bicyclist pedals forward, the environment pans behind him. The 3D models' depth creates a parallax effect as the "camera" moves across the scene; the palm trees, buildings, and clouds subtly rotate and overlap in the distance. In the foreground, the sidewalk is placed on a plane parallel to the ground, and the cement segments dynamically move in perspective.

From his webcomic, *Schoolgirls*, Stephen Vuillemin uses a variation of the scrolling background motif in his animation of two figures ascending a spiral staircase (see Figure 3.15). He perpetually rotates the staircase with frame-by-frame animation, and places looping animations of the characters stepping up, making it appear as though they are climbing an impossibly tall tower. As the "camera" rotates, Vuillemin's solid composition maintains its balance with clearance for the text bubbles.

Figure 3.14 Three frames from Ardhira Putra's *Morning Breeze* video show a central figure bicycling, with a cityscape panning in the background to show his journey.

Figure 3.15 Two frames from a GIF in Stephen Vuillemin's *Schoolgirls* "Episode 3" show keyframes from complex walking cycles, which are animated on top of a rotating spiral staircase.

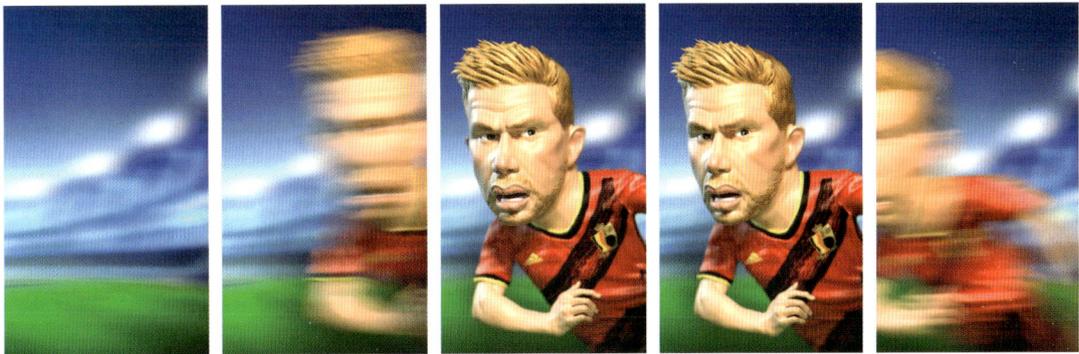

Figure 3.16 Five frames from Wesley Bedrosian's animation of soccer star Kevin De Bruyne for *Eight by Eight* on Apple News Channel.

In Wesley Bedrosian's animation of soccer player Kevin De Bruyne for *Eight by Eight*, he uses rapid movement to suggest a running action (see Figure 3.16). The video starts with an environmental painting of a soccer stadium, and De Bruyne swiftly moves into the center of the composition from the right with a motion blur. When the model is centralized, Bedrosian subtly rotates it, showing off its depth and maintaining a degree of motion. Finally, he zips back off screen to the left, again with a motion blur. The 3D model of De Bruyne features no character animation, but the combination of his active pose and the speedy motion gives the viewer the sensation that he is running on the field. While this illustration doesn't technically contain a camera movement, the figure's animation in and out of the shot fulfills a similar goal, suggesting active movement.

Atmospheric and Ambient Effects

Illustrations are designed around naturalistic or fantastical environmental animations like falling rain, crackling fire, or lighting shifts.

Scenes are designed around environmental effects to help convey time, place, and mood to the viewer. These animations may depict weather conditions like falling rain and snow, or a breezy curtain flapping in the wind. The environmental effects may be naturalistic depictions of lighting, like sun rays peeking out from a cloud, or a flickering lantern in a cavern scene. Alternately, they may represent fantastical effects, like sparkling magic or pixie dust.

In "Turning Leaves," Coffeecakescafe illustrates New York City's Washington Square Park (see Figure 3.17). Set during fall, the animation of falling leaves draws focus to the changing seasons. The selective color palette combines rich golds, browns, and reds to emphasize the autumnal theme, while the tactile cut-paper animation style transports the viewer to Coffeecakescafe's sketchbook with a documentarian authenticity.

Benji Lee's webcomic, *Thunderpaw: In the Ashes of Fire Mountain*, uses animated GIFs to support the mood and narrative of its story. Lee often illustrates scenes with full environments brought to life with ambient animation, like blazing fires, pluming smoke, and falling rain. Following a feast of hallucinogenic mushrooms, protagonist Bruno feels like he is floating in calming waters (see the panel layout in Figure 3.18). Across a series of comic panels, Lee animates the stream's flow, along with the rippling of the water. The gentle repetition of the water animation suggests a meditative quality that matches Bruno's state of mind.

W. Scott Forbes tells a story about suburban infidelity in his animated short, *A Good Wife* (2012). The animation is edited together from well-composed illustrations that use minimal animation to support the story. Forbes uses various techniques, including animating his impressionistic brush strokes, moving the camera to show changes in time and space, and adding ambient lighting effects that support the mood of his illustrations. In Figure 3.19, Forbes illustrates two children watching television, shown from the exterior of their modern home. The animated glow appears as though a television program is playing. This simple motion draws the viewer's attention to the living space to investigate the protagonist's home and family.

Figure 3.17 Three frames from a video by Coffeecakescafe's stop-motion "Turning Leaves" video show the animation of its cut-paper leaves.

Figure 3.18 Two animation frames from a panel layout in Benji Lee's *Thunderpaw* webcomic use fluid frame-by-frame animation to depict the soothing flow of water.

Figure 3.19 Two frames from *A Good Wife* (2012) by W. Scott Forbes show the illumination of a television set.

Textural Effects

Animated textures, patterns, and CG visual effects are used abstractly to add visual interest.

Like ambient effects, tactile effects can emphasize the mood or feeling in an illustration, but through abstract pattern and texture. Textural effects may be masked to a single shape, integrated within the whole image, or overlaid on top. These effects often recall early experimental animation, using clever and inventive approaches to make the image move without relying on character animation.

In Juliana Vido's "Quarantine Mood" GIF, she illustrates a character staring at her smartphone, wearing a sequence of different outfits (see Figure 3.20). The animation functions like a slideshow, with the character shown in the exact same pose while the outfit and hairstyle change. Vido masks different textures and patterns within the character's sweatsuit, creating the impression of multiple cozy outfits. The consistent pose and repetition remind the viewer of the monotony of social distancing during the early days of the pandemic.

Tribambuka uses a variety of textural mark-making approaches to draw on top of live-action video in the Arthur Brothers' music video "Violet Hum." In the shot shown in Figure 3.21, she plays with pattern, such as polka-dots, and texture, like gestural paint strokes. These patterns and textures go in front and behind the figure, playing with the viewer's perception of depth. They transform the raw footage into experimental, mixed-media animation.

Figure 3.20 Four frames from Juliana Vido's "Quarantine Mood" GIF use a sequence of patterns and textures to suggest the passing of time.

Figure 3.21 Three frames from a shot in Tribambuka's music video for "Violet Hum" by the Arthur Brothers. Hand-painted textures are incorporated with live-action video to create an experimental multimedia effect.

Figure 3.22 Two frames from "Do You Believe in God, or Is That a Software Glitch?" GIF by Yoshi Sodeoka for *The New York Times*. Sodeoka animates digital glitches on dimensional planes in the illustration.

Textural effects may also come in the form of digital CG animation. Yoshi Sodeoka overlays glitchy effects on top of an image of a head with its brain exposed in his illustration for *The New York Times* (see Figure 3.22). The glitchy effects simulate television static and digital signal errors, with many noisy and colorful glitches. Sodeoka places the effects onto dimensional planes, creating the illusion of dynamic perspective. The result is both futuristic and introspective, referencing the article's title.

Metamorphosis

Objects, characters, and words transform into one another for storytelling purpose.

Borrowing sensibilities from cartoon animation, images will morph into one another to support a conceptual idea. While morphing is possible in live-action filmmaking with the help of advanced digital effects, it is a technique that lends itself well to frame-by-frame animation. When used in a looping GIF, the metamorphosis may result in a mesmerizing quality.

In Cindy Suen's "Hug," two of her cute cat characters tightly embrace, with their arms wrapped around one another (see Figure 3.23). During the hug, they merge into a single unit. To complete the loop, Suen separates the characters so they may hug again. In this GIF, the transformation of two cats into one symbolizes the unity that physical love can provide.

Lily Padula uses several morphing animations in her video *Contagion* for NPR. Figure 3.24 shows one of these transformations, with a brain turning into an eye. These visuals complement the audio narration, which says, "One of the ways emotions are produced is from the outside in." Padula uses the brain to suggest internal emotions, while the eye represents external stimuli. The metamorphosis visually describes the story.

Chris Piascik uses metamorphosis frequently in his work, both with his illustrated subjects and hand-lettering. For example, Figure 3.25 shows how he transforms a drawing of a motorcycle into the phrase "Go Ride." Piascik cleverly transforms discrete parts of the bike into the letterforms, such as turning the back tire into the "g" by unraveling the rubber into the curly letterform. The skillful hand-drawn animation lends itself well to the looping format as the viewer investigates each letter's metamorphosis.

Figure 3.23 Four frames from Cindy Suen's animated GIF "Hug" show keyframes from a metamorphosis that visually describe a close relationship.

Figure 3.24 Four frames from Lily Padula's *Contagion* for NPR show a metamorphosis from a brain to an eye. Padula cleverly gathers the wrinkles and folds of the brain into a circular shape that becomes the eye's pupil.

Figure 3.25 Five frames from Chris Piascik's "Go Ride" show how he transforms image into words in this animated GIF.

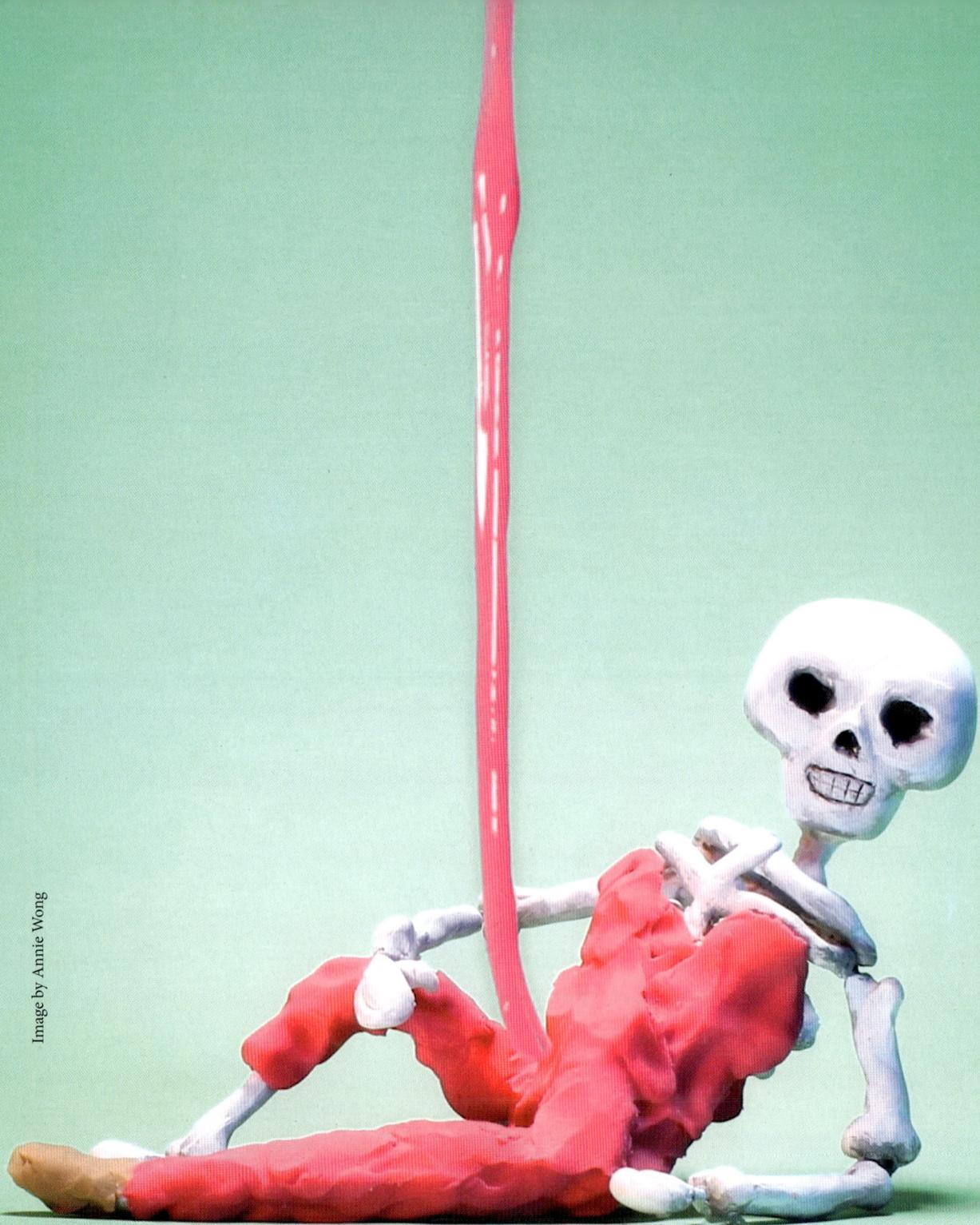

CHAPTER 4

Contemporary Practice

Professional Outcomes

This chapter surveys work from twenty-seven contemporary illustrators, digital artists, and studios that represents a breadth of different illustration outcomes, aesthetics, media approaches, and animation techniques. The included works are organized into five categories based on the purpose and intent of the work. These categories showcase a variety of techniques, visual styles, and modes of thinking while highlighting common themes and strategies employed by today's illustrators:

- **Advertising and commercial:** Work commissioned by a company to promote a product or service.
- **Editorial, non-fiction, and educational:** Illustrations that explain or respond to a text.
- **Interactive narrative:** Narrative stories that require interaction, such as comics and games.
- **Time-based narrative:** Films, television shows, and videos that are viewed for entertainment purposes.
- **Exploratory and experimental:** New media projects that investigate unique ideas.

In many ways, these categories align closely with traditional illustration markets. However, the addition of motion creates intriguing relationships between works that may seem unrelated in their static forms. For instance, we will look at video games and comics together, as they often require the viewer to interact with narratives in a similar manner.

Breaking Boundaries

While individual illustrators are discussed within these purpose-based sections, it is common for an illustrator to produce works in many markets, such as an illustrator who creates editorials *and* comics, like Stephen Vuillemin. These market areas shouldn't be seen as exclusive silos for illustrators but rather as a way of examining the common threads that illustrators use when working towards a similar purpose. Web links to each illustrator's portfolio are included so you can investigate their work online and see the animated projects in motion.

Advertising and Commercial

Attention-grabbing imagery with the potential for viral sharing is created to promote a product or service.

Forms:
- Video advertisements
- GIFs designed for social media
- Product/service explainers
- Idents
- Messaging stickers

Features:
- Promotes a product or service.
- Attention-grabbing.
- Cute, quirky, or clever.

In a world saturated with logos, jingles, products, and mascots, advertisers must persistently develop new approaches to capture customers' attention. Pre-dating photography, illustration was *the* way to create imagery for advertisements, product designs, and packaging to sell goods and services. Mass production of consumer goods following the industrial revolution led to the type of refined, international branding required of advertising today. Consider Coca-Cola's iconic renditions of Santa Claus, first illustrated by Haddon Sundblom in 1931, that co-opted Christmas traditions to sell soda to the masses.

Since the launch of the World Wide Web, illustrators and their clients have been experimenting with the dynamic qualities of screen-based viewing to enhance consumer engagement. Promoting a product online with irreverent GIFs or videos may seem ordinary today, but it is a young practice born from the inception of social media. Further, advances in big data have given advertisers detailed information about consumers, who can be targeted with tailored advertisements that suit their personalities and interests.

While commercial illustration can take many forms and be created with a variety of media, it must be eye-catching and shareable. Illustration must stand out from the feed and stop a reader from scrolling or pressing the "skip ad" button. Note how the artists in this section use bold shapes and striking colors to illustrate in a relatable manner that offers a personal touch, inviting the viewer to engage with them. The strongest illustrations in this category are so charming, whimsical, clever, or beautiful that the viewer is enticed to share with their personal networks, directly involving them in the advertising campaign.

Annie Wong (US)

headexplodie.co

Annie Wong (known online as Headexplodie) is a second-generation Chinese American stop-motion artist based in California. She creates playful sculptures to animate videos for clients, including Apple, Facebook, and Vans. Her work is brightly colored and tactile, delighting in the physical texture of the clay she uses to sculpt. Her zany aesthetic often employs anthropomorphic characters or cute blobs to act out a narrative. The result is a wave of nostalgia, evoking the 1980s clay animation segments from *Pee-wee's Playhouse* or the *California Raisins*, but for the social media age.

Wong's contribution to Lemonade Insurance's #connectedbylemonade social media project is emblematic of how she applies her humorous sensibility to stop-motion animations. Art directed by Devin Croda, the #connected project commissioned dozens of artists to create looping animations as content for Lemonade's Instagram feed. The big idea behind these videos is that they all feature a vertical pink line in at least one frame of animation, which visually "connects" the video thumbnails in the feed. This project ran for over a year and featured the diverse artistic work of many talented illustrators and animators, resulting in an impressively consistent visual motif on Lemonade's feed.

Figure 4.1 depicts four frames from Wong's video, which animates a skeleton transforming into a human and back to a skeleton. Lemonade's "connected" pink line is integral to the metamorphosis, here represented by a magenta liquid that pours flesh onto the skeleton. The now-living figure waves at the camera and then melts back into bones, completing the loop. In an interview with Lemonade, Wong says, "The fact that these are Instagram videos meant the animation would loop, mimicking the cycle of life and death. This sounds so serious and philosophical, but at the end of the day, I just wanted to show a cute girl getting her skin melted off and not being too bothered by it!" (Lemonade 2020). The combination of the video's wacky yet relatable concept, friendly

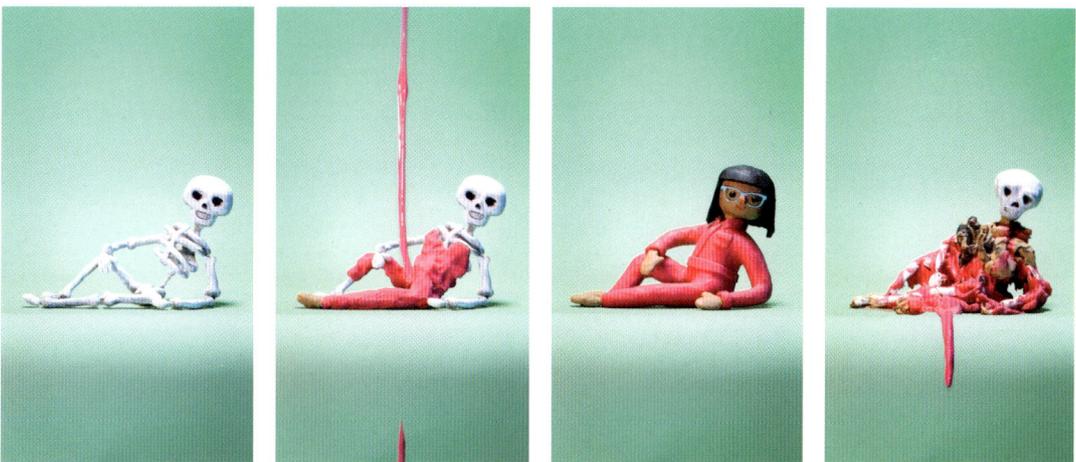

Figure 4.1 These four frames from Annie Wong's "Connected by Lemonade" video showcase her playful sense of humor and tactile approach to illustration.

Figure 4.2 Stills from Annie Wong's *Coasts* animated video for the California Avocado Commission (2020).

illustration style, and mesmerizing animation quality invite the viewer to engage with the advertisement.

Wong also creates longer videos, like her 15-second animated advertising spot for the California Avocado Commission, called *Coasts*. This animated video portrays a cute sailboat character gliding across the ocean and stopping at a beach next to a palm tree. Then, letterforms pop into the scene, spelling the word "avocados," with the tree acting as the "C" and the sailboat acting as the "A" (see Figure 4.2). This cleverly composed final shot functions beautifully as a single illustration, while the boat's movement and spelling animation add a wonderful subliminal message tying the idea of an avocado directly to the California coast.

Figure 4.3 A sequence of frames from Annie Wong's *#TheSpaceBetweenUs* video, which promoted social distancing during the height of COVID-19.

As with her *Lemonade* video, Wong uses her trademark clay animation style with big friendly shapes sculpted in bright, welcoming colors. In addition to malleable clay, other materials, like paper and pebbles, are used to complete the scene. Wong cleverly uses cellophane to visualize the ocean's surface, with the translucent material picking up the set lights to represent gentle waves.

Landing somewhere between advertising and social messaging, Wong's *#TheSpace-BetweenUs* video, created in collaboration with the design team at Instagram, promotes social distancing while encouraging human connection during the height of the COVID-19 pandemic. In the video's first animated segment (see Figure 4.3), we can see a building with four windows. As the animation progresses, friendly clay characters emerge window by window, playing different musical instruments and enjoying each other's company at a safe distance. Commissioned by Instagram, the video helps advertise the social platform as a means of staying connected while reiterating important messaging about ways to stay healthy during the spread of this unprecedented and deadly virus.

Throughout the video, Wong uses a stationary camera, which offers a complete narrative understanding within each shot and is enhanced by her charming character animations. Wong's humanistic voice as an illustrator encourages views, comments, and sharing—aiding in the distribution of this vital messaging.

Ellen Porteus (Australia)

ellenporteus.com

Based in Melbourne, Ellen Porteus is a multidisciplinary artist with a psychedelic Pop art flair whose client list includes global brands like Facebook, Apple, and Nike. Her extensive portfolio includes everything from giant murals to tiny GIFs, but her bubbly style and fluorescent palette make her work instantly recognizable. Her animated work is particularly unique because of her use of patterns in motion.

The GIF set that Porteus created for Quantcast's rebrand is an excellent example of how she uses repeating patterns and how a series of images can create a distinctive look across multiple advertising pieces (see Figure 4.4). Quantcast is a big data company specializing in audience insights and advertising, and these three GIFs are meant to visualize areas of data collection: communication, retail, and technology. Porteus's use of pattern is particularly inventive, as each image features a scrolling camera movement that shows off the repetition of the iconographic imagery. The "retail" image animates a perpetual stream of bags being filled with product and boxes being packed for shipping.

Each image uses a different color palette to pair with one of Quantcast's brand colors. While the diverse imagery of bees, shipping boxes, and digital devices do not have a thematic connection, the way that Porteus designed and animated the images makes a clear set. She maintains a consistent tone with the thick stroked outlines, iconographic shapes, and repeated brick patterns. The intended placement of the GIFs within the brand logo is an innovative use of motion illustration for advertising purposes.

Figure 4.4 Sample frames from a series of GIFs created by Ellen Porteus for Quantcast's 2015 rebrand. These illustrations were designed to be masked within Quantcast's "Q" logo and function independently on other branding collateral.

Tribambuka (UK)

tribambuka.co.uk

Tribambuka, also known as Anastasia Beltyukova, is an illustrator and animation director based in London. She has created work for clients, including CNN, NBC, Procter & Gamble, and the Migration Museum. With a style that draws on the abstraction of Russian Constructivism and the playfulness of the swinging sixties, her collaged approach to illustration combines drawing, photos, and textures to create a uniquely tactile viewer experience. She produces narrative work for many purposes including advertising, editorial, and entertainment.

Tribambuka's explainer video for Zappi, a consumer insights platform, is an exciting example of how motion illustration can be used for videos in the commercial space. (An "explainer video" quickly introduces a product, service, or company to potential customers.) The Zappi video shows how its platform can be used to discover and understand consumer trends as a tool for marketing professionals to make decisions about product development and advertising. Tribambuka uses her sharp visual communication skills to simplify Zappi's complex toolset with easy-to-understand instructions illustrated with a whimsical style.

The frames in Figure 4.5 show how she illustrates with a collage of techniques and effectively uses transitions to tell a specific story. Here we see five "consumers" with different ideas represented by thought bubbles with different patterns and textures

Figure 4.5 Four frames from Tribambuka's *Zappi Animated Explainer* show a clever transition between two shots. Notice how the small thought bubbles in the first frame grow to become the background in the frame.

inside. The transition expands the bubbles to fill the screen, bringing the "user" into a visual representation of the consumer mind. The motion illustration cleverly conveys how the Zappi platform allows users to make better decisions with consumer data.

This video uses a combination of conceptual and instructional illustrations which walk the viewer through the process of using Zappi. For instance, Figure 4.6 shows frames from a sequence where the video gives a concrete example of how consumer insights can alter the decision-making for product development, in this case, for beverage packaging. The animated sequence shows a bottle design dynamically changing color and size, finally receiving an intricate scalloped label. The motion illustration medium is ideal for explainer videos, as it allows for the quick visualization of concepts and ideas that may be difficult to describe with live-action video or photography.

You can read more about Tribambuka's work in the **Time-based Narrative** section.

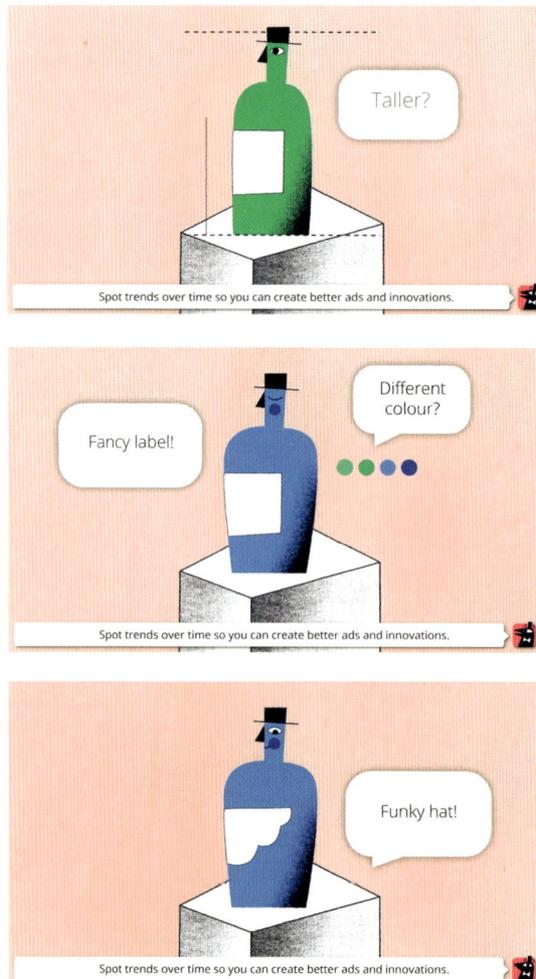

Figure 4.6 Illustrators can simplify instructional information in video explainers. These three frames from Tribambuka's *Zappi Animated Explainer* show the progression of a product design as the user alters its shape and color.

Yukai Du (China/UK)

yukaidu.com

Yukai Du's playful work balances big shapes, vibrant colors, and impressionistic textures with a fluid animation style. Born in China and working in London, she creates illustrations for clients including Adobe, Apple, and MTV. Her distinctive motion illustrations are known for seamless transitions where one image morphs fluidly into the next. While her portfolio is organized into separate sections for animated shorts, static illustrations, and looping GIFs, her distinctive visual voice is immediately recognizable regardless of form. In conversation with Du, she identifies well-executed transitions and a sense of humor as qualities that make for a good motion illustration.

Much of Du's work lives in a sweet spot between cartoon animation and motion graphics, as seen in her explainer video for YORA, a pet food company. Produced by Studio Bliink and Junction Studio, and directed by Tom Neish, with additional animation by Nick Murray Willis, the video seamlessly advances through a series of shots that explain the ecological impact of pet food and how YORA offers a sustainable solution (see Figure 4.7).

Du's singular aesthetic approach is applied across a variety of visualization techniques—including character-driven animation, fluid motion graphics, and kinetic infographics—to express YORA's message of sustainability. A subtle paper texture is laid over the entire video, which animates every few frames, giving the effect of a handmade print come to life. The minimal blue/green color palette reinforces the eco-friendly messaging. Her friendly, humanist illustration style emphasizes the advertisement's positive messaging while making the product approachable.

In addition to her commercial work, Du creates many personal projects to explore new ideas and techniques. Her looping "Dancer" GIF (see Figure 4.8) depicts a figure who breaks apart into abstract shapes as she moves, conveying the intangible sensations of dance. The GIF's limited color palette balances warm blues and greens against a bold orange, creating strong visual impact with a complementary scheme. The confetti texture and dot patterns masked by the shapes of the shirt and pants give these graphic images a sense of tactility and imbue them with a retro quality. The frame-by-frame

Figure 4.7 Examples from three different shots in Yukai Du's *YORA Pet Food* explainer video show how character animation, illustrated patterns, and type-based infographics can be used together to tell a complete story.

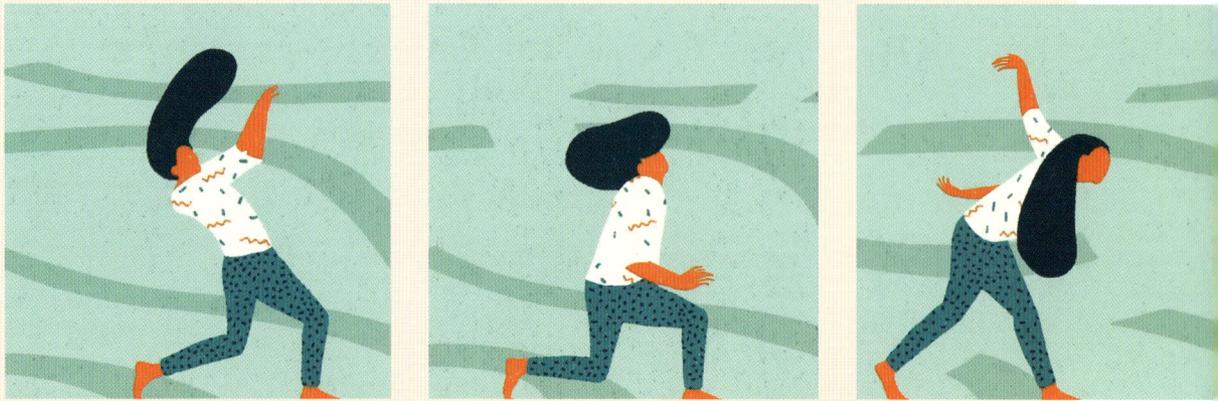

Figure 4.8 Six frames from Yukai Du's "Dancer" GIF show key poses from the figure's dance and how the graphic parts of the figure transform into abstract shapes.

animation technique highlights Du's trademark fluid approach to motion, with smooth character animation that moves the dancer through several poses before melding into flowing abstract shapes. Ribbons of low-contrast color swim through the background, adding supporting motion to the dance. Du seamlessly combines believable character animation with the kind of moving shapes often used by motion designers.

Number Animation, an experimental project from Yukai Du, shows how easily her recognizable visual voice can be applied to typographic works, reiterating the blurry intersection between illustration and graphic design (see Figure 4.9). This set of ten GIFs, which depict the Latin alphabet, was created as Du's contribution to *36 Days of Type*, an annual design challenge promoting the endless graphic possibilities of typography (see more at 36daysoftype.com). Du used this project to experiment with the 3D software package Cinema 4D. Each numbered GIF uses 3D rendering to show the dimensionality of the extruded letterforms with playful camera movements. For example, in "8," the camera moves perpetually forward, revealing a progression of eights with different color and texture applications. The "infinite zoom" has a hypnotic effect

on the viewer, with no clear beginning or end. Du depicts the parade of numbers with her trademark flat shapes, bold colors, masked areas of pattern, and intermittent paper texture. She adds extra dimension and interest to each GIF with the swirly abstract shapes she is so well-known for.

Du honed her graphic voice as an illustrator with early projects, like her Master's graduation film, *Way Out* (2015). This animated short, inspired by Sherry Turkle's book *Alone Together*, depicts a lonely world where technology has completely replaced human connection. As in her *YORA* video, Du strings a sequence of illustrated shots together to tell a longer story. The film begins with images of people obsessively interacting with their phones, oblivious to those around them. The imagery is intentionally still, using the nearly static figures to show how lifeless they have become in their fixation with technology. However, Du uses some limited character animation, such as fingers typing, along with ambient lighting and texture animation, to indicate that the world is still alive.

Additionally, Du creates more prominent movements via transportation in the city, such as buses and subways. In Figure 4.10,

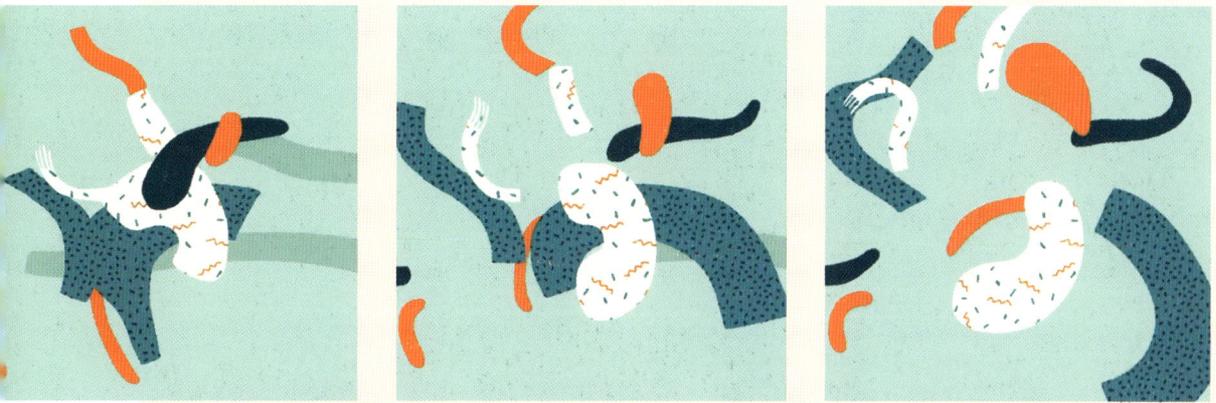

Du animates a bus passing from the left to the right of the screen. The bus's movement contrasts against the stillness of the crowds, emphasizing the dreary isolation of these people.

Notably, *Way Out* was awarded a "Staff Pick" designation on the streaming service Vimeo. Rewarded for the exquisite quality of her work, from the beautifully composed images to the timely storytelling, this type of recognition gave Du's video significant reach through extra promotion to Vimeo's viewers. While it is impossible to know exactly how social media curators or algorithms choose what work to promote, *Way Out* demonstrates that independent artists can get visibility for their animated content with a well-developed visual voice, strong craft, and a relatable story.

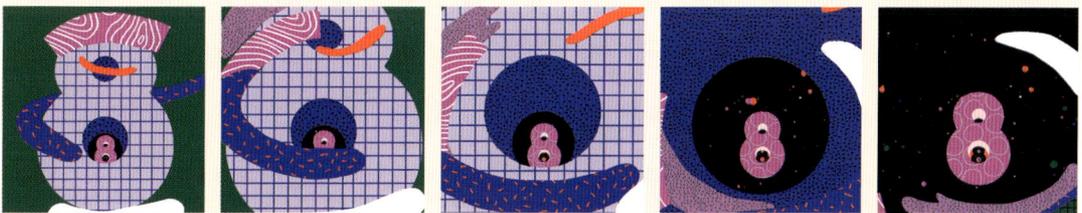

Figure 4.9 These five frames demonstrate the forward camera movement and fluid abstract animation used in Yukai Du's *Number Animation*, "8."

Figure 4.10 These three frames from Yukai Du's *Way Out* show how a single moving object (the orange bus driving in the background) can make a shot feel alive.

Tell us about your work. How do you describe your voice as an illustrator?

My work lies in between static images and moving images, mostly digital with a hand-drawn-looking style. It's vibrant, textured, and craft-looking with an abstract narrative. I love using visual elements like geometric shapes, lines, dots, and fluid movements to represent an object, recreate a place or tell a story—something processed by my creativity that cannot be captured or photographed in real life.

In your bio, you call yourself an "illustrator" and "animation director." What do these identities mean to you? How do you think your training as an illustrator sets you apart from other animators?

The further in my career, the more I understand what my specialized area is and what I enjoy doing the most. These identities define what I would like to be seen and be hired as, to help me focus on what I like doing the most. Animation is such a broad area with many roles. I don't think being an illustrator sets me apart from other animators; I'm just an artist who can do illustration and animation directing in the production.

Your work deftly traverses print and screen applications with broad outcomes, including postage stamps, in-store displays, music videos, GIFs, etc. How do you approach a new illustration assignment? Does anything about this approach change when you are designing animated content?

Although my works are mostly digital, my approach always starts with paper and pen. I love the analog way to think and organize my thoughts. I will sketch very rough ideas on paper over and over again until I have something good to continue. For illustrations, it's more about finding the best compositions and where they will be shown. For example, if it's on stamps, I would think about a simpler composition because it's very small. If it's for a big in-store display, I would go for something more complex with more details and people to look at. For animations, because it's moving, a single composition is less important; my sketch will focus more on the story, if the transition makes sense, and how the timeline will flow.

Your portfolio features many short animations and looping GIFs. What qualities do you think make for a good short versus a GIF?

To me, an animated video is more about storytelling. The visuals and style should be well-executed, but they should all work towards the narrative and engage viewers to understand the story. It doesn't mean storytelling isn't important in GIFs, but I think the visual itself can stand alone in GIF without considering too much a full story, it could be just some eye candy or a witty joke.

Some of your projects were illustrated and animated entirely by you, and others were a group effort. What is it like working with additional animators when bringing your illustrations to life? What are the benefits of working with a team?

I love working with other animators. I'm always amazed by how they can animate my works. I have certain things that I like to have control of, like the patterns and the textures in my works. However, when it comes to movements and animation, I'm very open and love bringing talents on board if I could have their insights into what we could do to make them better. Working with a team can really bring the quality to a new level and achieve something ambitious with a limited amount of time.

What tools do you use to create your animated work? Is there any technology you are experimenting with or eager to try?

Wacom Cintiq, MacBook, Adobe After Effects, Photoshop and Animate, sometimes iPad with Procreate. I would love to try animating for a VR experience!

Are there any motion illustrators or animators who inspire you?

BUCK studio, Moth Studio, Robert Hunter, Justyna Stasik, Christopher DeLorenzo, and many, many others.

Do you have any predictions for where the discipline of illustration is headed? What should illustrators be preparing for?

No, I don't. It's very hard to follow trends; the best way to prepare is to keep exploring and trying to create with your own voice. It's better not to know where it is headed.

Do you have any advice for illustrators looking to get started with motion?

Start with the illustration programs you are comfortable with, like Photoshop, Procreate, etc. They have great animation functions. When you get more familiar with the process and know more about what you'd like to animate, you can choose the more advanced programs. For example, if you want to explore 2D animation, you can try After Effects, or if you like to do more 3D, you can try to learn Cinema 4D.

Figure 4.11 In the dramatic ending of Yukai Du's *Way Out*, a torrent of virtual communication streams through the city. Du employs her trademark fluid animation style filled with lively patterns to serve the narrative.

Editorial, Non-Fiction, and Educational

Powerful, distinctive, thought-provoking illustrations respond to stories that educate, explain, and editorialize.

Forms:
- Editorial
- Documentary
- Infographic
- Explainer
- Social impact
- Educational

Features:
- Derived from and/or paired with text.
- Explains and informs.
- Expresses a point of view.

The rise of print media led to a cultural appetite for news and information, providing a perfect vehicle for publishers to share current events and sway public opinion. Illustrators were there at the beginning of mass publication to clarify text and add meaning with visually appealing imagery for topics including politics, society, business, health, science, and technology.

The introduction of the web, social media, and video streaming has opened new opportunities for illustrators to create digital content. After the 2010 launch of Apple's iPad, frenzied publishers raced to create digital versions of their magazines. By 2012, popular titles like *Wired*, *The New Yorker*, and *Time* offered apps with animated and video content. Although the popularity of these apps was a short-lived fad, they marked a shift where publications began to migrate fully online to be viewed in browsers and smartphones.

By exploiting the dynamic properties of screen-based media, today's illustrators enhance their images with animation to support visual communication. Illustrators might create looping GIFs for publications like newspapers, magazines, and blogs; as well as videos that educate for exhibitions, museums, and online resources. The works in this section explain, inform, and respond to non-fiction subjects, breaking down complicated information and visualizing it in an engaging way for the viewer.

Red Nose Studio (US)

rednosestudio.com

Chris Sickels, the artist behind Red Nose Studio, creates fantastical stop-motion animations with handmade puppets and physical sets. His three-dimensional mixed-media work delicately balances texture, pattern, color, and light to tell stories with grace and subtlety. He produces imagery for nearly every illustration market, including children's books, animated films, advertising campaigns, and editorial assignments. His distinctive voice as an illustrator, and cross-disciplinary portfolio of hand-crafted dimensional work, reinforces the fact that there is no specific style, medium, or mode of working in the illustration field.

As an editorial illustrator, Sickels uses stop-motion animation to breathe life into imagery meant to be viewed both in print and on the screen. For example, he illustrated three section headers for *Scientific American*'s "Truth, Lies, and Uncertainty" issue, released as a deluxe interactive web version and printed magazine. This issue explores the dissonance of fact in today's divided world, using science to explain how we determine truth and how bad actors take advantage of human instinct (Fletcher, Schwartz, and Wong 2019). In these illustrations, Sickels represents the three topics with animals interacting with humans: a lion as the mount of truth, a snake whispering lies into a reader's ear, and a precarious elephant on stilts representing uncertainty.

Because editorial assignments will be seen adjacent to text, it is essential that the illustrator carefully compose the image around this. In the print version of "Truth, Lies, & Uncertainty," each section is shown with the headline and article titles with page numbers printed on top of the illustration (see Figure 4.12). Each image has a strong composition with planned negative space, allowing the graphic designer to set type on top without creating unwanted overlaps as the image moves.

As seen in Figure 4.13, the motion depicts limited character animation with the figure and lion bravely surveying the landscape, turning their heads towards the viewer as a hat drifts by. The courageous girl with the megaphone, mounted atop the "king of beasts," shows the strength of truth, while the hat perhaps represents some sort of doubt or distraction.

The editorial illustrator must walk a fine line with motion work: using animation to add visual interest to the image without being so overwhelming as to distract from the text or annoy the reader. The gentle motion animated by Red Nose Studio fits the bill: enticing the viewer with fantastical, thought-provoking imagery while taking advantage of the digital medium.

Figure 4.12 This page layout from *Scientific American*'s "Truth, Lies, & Uncertainty" issue shows how Red Nose Studio collaborated with the designer to develop a moving illustration that type will fit neatly into.

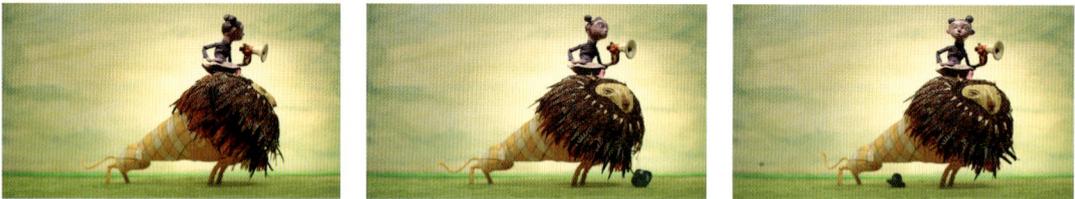

Figure 4.13 Three frames from Red Nose Studio's "Truth" animated GIF for *Scientific American* show how its careful character animation doesn't break the negative space reserved for the typography.

Richard Borge (US)

richardborge.com

Richard Borge is an illustrator who creates clever conceptual imagery for clients, including *Newsweek*, *The New York Times*, *Bloomberg*, and *Time*. He uses 3D software to render illustrations with a playful visual voice inspired by antique toys. His images are assembled from simplified geometric forms and connected with joints and hinges. The realistic textures suggest materials like metal or wood, and the coloring often feels like time-worn paint, with computer-generated scratches and scuffs. Borge's signature antique toy style adds an imaginative quality to complex and dry topics in science, finance, and tech.

The strongest illustrators in this category use animation as an integral storytelling tool. For example, Borge's "Market Swings" GIF, created for the *Wall Street Journal*, depicts a swing set with iconography from an American dollar bill (see Figure 4.14). The money-green set has the "Eye of Providence" painted at its apex. The animation shows the characters in the seats swinging wildly, especially the orange figure who reaches hazardous heights.

Borge's minimalist illustration uses motion to add meaning and context for the viewer. The dangerously high swinging may represent intense market volatility, or perhaps the investors who play it safe versus those who take risks (Pollack 2018). The use of visual metaphor is a classic tool for editorial illustrators, allowing the reader to interact with the image by combining two ideas in their mind (money and a swing set) to generate a deeper meaning about stock market risks.

"Security," another editorial GIF for *The Wall Street Journal*, relies on a narrative approach (see Figure 4.15). The illustration shows a room with a figure reading a tablet. Robotic eyes creep in from the left, and the pupils turn red, suggesting that they are recording. The man gets the sense of being watched and turns to look, but the cameras hide, and the image loops. Borge's fantastical representation of being spied on lends the virtual topic a dangerous physicality, making it more relatable.

Often, editorial illustrations are designed for mixed use in the print and digital formats of the publication, and therefore must function effectively with *and* without animation. In "Security," the animation frame with the invasive cameras spying on the character was used as the print illustration. Developing an image that is as exciting when it is static as it is in motion makes the illustrator's job more challenging. Here, it is likely that Borge used his superpower as an illustrator to depict a complete narrative in one image, then expanded this idea for motion to bring the scene to life.

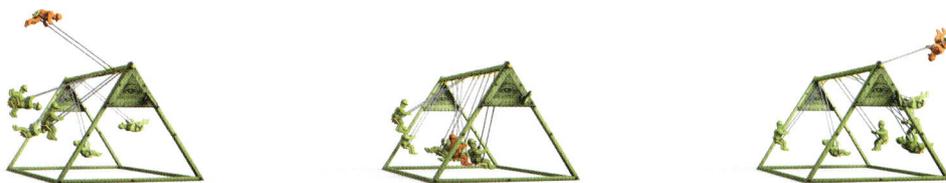

Figure 4.14 Three frames from a GIF by Richard Borge for an article titled "If Market Volatility Is Back, Are You Ready" for *The Wall Street Journal*. The illustration uses visual metaphor to convey its message through motion.

Figure 4.15 Editorial images must function both in print and digital editions. These four frames from Richard Borge's "Security" GIF for *The Wall Street Journal* show a man being spied on by robots, with a careful composition that tells its entire story in one image.

Luis Mazón (Spain)

mazonluis.com

Based in Barcelona, Luis Mazón has illustrated for clients including *The Washington Post*, *The New York Times*, *The New Yorker*, and *The Ringer*. His work is known for its impressionistic approach with a tactile mark-making application that looks like crayon or pastel. He is perhaps best known for his moving portraits, which utilize a line-boil effect to bring the painting to life. Mazón also creates conceptual pieces in other styles that are more graphic, but always with a handmade organic feel.

Figure 4.16 shows frames from Mazón's portrait of Timothée Chalamet from the movie, *Call Me by Your Name*. This image was used as the cover of *Little White Lies* magazine, a bi-monthly independent publication that champions films and filmmakers. Painted with Mazón's trademark impressionistic dabs of color, the textural brush strokes feel like the build-up of oil pastels, while white areas of paper show through the marks.

The motion adapts the "line-boil" technique from cartoon animation, where static objects are redrawn in short loops to give them the illusion of life. Here, Mazón repaints the entire image three times. The slight variations in mark-making are apparent when the paintings are sequenced in an animated GIF. The result brings the subject of the portrait to life in a unique way that takes advantage of the digital medium.

Mazón's motion illustration for the Swiss magazine *Republik* responds to an article about the European Union's collective interest in challenging the United States's big tech companies on issues like fake news, copyright, and data theft (Fichter 2019). This image utilizes a bold, cartoony style depicting the US as Uncle Sam's hat, fighting with a Facebook-shaped sword against a personification of the European flag, who uses her gold star as a defensive shield (see Figure 4.17). Mazón combines known symbols together to create a new meaning with his visual metaphor. This image

Figure 4.16 Three frames from Luis Mazón's cover illustration of actor Timothée Chalamet for *Little White Lies* magazine. While they appear similar when viewed in static, each frame has slightly different brush strokes, giving the sensation of a living painting during animation.

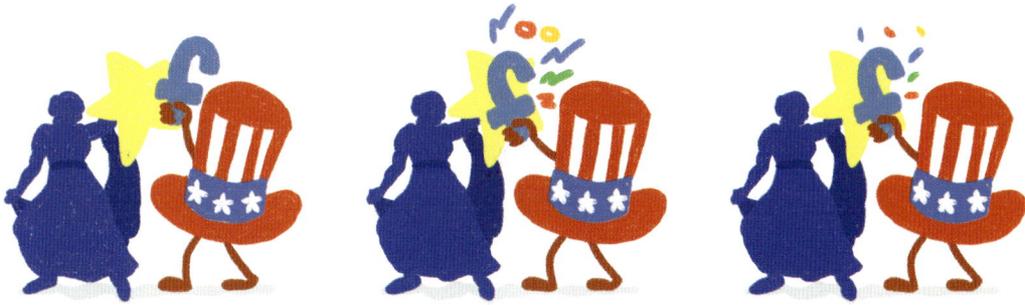

Figure 4.17 Luis Mazón's "Europa vs. Big Tech" GIF for *Republik* personifies the two entities with symbolic shapes.

cleverly personifies the EU and US tech, simplifying a complex issue into a single understandable image.

While not necessary to understand the image, the motion shows the sword clashing against the shield, with Google-colored action lines bursting out of the impact. Additionally, Mazón uses a similar line-boil technique, as in his *Call Me by Your Name* illustration, completely redrawing each frame of animation to give the viewer an impression of a painting come to life. The added motion grabs attention, enticing the viewer to take a closer look at the article.

Wesley Bedrosian (US)

wesleybedrosian.com

Wesley Bedrosian has created editorial illustrations for a who's who of publications, including *Time*, *Vanity Fair*, *The New York Times*, *Newsweek*, *BusinessWeek*, *Billboard Magazine*, *Forbes*, *Fortune*, and *The Washington Post*. Originally known for his delicately inked conceptual illustrations, he has become known for his instantly recognizable 3D portraits of public figures and celebrities.

Bedrosian has developed a streamlined process to facilitate editorial work in this style. To create these, he uses Pixologic ZBrush to sculpt the digital models and Luxion Keyshot to render materials and lighting for the final illustration. These software packages are commonly used by teams of artists in the big-budget entertainment and gaming industries; his use of highly detailed 3D models is rare in the illustration field, which demands tight deadlines from independent artists.

In his "Dr. Amen" illustration for the *New York Observer*, Bedrosian uses his 3D illustration technique in combination with character animation to create a GIF (see Figure 4.18). This editorial image portrays Dr. Amen as a snake oil salesman, using the Public Broadcasting Service's megaphone to sell his dubious medicine to a naïve public (Bernstein 2016). Bedrosian animates naturalistic body movement and facial expressions as Dr. Amen barks to an unseen crowd, fully bringing the character to life.

Figure 4.18 Three frames from Wesley Bedrosian's GIF illustrating the article "Head Case: Why Has PBS Promoted Controversial Shrink Dr. Daniel Amen?" for the *New York Observer*.

The digital 3D format offers many ways to make Bedrosian's masterful portraits move, resulting in a wholly original art style for the reader to enjoy as they scroll through their favorite publications. Placed next to contemporaries like Richard Borge and Chris Sickels, his work shows the versatility of 3D animation techniques to establish a unique illustrative voice.

@Coffeecakescafe (US)

instagram.com/coffeecakescafe

Coffeecakescafe documents their everyday life in New York City with hand-drawn illustrations of the city. Their drawings mark the change of seasons, highlight social issues, and promote favorite local spots. Their journey with motion illustration began as a healing project. Diagnosed with an autoimmune disorder that causes motor skill challenges and memory loss, they taught themself drawing to focus, imagine, and use their hands.

This project by Coffeecakescafe is fundamentally different from editorial projects in that a client did not commission it. Instead, the artist creates each illustration as part of a meditational art practice and shares them to engage with a larger community. In an email exchange, Coffeecakescafe wrote, "Through the craziness of lockdown during COVID, fear, etc., I lived through my art. I imagined going to all the places I draw. I imagined being inside the cab that drives by in my drawing … I want to transport people into my picture and have them feel like they are in it."

Coffeecakescafe produces their work exclusively with traditional tools like pencils, markers, and paper, with animation shot entirely in-camera. Their video, "Good Morning New York," shows off the handmade technique (see Figure 4.19). The background, figure, and leaves are all drawn on separate pieces of paper. To create the illusion of leaves falling, Coffeecakescafe uses a stop-motion technique, taking one photo at a time as they move the paper leaves into the shot by hand. Their works sometime feature unconventional materials as well. For instance, this illustration uses cotton fibers to represent the coffee's steam. The fibers are gently moved in each animation frame, giving the viewer the sensation of rising vapor blowing in the wind.

As an illustrator, Coffeecakescafe fills a documentarian role. Many of their illustrations capture lovely moments around the city, depicting well-known buildings and monuments, or capturing the beauty of leaves falling in the fall. They also use their following as a platform to promote critical issues such as Black Lives Matter, LGBTQ rights, and support of local business.

Figure 4.20 shows their motion illustration celebrating the Stonewall Inn, the historic site of riots that launched the Gay Rights movement in 1969. They shared this video on their Instagram feed during Pride Month, illustrating rainbow flags decorating the space, with a "Love is Love" banner appearing one word at a time. The rainbow coloring applied to the flowerpots in front of the building reiterates the pride palette. Coffeecakescafe is an inspiring example of how illustrators can create personal work they are passionate about, and use online distribution channels, like Instagram, to share them with the public.

Figure 4.19 Coffeecakescafe uses traditional drawing methods and cut-paper to create motion illustrations, as seen in these two frames from their video, "Good Morning New York."

Figure 4.20 These three frames show how the animation builds in Coffeecakescafe's "Happy Pride" video. The rainbow banners progressively build on, filling the space with color.

Lily Padula (US)

lilypadula.com

Lily Padula is a multidisciplinary illustrator and animator based in Brooklyn, New York. She has produced work for clients including *The New York Times*, *The New Yorker*, the Metropolitan Transit Authority of NYC, and National Public Radio. Padula's passion for animation started with GIF experiments in the early 2010s, leading to work with motion on editorial assignments and longer videos, such as NPR's *Maladaptive Daydreaming*, which won a gold medal from the Society of Illustrators in 2018. She is known for surreal concepts that illustrate complex topics in a manner that is both interesting and understandable to the viewer, touching on issues like environmentalism and science.

Padula's "Great Barrier Reef" illustration shows her ability to use narrative imagery to explain a complex scientific story (see Figure 4.21). The GIF was made for an article in *The New Yorker* about the chain reaction caused by CO_2 emissions, resulting in the "bleaching" of corals and further endangering all animal and plant life in the ecosystem (Sullivan 2018). Padula's illustration cross-fades between two shots set underwater with the camera pointing towards the sky: a lush, colorful depiction of the reef, and a dead version where the coral has bleached and the fish have turned to skeletons. Both shots feature a human swimmer as the focal point, reminding the viewer of our culpability in this tragic sequence of events. To bring the illustration to life, Padula adds secondary animation of bubbles, light diffusion, and a gentle sway to the corals in the shots.

In *Maladaptive Daydreaming* (2018), her award-winning animated short for NPR, Padula uses her refined illustration skills in combination with a variety of motion techniques to visualize a non-fiction audio story. The story is narrated by *NPR's Invisibilia* host Meghan Keane, with first-person accounts from "M," a woman who experiences waking daydreams that bring her intense pleasure through full-bodied fantastical experiences, but cause difficulties in her everyday life (Rizzo 2018).

Padula uses a transformational effect in the opening shot (see Figure 4.22). Starting with a black screen, colorful lines twirl and pop into the composition, slowly forming the face of the video's subject, M, who begins telling her story. The colorful lines and swirls represent the abstract intangibility of the mind's eye as it forms imagery, giving the viewer a representation of how M might feel.

Figure 4.21 Three frames from Lily Padula's GIF for *The New Yorker* article, "A Tiny Coral Paradise in the Great Barrier Reef Reckons with Climate Change," illustrate the transformation of lush corals into a dead reef.

Figure 4.22 Four frames from a surreal shot in Lily Padula's *Maladaptive Daydreaming* for NPR.

The animated short feels almost like a picture book set to time. Each shot functions as a complete narrative, with evocative compositions, character placement, and environments. The animation serves in a supporting role to add visual interest, deepen understanding, and move the story forward with transitional effects. In a retelling of the manifestation of M's daydreams, a later shot shows a naturalistic scene of her as a child on the swing set in her backyard (see Figure 4.23). As she swings, a celestial cloud fills the screen, and M's body drifts into her imagination to go on adventures. The scene transitions visualize M's sensation of daydreaming for the viewer, driving the story forward with the animated effect.

Figure 4.23 A sequence of frames showing a scene transition from Lily Padula's *Maladaptive Daydreaming*.

As an adult, M discovers a website for people who call themselves "maladaptive daydreamers." The narrator describes them as "People who say they're so obsessed with their fantasies, they can't live their real lives" (Padula 2018). At this moment, Padula presents the most striking image of the entire video: M walking through her imaginative space, filled with towering figures with abstract patterns recalling the colorful lines used in the opening shot (see Figure 4.24). Padula's balance of value and scale gives it an epic quality. The fantastical effect uses surrealist art to visualize M's dream world.

In addition to her conceptual work for NPR, Padula illustrates non-fiction topics with representative imagery. For example, her animated short for The Wilderness Society, *Connectivity*, promotes the creation of a network of paths for wildlife to move between national parks and other wild areas in our inhospitable modern world. As the video explains, human infrastructure, like roads and power lines, prevents animals from migrating to locations for shelter, food, and mating. Padula depicts concepts like "wild overpasses" and shows what a network of wild paths might look like mapped onto the United States (see Figure 4.25). This short is similar to "explainer videos" used in advertising, but instead of selling a product, this type of video convinces the viewer to take action for the public good.

Padula's animated portfolio embraces new opportunities for illustrators to translate their skills through storytelling that documents our weird and wonderful world, and influences the public to take action to save it.

Figure 4.24 Lily Padula carefully contrasts black and white tones with big and small shapes in this dynamic composition from *Maladaptive Daydreaming*.

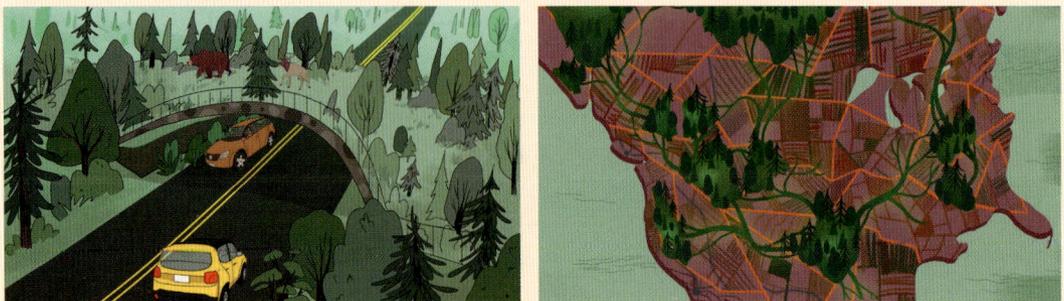

Figure 4.25 Two shots from Lily Padula's short, *Connectivity*, for The Wilderness Society. Animated videos have the potential to create social awareness about important issues and present solutions.

Tell us about your work. How do you describe your voice as an illustrator?

I always find this question hard to answer, because working as a commercial artist means I have to adapt each piece to meet the client's needs. First and foremost, I focus on capturing the appropriate emotion. I tend to rely on surreal concepts and carefully considered color palettes to achieve the correct mood.

You describe yourself both as an "Illustrator" and "animator." What do these identities mean to you?

I don't really think of them as identities, to be honest. There's a tendency, particularly among creatives, to define ourselves by our work. To me, "illustrator" and "animator" are both job titles, and I strive not to let work define myself or my life.

In addition to your animated projects, you've done a significant amount of work for print. Does the addition of animation change anything about your approach to creating an illustration?

I definitely create simpler designs when I know animation will be incorporated. This choice is due to the extra time required to animate, and because too much detail or texture can distract from the work. For example, in a static illustration, I may include a few layers of highlights and shadows, but in an animation, I would either reduce or eliminate those layers. The more complex the final animation will be, the more I try to simplify the design.

Digital readers and web-based news sites have encouraged art directors to ask for animated versions of editorial assignments. Do you have any advice for designing an image that will be dynamic in motion and when it's static?

It's important to keep illustration rules like composition, visual hierarchy, and color theory at the forefront of a piece. If the illustration isn't dynamic in the first place, adding animation won't solve that. I approach animation as a complementary addition to an editorial illustration, something that can enhance the understanding of the concept, but that doesn't rely on the animation for comprehension. As editorial budgets tend to be quite low, figuring out efficient animation methods is essential.

Your portfolio features several animated pieces for non-fiction subjects, such as your work for NPR. These short films seem like a new avenue for editorial illustrators to produce work in a longer format. How do you see these projects in the context of the illustration profession?

Longer-form projects allow for a concept to unfold over time, which is quite different from an illustration that needs to communicate with a single image. The longer format and resulting bigger budgets have been wonderful for me personally, as I was burning out on small editorial jobs to pay my bills. However, it's not a 1:1 jump that editorial illustrators can make. On top of drawing and animating, I've been responsible for art direction, project management, video production, editing, and even basic sound design. It took many years of making my own personal work and working in advertising commercial studios before I had the necessary skills to create pieces like the one for NPR.

Are there any advantages an illustrator can bring to an animation project vs. an animator? If so, what?

Illustrators have training in conceptual and visual problem-solving and can use those skills to create really imaginative animations. Creating an immersive scene with simpler animation

is more effective at communicating than a polished character animation alone would be. Animators tend to have more specific training to develop a skill set that works best as part of a team. As illustrators tend to be individual freelancers, we take a broader look at the content and can wear more hats.

What tools do you use to create your animated work? Is there any technology you are experimenting with or eager to try?

I mostly use a combination of Photoshop and After Effects to create my work. I like to keep a hand-drawn, natural feeling to my work, and Photoshop is the easiest tool for me to use to that end. I'm actually interested in going back to more traditional methods of animation, such as stop-motion, for my own personal work.

How did you learn animation techniques? What advice do you have for illustrators who want to add motion to their repertoire?

I graduated college in 2013 as GIFs were gaining a lot of attention, and was inspired by the possibilities that animation could bring to illustration. Many of my jobs at the time were editorial, and you could often get some extra money for adding animation, so I got a lot of practice making very simple 2- to 3-frame GIFs. I slowly increased their complexity as I got more comfortable with animation as a medium. After about two years of making GIF animations in Photoshop, I took a few jobs that introduced me to the basics of Flash and After Effects. There's a steeper learning curve to these programs, so I relied on online tutorials and the help of more experienced friends to begin incorporating them into my work.

My advice to other illustrators starting out in animation is to take things slowly, and don't be afraid to fail! A lot about animation and video production can feel technical and sometimes frustrating, but there's a real sense of satis-faction about sticking with a problem until you work through it.

Are there any motion illustrators or animators who inspire you? What makes them interesting?

I've long been inspired by Lilli Carre's work. I love how she retains a distinctly hand-drawn feeling throughout different mediums like illustration, comics, and animation. She isn't too precious with anything, which makes her work feel really alive. I also love a lot of animated movies from the '70s, such as *Fantastic Planet*.

Do you have any predictions for where the discipline of illustration is headed? What should illustrators be preparing for?

Illustration is more in demand than ever, with industries like games, movies, publishing, fashion, and advertising pushing for more and more content. These industries post record profits year over year, and yet illustrators' wages have been largely stagnant for close to 100 years at this point. An advertising job in 1935 paid the same dollar amount as it does today, but in 1935 an artist could buy a house with that wage.

I see clients requesting full copyright transfer for a standard $500 editorial job, huge gaming studios paying 1/5th of the fair rate for freelance artwork, and worst of all, I see other artists chastising those who call out the unfair practices of major companies, saying we should be grateful for the crumbs they offer us. Though these companies rely on our creativity and labor to make their astonishing profits, they fight tooth and nail to avoid giving anything back to the people who make it possible for them. Our culture loves art, yet any attempts by the people who make it to gain the respect and compensation they deserve are met with ridicule.

Unfortunately, I think illustrators should prepare for all of these trends to get worse. We see it now with these AI image generators, which could not exist without stealing the work of real artists. We see it with the sacrifice of beloved animated shows to prop up a corporate merger. Illustration is a complex set of skills that takes years of dedicated training to master, and we need to lift each other up. Share your wages and salaries, learn about copyright, licensing, and usage fees, and always ask for more money. Doing this will not only help you make the living you deserve, but will pave the way for those who come next.

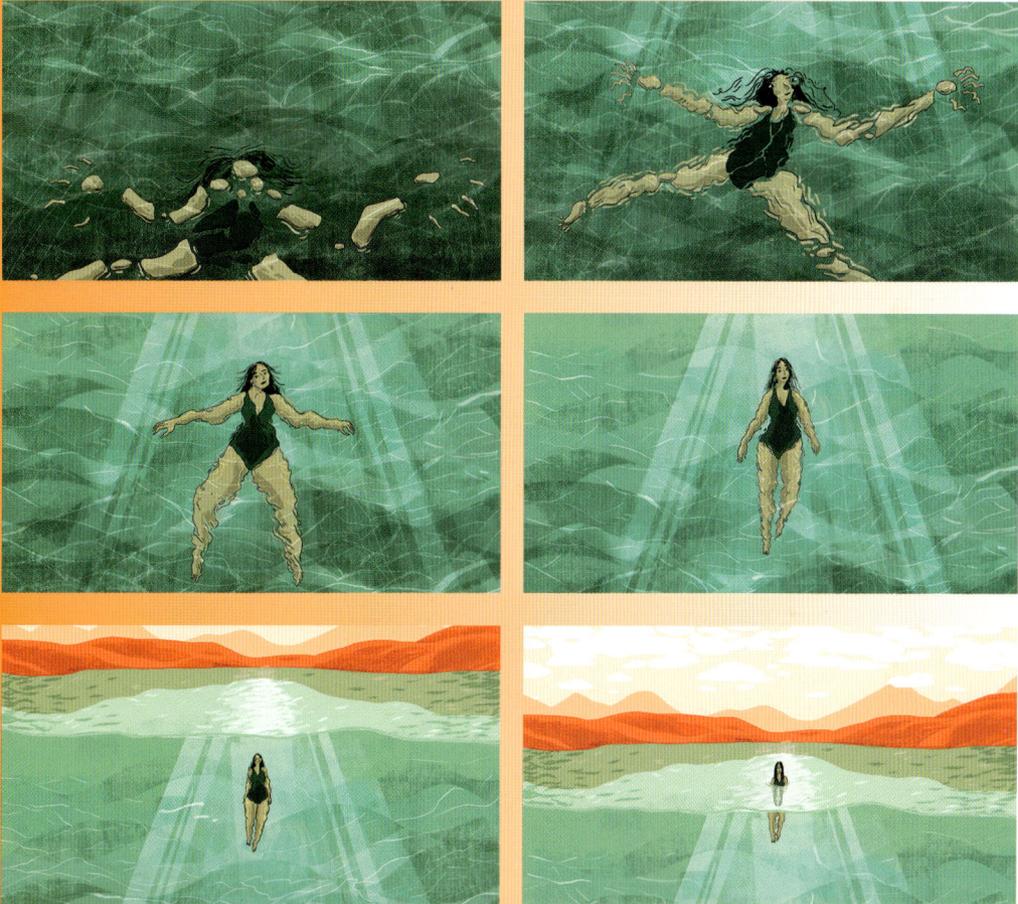

Figure 4.26 These six frames come from Lily Padula's GIF "Up From the Depths." The animation depicts ocean fragments melding together to form a female figure swimming to the surface. The fragments look like refracted light bouncing through ocean waves, while simultaneously giving the viewer the sensation of an otherworldly transformation.

Sequential and Interactive Narratives

Viewer interaction drives the narrative forward in hybrid projects that blend elements of traditional print publishing with gaming.

Forms:
- Comics
- Picture books
- Visual novels
- Games
- Interactive websites
- VR experiences

Features:
- Tells a story with text.
- Requires viewer interaction.
- Reimagines traditionally published media formats with digital technology.

Traditionally published stories have been adapted to animated media since the start of film. Take, for instance, Émile Cohl's animated adaptation of George McManus's popular comic strip *The Newlyweds* (1913), or Diane Jackson's gorgeous short film *The Snowman* (1982) based on the 1978 children's book by Raymond Briggs.

Today's illustrators use motion to extend a rich history of narrative storytelling in various mediums, including sequential art, children's books, and narrative games. The introduction of smartphones and tablets has made interactive media more accessible, leading to an abundance of interactive narrative apps. These projects are designed from the start as interactive animated experiences, such as William Joyce's children's book app, *The Fantastic Flying Books of Morris Lessmore* (2011), Ryan Woodward's interactive comic, *Bottom of the Ninth* (2012), Wesley Allsbrook's VR short, *Dear Angelica* (2017), and Annapurna Interactive's interactive story-game, *Florence* (2018).

The works in this section offer a complete narrative experience and involve some level of interaction, which could be as simple as clicking to the next page on a webcomic, or as complex as playing a video game with an embedded story. Some are traditionally published media like books and comics that take new digital forms. Others come from the gaming industry with virtual experiences that invite the player to participate in the story. These projects may be personal, such as Benji Lee's serial comic *Thunderpaw*, or exist for commercial purpose, like Chiquimedia's *Mortimer and the Dinosaurs*.

Benji Lee (US)

repoghost.com & thunderpaw.co

Based out of Los Angeles, Benji Lee is an illustrator and comic artist known for their innovative webcomic *Thunderpaw: In the Ashes of Fire Mountain* (2012) and *Garbage Night* (2017), published by Nobrow Press. Lee's work reminds the viewer of early cartoon animation, with wide-eyed characters, fluid line work, and bright colors. Their stories are often framed around friendships between anthropomorphic animals who work together to deal with challenging situations. Over the past several years, they have worked in the animation industry as a Storyboard Revisionist on Cartoon Network's *Craig of the Creek*.

Their groundbreaking episodic webcomic, *Thunderpaw*, uses animated GIFs to tell a story that was designed specifically for the digital format, taking advantage of what comics expert Scott McCloud describes as the "infinite canvas" (McCloud 2006). The story revolves around friends Bruno and Ollie, who are trying to survive a post-apocalyptic event. It was produced monthly, with support from readers through the crowdfunding platform Patreon.

Thunderpaw uses typical comic devices, like sequential panels and word bubbles, but integrates looping GIFs and clever web layouts to bring the world and its characters to life. The motifs discussed in **Chapter 3**—simple character actions, atmospheric effects, and scrolling backgrounds—are on full display in *Thunderpaw*. Lee reinforces the narrative with motion that causes the reader to "feel" the weather through environmental animation and the passage of time with looping walk cycles. In a series of panels from the comic's first chapter, Lee illustrates Bruno and Ollie traversing a dangerous terrain (see Figure 4.27). Lee animates the blazing fire in the background, along with simple character animations that draw our attention to the main characters. The motion creates a menacing sense of drama, but Lee keeps the narrative within comic framing, using three panels to show the characters' journey.

Figure 4.27 Two frames from a GIF with three panels from Benji Lee's *Thunderpaw*. The towering flames are animated, strengthening the sense of danger in the pointy rubble-filled environment.

It is towards the end of *Thunderpaw*'s first chapter, however, where Lee uses the web platform to its full potential as they break the formal dimensions of a printed comic with uniquely long horizontal and vertical page layouts. The viewer must scroll the browser window, taking part in the action by "traveling" through the story with the characters. Figure 4.28 shows a dramatic example, depicting a vertical tunnel that the characters are moving down. The comic panels are juxtaposed over a foreboding looping GIF of countless eyes opening and closing. The effect is jarring and surreal, immersing the reader in the world of *Thunderpaw*.

Lee's innovative use of GIFs in *Thunderpaw*, along with contemporaneous projects from artists like Boulet's *Our Toyota was Fantastic* (2013) and Zac Gorman's *Magical Game Time* (2011), showed what was possible in the early days of animated webcomics, and helped shape how illustrators use animation today.

Figure 4.28 This image re-assembles Lee's epic vertical web layout by placing the comic panels over a static version of its "blinking eye" GIF. The drama of this particular page in *Thunderpaw* is jaw-dropping and best experienced in its native digital format.

Chiquimedia (Spain)

chiquimedia.org

Based out of Barcelona, Chiquimedia produces interactive children's books that can be played on phones and tablets. Through the coordination of developer David Rodríguez, they have released several titles, including *Nurot* (2015) with illustration by Héctor Zafra, *Clean and Bright* (2016) with illustration by Daniel Torrent, *Mortimer and the Dinosaurs* (2016) with illustration by Màriam Ben-Arab, and *A Very Busy Bug* (2019) with illustration by Jaime Vicente. Their productions are a team effort, bringing together the talents of illustrators, animators, writers, musicians, and educators.

Chiquimedia's apps are part book, part game. Each title uses an illustrated sequential page format like a picture book, but with interactive elements and mini-games that allow the reader to take an active role in the storytelling. Their apps are designed to capture children's imagination and encourage problem-solving.

One of Chiquimedia's most popular titles is *Mortimer and the Dinosaurs*, written by David Rodríguez and Màriam Ben-Arab, and animated by Manu Kalabria, with additional animation by Ben-Arab and Rodríguez. The story follows a grouchy space alien, Mortimer, who travels to Mesozoic-era Earth on a sightseeing vacation. The beginning of the book starts with Mortimer packing his bags and traveling in a spaceship, with mishaps along the way. Once he arrives, he treks a zoo-like park and encounters many kinds of dinosaurs, teaching children about their names and characteristics. Ben-Arab's lush, textural painting style uses bright colors and a contrast of large and small shapes to capture a child's imagination.

Each page features an interactive feature for the reader to take part in the story. One of the most striking illustrations comes mid-way through the story, as Mortimer approaches a sign reading "triceratops" in front of some tall grass. A slider on the grass invites the reader to push it out of the way, revealing a shy triceratops in the distance, which Mortimer takes a photo of (see Figure 4.30). Another page engages the reader's problem-solving skills, asking them to match similar footprints (see Figure 4.29). This type of interactive picture book fully engages the reader with the narrative because they must interact with the illustration for the story to progress.

Figure 4.29 In this mini-game, the reader helps Mortimer follow a specific shape of footprint to reach the Tyrannosaurus Rex. A path is formed by clicking on the matching foot shape in each column, which Mortimer follows. The game randomizes the location of the footprints each time the reader views the page, making the puzzle unique every play.

Figure 4.30 In contrast with the book's digital format, Màriam Ben-Arab's textural illustrations lend *Mortimer and the Dinosaurs* a handmade feel. On this page, the viewer helps Mortimer snap a photo of a triceratops.

Playdead (Denmark)

playdead.com

Many exciting projects in the gaming space share common themes with motion illustration. Founded by game designer Arnt Jensen and programmer Dino Patti, Playdead is an independent game developer based in Copenhagen, known for its platform puzzle games *Limbo* (2010) and *Inside* (2016). Playdead has been praised for its evocative art direction and boundary-breaking visual style.

In Playdead's *Limbo*, the player controls a little boy who journeys through dangerous environments searching for his sister. Dangers abound, including spiky traps, creepy children, buzz saws, and a giant spider. The game is built around "trial and death," where the avatar will die over and over as the player gains a deeper understanding of the puzzles that prevent him from moving forward. Through repeated tests, the player can finally solve each puzzle and go on to the next.

A 2D platformer, *Limbo* builds on the established game format used by classics like Nintendo's *Super Mario Bros.* (1985) and Sega's *Sonic the Hedgehog* (1992). However, *Limbo* adds to the genre with an innovative art style that emphasizes the moody introspection of the implied story. The game uses pure-black silhouettes for the playable character and main platforms, atop gauzy grayscale backgrounds that add depth to the scenes (see Figure 4.31 and Figure 4.32). *Limbo*'s atmospheric in-game physics and simple loops are variations on the kinetic motifs discussed in **Chapter 3**, using secondary animation to add context and interest to each shot. Remarkably, the player can pause the game at any moment, and the image always looks like a complete illustration. Games like *Limbo*, with rich visuals and deep narratives, show how illustrative qualities can be used in interactive media to engage the player.

Figure 4.31 This moment from Playdead's *Limbo* depicts a broken Hotel sign, with in-game physics generating the sparking electric effect. As in the rest of the game, the strong silhouettes and hazy background paintings evoke a spooky, dreamlike feeling. The careful level design leads to gorgeous visual compositions throughout the gameplay.

Figure 4.32 Here we see the playable character in action, jumping toward a rope. In one of the game's many puzzles, the player must discover how to use it to swing onto the platform in the upper right. The glowing area of the background painting carefully lines up with the rope, highlighting its importance in the puzzle.

Game Grumps (US)

gamegrumps.com

Game Grumps is a multimedia company that produces web shows, publishes young adult novels, and develops video games. In *Dream Daddy: A Dad Dating Simulator* (2017), the player interacts with a story about a single dad moving to a new town with his daughter. Written by Vernon Shaw and Leighton Gray, *Dream Daddy* features detailed character sprites and lush paintings of environments that illustrate its romantic choose-your-own-adventure story.

Dream Daddy is an example of a developing genre in gaming: the **visual novel**. Equal parts game, illustrated book, and written story, the visual novel follows digital trends in picture book apps, except these are made for adults. The gameplay of *Dream Daddy* presents the player with several potential paramours to go on dates with, which will be scored for their success. Different choices emerge throughout each date, resulting in funny, awkward, scary, and romantic interactions. Mini-games, inspired by retro arcade classics, are inserted within the dates, and the story has multiple endings depending on the player's choices.

In *Dream Daddy*, the animation happens through the game's programming and user interface. Different character sprites are placed on top of background paintings, depending on what the script calls for. The characters' facial expressions and poses change to support the text. Some parts of the story feature additional illustration, like the sequence of Polaroids from the introduction, that explain the relationship between the player and their daughter (see Figure 4.33).

Figure 4.33 Two moments from the introduction of *Dream Daddy: A Dad Dating Simulator* by Game Grumps. The game uses illustrated sprites of characters that can change pose and expression, overlaid onto background paintings, to tell its story.

Figure 4.34 *Dream Daddy* starts with a fun character creator, allowing the player to design their avatar with pre-made features and styles, which will become part of the visual novel.

Additionally, the player gets to customize their own character, which features in dialogue during gameplay (see Figure 4.34). Custom graphics for facial features, hairstyles, clothing, and accessories personalize the story, giving the play an intimate connection with the game. Visual novels like *Dream Daddy* present an exciting avenue for the illustrator—the ability to design and illustrate characters, environments, and narrative imagery for the gaming industry.

Lucas Pope (US/Japan)

dukope.com

American video game designer Lucas Pope is known for his award-winning indie games, including *Papers, Please* (2013) and *Return of the Obra Dinn* (2018). These games are built around deep narratives, drawing from social issues, class status, and world history. In *Papers, Please*, a "Dystopian Document Thriller," the player wrestles with ethical dilemmas as an immigration officer at the checkpoint of a fictional Eastern Bloc country. They must balance their personal welfare, like paying rent, with the welfare of strangers, as they examine immigration documents and decide who gets to enter. Pope's thoughtful storytelling asks players to reconsider their values through the complex lenses of class, bureaucracy, and globalism. Much like Game Grumps' *Dream Daddy*, *Papers, Please* has a scripted story with multiple endings based on the player's choices.

Pope's second commercial release, *Return of the Obra Dinn*, is a first-person mystery adventure that also offers a thought-provoking narrative. Set in 1807, the player becomes an insurance investigator, discovering what happened to the merchant ship *Obra Dinn*, which went missing for five years before reappearing off the coast of England with no survivors. The gameplay is a logic puzzle, asking players to identify and deduce the fate of each passenger through open exploration of the ship, with the ability to examine moments from the past, and a logbook to record each detail.

Inspired by early computer graphics, Pope's art direction evokes a nostalgic mood and supports his complex narratives. *Obra Dinn* is a 3D game rendered in a simulated 1-bit graphic style, using only two solid colors. A technical limitation during its heyday, the 1-bit style adds noir drama to *Obra Dinn* with the obscurity of hard shadows and diffused details (see Figure 4.35). It is also an economical choice, allowing Pope to develop the graphics himself, without competing with the time-intensive ultra-realism produced by the AAA gaming industry.

Obra Dinn is made in the Unity game engine and uses a custom-programmed solution to present the 3D graphics in only two colors, with dithering patterns representing tonal variation. Pope meticulously experimented with the best way to render the dithering pattern in high definition, adjusting for modern 3D camera movements without causing eyestrain or distracting moiré effects. The resulting effect is stable and friendly on the eye, tracking the dithering pattern through camera movement (see Figure 4.36). These careful graphic considerations give every dynamic frame of *Return of the Obra Dinn* an illustrative look.

Figure 4.35 Lucas Pope's game, *Return of the Obra Dinn* (2018), uses simulated 1-bit graphics and dithering patterns that evoke early video games. The game's setting in the early 1800s, combined with its 1980s rendering style, and modern 3D graphics, create a uniquely timeless graphical pastiche.

Figure 4.36 *Obra Dinn's* fine-tuned dithering patterns render complex depth and form in only two colors, like the action-packed rainstorm in this shot.

Stephen Vuillemin (France/UK)

instagram.com/aycevee

Stephen Vuillemin is a French illustrator, animator, and comics artist based in Paris who previously worked from London and Taipei. His narrative illustrations tell stories with a fantastical, twisted edge. He creates work across multiple markets, including editorial, advertising, comics, and animation for entertainment. In addition to his self-published comics, he has produced work for publications including *GQ*, *The New York Times*, and *The Atlantic*, as well as animation work for The Mill, Passion Pictures, and Wizz. Notably, he designed and animated the hallucination scene from Fox's blockbuster, *Deadpool* (2016); directed an animated short for Chanel called "The Camellia Merry-Go-Round" (2021); and released his own short film *A Kind of Testament* in 2023.

Vuillemin is best known for his GIFs that blend expertise in illustration, comics, and frame-by-frame animation. In *Cartoon Brew*'s long-running "Artist of the Day" feature, animation historian Chris McDonnell wrote, "Stephen has elevated the art of the animated GIF by producing work specifically for that format … When the same publications run static print versions of the GIF illustrations, Stephen's work flops the paradigm: the print version is the modified, adapted, and even inferior version when compared to the animated online version—but only because it lacks the motion. Stephen's static illustrations are equally strange, humorous, and appealing to view" (McDonnell 2013).

Vuillemin's 2015 comic for *Professeur Cyclope*, a digital publication devoted to comics and fiction, is an excellent example of

Figure 4.37 This GIF from Stephen Vuillemin's "Histoire des Démons et des Armures Géantes" (History of Demons and Giant Armor) for *Professeur Cyclope* animates the colorful explosion of confetti, celebrating the knighting of a fan-art illustrator.

his illustrative voice and narrative sensibility. It is a dark satire, skewering modern obsessions with gaming, fame, and intellectual property. In the comic, a mother recounts the "History of Demons and Giant Armor" to appease her starving child and defend her husband's gaming addiction. In this tale, which may or may not be true, she describes how an accident with the Hadron Collider opened a door to hell. Demons came through and massacred

most of society, only sparing the most famous and popular artists. They enslaved the remaining populace with video games and a craving for virtual wealth.

This all sounds quite dark, but Vuillemin humorously peppers the narrative with random cultural references, specifically naming Coachella, David Guetta, and *Breaking Bad*. Vuillemin's demons have a taste for popular music, TV shows, video games, and fan art. The mother narrates, "demons love fame, and they are happy to rub shoulders with stars." The comic even pokes fun at the contemporary illustrator. Figure 4.37 shows a witty panel describing the demons' latest activities. Translated to English, the text reads, "They just made their favorite artist a knight of the underworld. He's a guy who does illustrations of *Game of Thrones* characters dressed as *Star Wars*."

Each panel of the comic is illustrated with animated GIFs, introducing subtle character animations and atmospheric effects, such as the festive confetti raining down on the knighting of the fan-art illustrator depicted in Figure 4.37. As with much of Vuillemin's portfolio, the illustrations work perfectly in static format, but come alive with the addition of motion, making full use of the digital viewing platform.

Vuillemin was one of the first illustrators to use animated GIFs in their comics. His 2011 webcomic, *Lycéennes* (2011), or *Schoolgirls*, features around 300 GIFs. Originally published on his blog, it was sold to *Professeur Cyclope*, and received significant attention for its innovative use of animation. Speaking to *Wired* in 2013, Vuillemin said, "I wanted to exploit the characteristics of blogs; the use of GIFs is part of that idea. Another of these characteristics is that there is potentially no end to a blog, you can keep updating it for your entire life. I could

Figure 4.38 Frames from three GIFs in Stephen Vuillemin's *Schoolgirls* (2011). Each row represents the animation from a single comic panel. Vuillemin smartly designed each GIF with a complete composition, so the story is apparent even without motion. He uses this clever blend of comic panels and animated action to illustrate an indecent moment between a man and his dog.

do 10 more episodes of *Schoolgirls*. There is no actual end to the story" (Stinson 2013).

Schoolgirls combines an appetite for animation with seductively vulgar imagery. Figure 4.38 shows a sequence of three panels that depict a revolting shopkeeper picking his nose and offering the booger to his dog, who eats it up. The unvarnished reality, glamour, and violence presented in *Schoolgirls* makes it tantalizing—it is like a soap opera for the social media era. As in "Demons in Giant Armor," *Schoolgirls* doesn't need the animation to function. Vuillemin smartly composes each panel of the comic to illustrate a complete idea, but the looping character animations and atmospheric effects only make it more appealing.

A signature of Vuillemin's GIFs is the use of visually apparent dithering. Figure 4.39 shows an illustration made for *British GQ* about sexting, which depicts a woman suggestively holding a hotdog while interacting with her phone. When we look very closely at her skirt, which appears as a solid shade of mint green, we can see that it is comprised of a pattern of discrete gray, yellow, and green tones that optically blend in the viewer's eye as a single hue (see Figure 4.40). The patterned dithering takes advantage of the built-in qualities of this retro image format, introducing pattern and texture that is native to the GIF format and pays homage to early computer art.

Figure 4.39 A frame from Vuillemin's *British GQ* illustration shows how Vuillemin uses dithering as a textural design element in his GIFs.

Figure 4.40 Detail of the dithering pattern shows how ordered patterns of dots and lines create the illusion of many subtle shades, just like the halftone patterns invented a century earlier.

Tell us about your work. How do you describe your voice as an illustrator?

I'm trying to be very complex and multi-layered in my expression, so I do a lot of personal work, such as comics and films, where I can write complex stories. I also do commissioned illustration and film directing work. When I do that, I try to be more simple and pure, just decorative. Again, it's about taking into account the medium; personal work and commissioned work are two different channels so they can't be the same.

You have a strong background in both illustration and animation. How does your experience in these disciplines influence your work?

It's very convenient having a background in both of these mediums, because when doing personal projects, I can handle everything by myself. Because I've been doing both for a long time, it's also led me to develop a personal style both in illustration and animation (every animator has their own way to make things move).

You are an early pioneer of the GIF renaissance, publishing your animated comic, "Schoolgirls," in 2011. What inspired you to use GIFs?

At the time, I took a trip to the biggest comic book fair in France, in Angoulême, in order to meet publishers and show them a book project I had. As an arrogant young man, I was expecting people to roll out the red carpet for me; but they were actually busy, somewhat disdainful, and showed little interest in even looking at my project. In reaction, I decided that I didn't need them—who needs a publisher when you have the internet? And that I would make an online comic. At the time, there were some online comics, but they were just a scan of a page (the most popular one in France was a guy called Boulet). I thought that my comic, unlike theirs, should be designed for the internet, and that it should be different from traditional comics. I was very fond of a website called *FFFFOUND!*, which was a kind of pre-Tumblr, that I used to spend ages scrolling. I decided to use the same scrolling principle. That seems obvious now, but it wasn't then. There were people posting GIFs on there too, but at the time, most of the GIFs you could find were clips from films and videos. I enjoyed them nonetheless. So, I decided that all panels in my comics would be GIFs that I'd make specifically for that. It would look like scrolling GIFs on *FFFFOUND!*, except that all of them would form a story.

Looking back, what effect did GIFs and motion have on the illustration field?

After I did the comics, I was branded a "GIF guy," and then I got commissions from clients in the editorial field, *The New York Times* being one of the first of them. Aside from editorial, I feel like it took ages for other clients to start to show interest in GIFs. Since then, I've tried to break away from this GIF guy label. GIFs still seem to be seen as the cheap cousin to animation film, and they still don't pay that much. Since they are much shorter in format and they don't display sound, they aren't as immersive as film. They are also cheaper to make. Most of my GIFs are between 600 and 800 pixels wide. It's smaller than an HD film. My policy is that I never zoom into the frame more than 100 percent when I draw them, so I don't draw in as many details as I would if it was a film.

Do you think illustrators are paid fairly to add motion to their work? Does something need to change in the industry?

It depends on the job; it seems that the industry is still figuring out the price for a GIF.

I've been offered jobs I just couldn't accept because [the rate] was way too low. Other times, it was just barely enough, so it forces you to find a trick to do it quicker. It often ends up with a fun, but not as impressive result as if you'd had more money and more time to do it. There is a fun part to it, but it's also frustrating when you're a perfectionist.

What do you think motion adds to a comic? Is there a point where a motion-comic stops being a comic and becomes something else, like a short film or interactive web experience? Is there value in these labels?

I don't know if there's value in these labels, but I believe that one should always be very aware of the medium they're using, so they can make the best use of this medium.

I believe that what draws the line between comics and film is if there is or if there isn't a timeline. Let's say that you'd add sound to your comics, then you'd have crossed that line, because sound is displayed in a timeline, unlike comics.

In my comics, the animation is obviously displayed in a timeline, but I've treated it as an "embellishment"—no crucial information is displayed in the animation. No matter how fast you scroll, you still get the point of each panel the same, as if it wasn't moving. You never have to wait; in that sense, I feel like it's still a comic.

In addition to comics, you're known for your editorial illustrations, which often have animated and static versions. How do you design something that needs to be dynamic in both motion and print?

For these too, I treat the animation part as an "embellishment" to the static part. The only animated parts are little loops here and there. But when I know that there will be no printed version, then I can allow myself to display some crucial information within the timeline, like in the devil snorting cocaine I did for pure baking soda.

What tools do you use to create your animated work? Is there any technology you are experimenting with or eager to try?

I always use the same tools, the same brush in the same software since I started. I feel like my drawing, animation, and color skills keep improving, but I like keeping the technology the same. It makes it easier to track my progress! Although once I finish my short film, I'd like to try something else for a change, maybe some wood carving.

Are there any motion illustrators or animators who inspire you? What makes them interesting?

I don't look at that much motion illustration actually, but lately, I'm quite into Smile Bam. I find that they're making a perfect use of their medium (animation for online platforms). The design is perfectly suiting the purpose. Otherwise, just in case no mention was made of Uno Moralez in this book, let me correct it right now. He's one of the best "GIF artists," and he was active when I made my animated comics. I like the very poetic animated loops Zhong Xian does, as well.

Otherwise, working in animation has led me to collaborate with plenty of very talented artists that I greatly respect. If I'd have to name a few: Jonathan Djob Nkondo for his mastery of the animation medium and his independence of mind. Jennifer Zheng for her sense of storytelling. Nicolas Ménard and Manshen Lo for their beautiful applied arts mentality … The Line, Moth, and Nomint are great too. And, of course, everyone at Remembers studio, in Paris, for their unique visions. I'm represented by Remembers at the moment, and I'm very happy here.

Do you have any predictions for where the discipline of illustration is headed? What should illustrators be preparing for?

I would advise illustrators to keep doing what they like. The industry should follow.

Do you have any advice for illustrators looking to get started with motion?

Go ahead and do it. Watch online tutorials—practice, practice, practice.

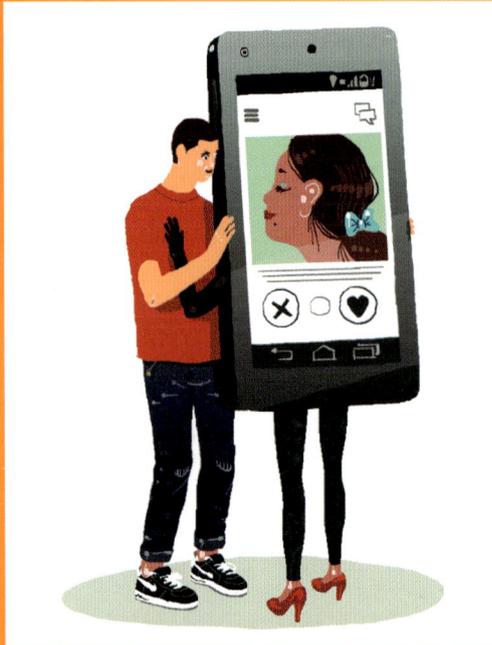

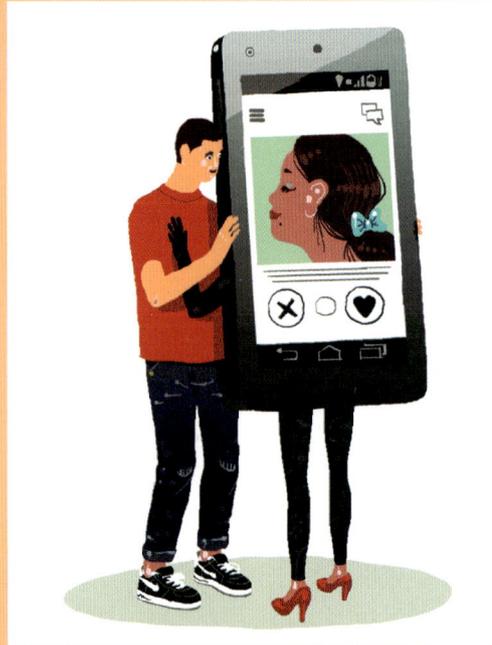

Figure 4.41 Two frames from Stephen Vuillemin's GIF for a *New York Times* article called "Connected: Love in the Time of the Internet." The animation features a glossy highlight flashing across the smartphone, drawing the viewer's attention to the online dating motif.

Time-based Narrative

Linear stories meant to be watched with the viewer's full attention as singular pieces of art, for entertainment.

Forms:
- Animated shorts
- Feature films
- Television shows
- Music videos

Features:
- Uses video to tell a linear story.
- Watched for entertainment.
- Audio enhances animation (sound effects, voice-over, or music track).

While the examples in this book are created mainly by independent illustrators and small studios, there are plenty of contemporary examples of widely distributed, big-budget projects with illustrative qualities. To name a few:

- Richard Linklater's rotoscoped films *Waking Life* (2001) and *A Scanner Darkly* (2006) feature unique and sophisticated hand-drawn styles that feel like moving illustrations.
- Ari Folman's animated film, *Waltz with Bashir* (2008), is built around the recognizable visual voices of illustrators Tomer and Asaf Hanuka.
- Dorota Kobiela and Hugh Welchman's *Loving Vincent* (2017) tells the story of Vincent Van Gogh with animation made from 65,000 traditional oil paintings.
- Aaron and Amanda Kopp's live-action documentary *Liyana* (2017) interleaves motion illustration scenes by Shofela Coker to tell a children's story.

Music videos have also experimented with illustrative motion since the dawn of MTV. Consider A-Ha's *Take On Me* (1985), Pearl Jam's *Do the Evolution* (1998), or the series of animated videos produced for the Queens of the Stone Age album *... Like Clockwork* (2013).

This section shows how illustrators can work within the cartoon animation ecosystem. The guiding principle connecting these projects is that they were either created by illustrators, feature an illustration mechanic, or have an illustrative voice. The illustrator's skillset shows up in multiple stages of production, like storyboarding, background painting, and the skillful rotoscope technique.

W. Scott Forbes (Canada/US)

wscottforbes.com

Working out of Los Angeles, Canadian illustrator W. Scott Forbes has over ten years of experience in the comics and entertainment industries. He has done production design for many television shows, including *Craig of the Creek*, *Jessica's Big Little World*, *Big Blue*, and *Paw Patrol*. As a freelance illustrator, Forbes has worked for clients including Marvel Comics, DC Comics, and BOOM! Studios. He began his career with the short film, *A Good Wife* (2012), which caught the attention of the animation world, demonstrating how independent illustrators can use limited motion to create engaging narratives.

A Good Wife tells the story of a mid-century woman's infidelity, captured through a sequence of vivid motion illustrations. Like a picture book set to time, it recalls the work of innovative film director Chris Marker's short film "La Jetée" (1962), which similarly used a montage of still photographs to tell a story. Forbes specifically chose this format to emphasize his strong skills as an illustrator, developing the story around still moments, limited motion, and compositing; some techniques he uses are looping brush strokes, lighting effects, and "camera" movements.

Forbes's film progresses through illustrated scenes of the namesake wife frozen in introspective thought, vivid memories of her affair, and ordinary moments from her family life. Figure 4.42 shows how Forbes uses camera techniques to bring his illustrations to life. The focus shifts from the fan in the foreground to the bed in the background, directing the viewer's eye to the rumpled sheets. We learn several things from this simple camera movement: first, that the story takes place on a hot day, indicated by the fan, and second that the bed was recently used.

Forbes uses a line-boil technique across the entire film to bring his paintings to life with looping cycles of the same image made with different brush strokes, as in Luis Mazón's motion illustrations. For example, in the shot shown in Figure 4.43, the wife drives home to her family. The camera slowly pulls forward, drawing the viewer into her detached facial expression. Traffic lights reflect off the windshield of her car, with the red stop light illuminating a judgmental glow on her face. The viewer wonders if she regrets her actions. *A Good Wife*'s use of well-composed illustrations blurs the definition of cartoon animation—a fantastic example of motion illustration.

Figure 4.42 These two frames from *A Good Wife* (2012) by W. Scott Forbes use blurring effects to simulate camera focus, a common technique used by filmmakers. By shifting the blur from the foreground to the background, the viewer's attention moves to the bed.

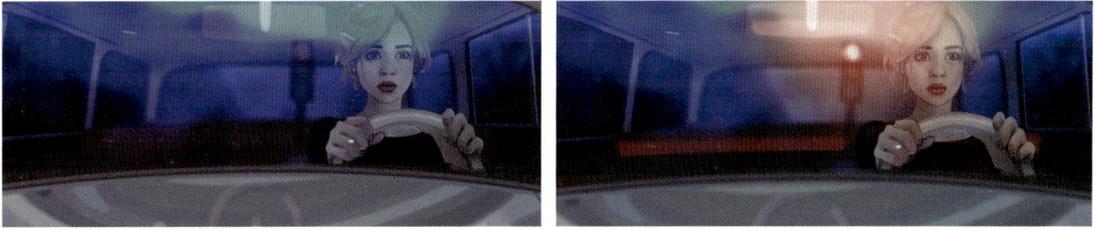

Figure 4.43 Forbes uses lighting effects, like the on-off of traffic lights in *A Good Wife*, to add subliminal meaning to the story. We are left wondering how the protagonist feels about her affair. Does the green light signal that she may repeat her infidelity, or does the red light signal regret?

Foreign Fauna (US)

foreignfauna.com

Based out of Minneapolis, Foreign Fauna is an animation studio and production company founded by directors Alicia Allen and Emory Allen. They create GIFs, commercial spots, and short films with various techniques, including fluid 2D animation, 3D modeling, and tactile motion design. The original narratives in their films combine heart and humor, using the familiar as a starting point for surprising and thought-provoking storytelling. For instance, in *Her Mother's Eyes* (2018), a man takes his dying houseplant to the emergency room. The medics operate without success but present its sapling for the man to bring home. The story plays on universal feelings tied to family, illness, and home gardening, drawing both tears and laughter.

Directed by Emory Allen, Foreign Fauna's *Meditate* (2019) pulls a similar trick, combining tragedy and surprise for hilarious results. In *Meditate*, an overwhelmed man uses meditation to overcome his fears of city living. The short employs a spare graphic style, with textural line work that calls to mind the pencil tests used in animation production. Allen's clever storytelling uses the language of comics to bring the viewer into the protagonist's mind as he begins his meditation practice. Figure 4.44 shows how a comic panel appears from outside of the frame, tightening around the character's face and removing his fears of the external world. The word "meditate" stretches from behind the panel as he begins a series of calming actions.

The word "meditate" continuously squashes and stretches, simulating the protagonist's gentle breathing pattern. Then, three comic panels appear one by one, framing his eye, nose, and mouth along with the audio directions: "close your eyes, breath in, breath out" (Figure 4.45). The overlapping animations of these gestures invite the viewer to participate in the meditation. The film's use of comics language gives it an illustrative quality, and the smart production design shows Foreign Fauna's ability to create original works that stand out from the saturated animation field.

Figure 4.44 Three frames from Foreign Fauna's *Meditate* (2019) show how comic panels are used as a storytelling device, isolating the protagonist as he begins to meditate.

Figure 4.45 These frames from *Meditate* use three comic panels, overlapping one another to highlight close-ups of the protagonist's eye, nose, and mouth in a single shot. The appropriation of comics language in animation offers the best of both storytelling mediums.

Mark Kaufman (US)

drawmark.com

Mark Kaufman is an illustrator and designer known for his political comics. He has produced work for publications including *The New York Times*, *The Progressive*, and *National Lampoon*. He is the creator of the comic strips *American Affairs Desk* and *I Drew This Thing*, as well as ongoing work for *The Nib*, where he also serves as the designer. His comics show off his biting wit with sharp satire, often remarking on politics and social issues. Many of Kaufman's comics feature caricatures of infamous political figures, whose likenesses are captured perfectly in his fluid yet scratchy inking style.

In 2017, *The Nib* produced an animated series with their roster of savvy political cartoonists for the streamer Topic. Kaufman teamed with the animators at Augenblick Studios to create shorts for this series, including "The New President is a Large, Sentient Gun" and a segment in "The Realest Fake News Show Ever."

Kaufman's "Fake News" pokes fun at Donald Trump's limited attention span and the chaos behind the scenes of his administration. In the video, Trump's staffers create a

fake TV news show by knocking a hole in his bedroom wall and performing "the news" behind it, feeding him critical information that would otherwise go ignored. Kaufman illustrates a harried Kellyanne Conway, who assists a construction crew by placing the "TV frame" around the hole in the wall (Figure 4.46). Augenblick's expressive animation combines digital puppets and hand drawing to bring Kaufman's comic strip aesthetic to life.

While this story could certainly be illustrated in a static comic strip, the fine-tuned character animation adds additional content to the cartoon. Figure 4.47 shows a "Fox News" show, with two of Trump's staffers posing as anchors convincing him not to use Twitter and go to bed. The dramatic facial expressions and body movements sell the performance and keep the viewer engaged throughout the video. Kaufman's animated work for *The Nib* combines elements of political comics, editorial illustration, and cartoon animation, which demonstrate the interdisciplinary nature of motion illustration.

Figure 4.46 A caricature of Kellyanne Conway scrambles to create a "TV" out of a hole in the wall in these three frames from Mark Kaufman's "Fake News" for *The Nib* (2017). The frenzied animation in this scene emphasizes the last-minute style of Trump's beleaguered administration.

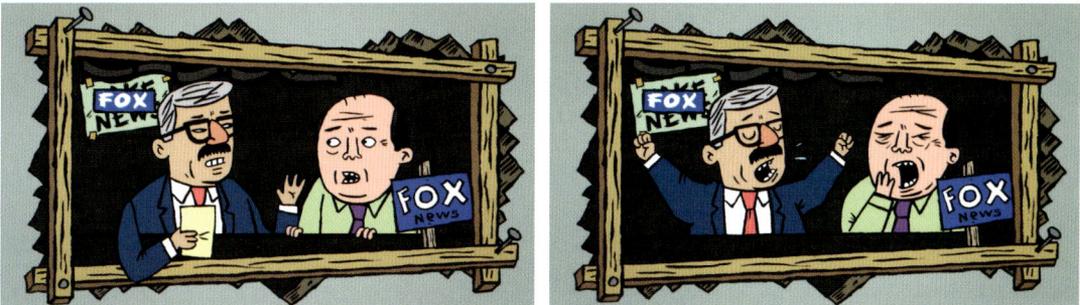

Figure 4.47 Kaufman's "Fake News" characters are brought to life with animation by Augenblick Studios. These two frames show the varied facial expressions and theatrical body movements used in a scene where two staffers persuade Donald Trump that he is ready for bedtime.

Tribambuka (UK)

tribambuka.co.uk

Profiled earlier in the **Editorial, Non-Fiction, and Educational** section, Tribambuka is a cross-market illustrator who creates linear animated films for many purposes, including editorial, advertising, and entertainment. Her mixed-media approach to illustration adapts well to a variety of topics. For instance, her sensitive *Heart of the Nation* video, created for London's Migration Museum, uses a collage of techniques to document the role of immigrants in the health system. In the entertainment category, Tribambuka's music video for "Violet Hum," by the Arthur Brothers, shows off her delightful imagination in an industrial undersea adventure.

Inspired by Heinz Edelmann's art direction on *Yellow Submarine* (1968), "Violet Hum" is animated in a collaged **cutout** style that integrates vintage photos, patterned shapes, fluid frame animation, blooming ink-blots, and live-action film to entertain the viewer. Tribambuka uses many of the kinetic motifs outlined in **Chapter 3**, such as simple character animation and scrolling backgrounds. Figure 4.48 shows an early shot depicting a whale swimming into the scene, its big mouth closing on a television with vocalist Danny Arthur on it. The whale's giant body moves forward, covering the entire screen and revealing three portholes, which Danny sings through. Secondary animation of colorful fish "swim" on top, marrying the live-action video with the graphic illustrations.

Tribambuka uses many animation techniques to bring "Violet Hum" to life. One of the most exciting shots depicts modern dancing by choreographer Kirill Burlov, enhanced by expressive, fluid, abstract animation (see Figure 4.49). Building on a history of experimental filmmaking, Tribambuka uses formal design elements like line, shape, color, and texture as dance partners. The animation explodes and vibrates as Burlov's arms swing across the frame, accentuating every musical beat. This abstract sequence balances wonderfully against the narrative illustration used in other parts of the music video, providing texture to this climactic moment in the song.

Figure 4.48 Three frames from a shot in Tribambuka's music video for "Violet Hum" by the Arthur Brothers show how digital puppets were animated with simple linear movements, such as this whale that moves from the right to the left of the screen.

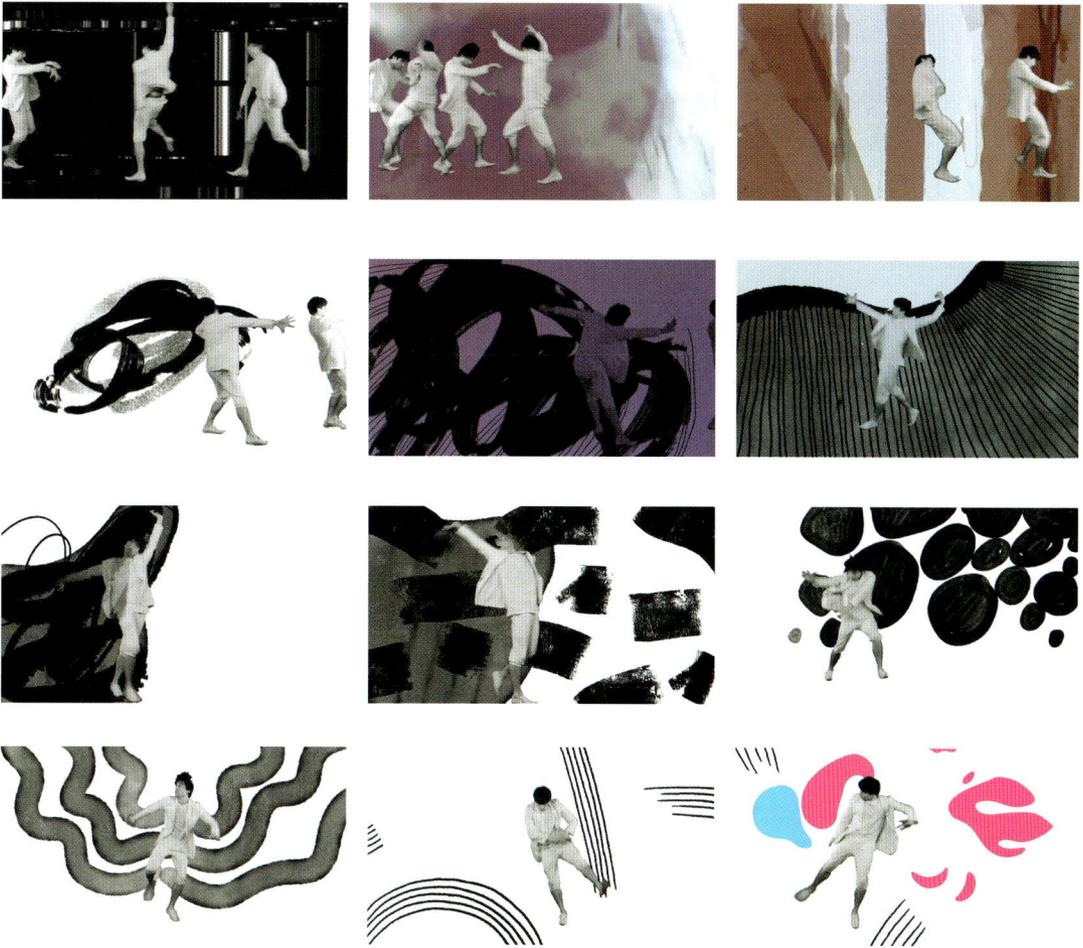

Figure 4.49 These frames show the variety of textures and mark-making techniques that Tribambuka uses in the dance sequence of "Violet Hum." The energetic swooshes, blobs, and bursts synch with the music track to create a unified audio-visual experience.

Undone, The Tornante Company and Amazon Studios (US)

Cartoon animation has a well-established history and practice within film and television media that is mostly separate from the professional illustration marketplace. However, the new era of streaming television has ushered in many original animated properties that share some defining qualities of motion illustration. *Undone* (2019) is one of those properties with a tactile aesthetic that feels like an illustration come to life and a narrative best served by the animation medium.

Created by Kate Purdy and Raphael Bob-Waksberg for Amazon Prime Video, *Undone* utilizes animation as a fundamental storytelling tool, visualizing the protagonist's shattered reality with dramatic scene transitions. It is created with rotoscoped animation, with visuals that call to memory Richard Linklater's animated feature films, which also feature detailed contour drawings traced over performances from live actors. However, *Undone* features a fresh and unique visual aesthetic that sets it apart: specifically, the use of volumetric soft-shading, which adds depth and complexity to the character designs, marrying them to the lighting in the production's oil-painted backgrounds.

This type of detailed visual style in animation is groundbreaking in its complexity, especially for a television series with over six hours of running time. Director Hisko Hulsing orchestrated the sophisticated animation aesthetic with artists at Minnow Mountain

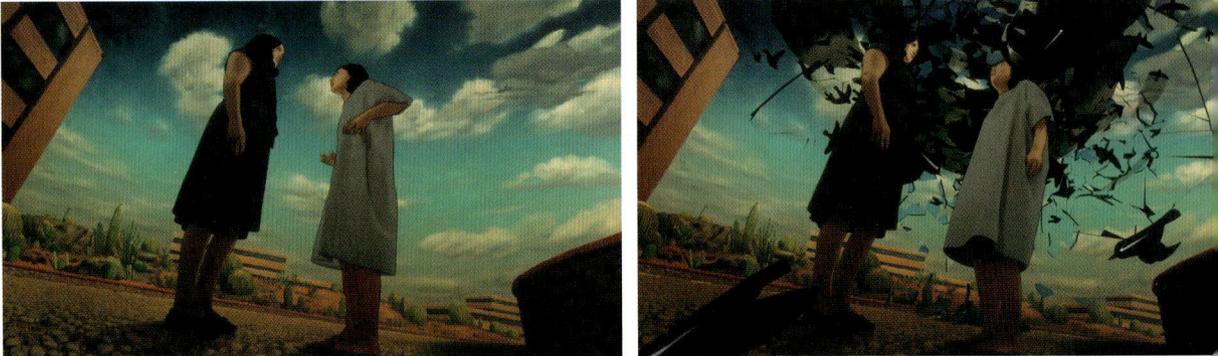

Figure 4.50 These four frames from *Undone* (Season 1, Episode 2) show a fantastical visual effect that supports the story of a woman who moves in and out of dreamlike spaces and visions. The imaginative visual effects are integral to the storytelling.

(US), who produced the rotoscoped line work, and World of Submarine (Netherlands), who painted the backgrounds, colored the characters, and composited the final imagery.

In *Undone*'s first season, the protagonist, Alma, experiences episodes where reality breaks around her, and she travels to dreamlike spaces. The viewer is uncertain whether these episodes are manifestations of a psychological disorder or whether she has a supernatural ability to move through time and space. As Alma learns about her ability to manipulate time, the animation integrates mind-bending effects and clever visual transitions to demonstrate what she feels.

The frames shown in Figure 4.50 exemplify how *Undone*'s dramatic visual effects support the narrative. This moment depicts a scene transition where Alma moves from reality to a dreamy space. Following an argument with her sister, the "real" sky shatters like glass, with shards falling on the sisters, revealing a deep black starfield. A flock of blackbirds simultaneously flies across the camera, aiding the transition as Alma floats through space.

This dynamic scene transition functions as gorgeous eye candy for the viewer. More importantly, it serves the story, helping the viewer relate to the disorientation and disembodiment that Alma experiences. Because the entire production is animated, the art style is consistent across the "real" and "fantasy" spaces. This consistency allows the viewer to believe that Alma's visions are just as real as her waking life. This type of transition is used frequently in season one of *Undone* to visualize Alma's movements in and out of dream spaces, memories, and alternate timelines.

Figure 4.51 Tunde's face is repeated in this dreamy montage from *Undone* (Season 1, Episode 3). This visual effect is reminiscent of those used in Norman McLaren's innovative short film, *Pas de deux* (1968), in which a dancer's movements are superimposed to elucidate the flow of the motion throughout the dance.

Figure 4.52 The subtle and complex performances of actors Rosa Salazar (Alma) and Daveed Diggs (Tunde) are captured by the animators in vivid detail through the rotoscope process in this shot from *Undone* (Season 1, Episode 2).

In addition to transitions, the story also presents in-scene visual effects to help us understand how Alma interprets her nascent abilities. In Figure 4.51, we can see two frames from her disorienting conversation with her boss Tunde. As he speaks to her, the animation is temporally superimposed, giving the sensation of slowed-down time or possibly the indication of multiple planes of existence. The animated medium gives the artists complete control over the composition, taking advantage of the flat areas of color to fuse his faces together. The multiple frames aren't simply faded onto one another, but distinctive facial features, like Tunde's lips, are carefully brought forward to create a sophisticated visual effect.

Notably, the production team intentionally chose the rotoscoping technique for *Undone* because it can clearly communicate nuanced emotional performances via micro facial expressions (Solomon 2019). Notice Alma's subtle change of expression in Figure 4.52. This shot only lasts a couple of seconds but tells the viewer a great deal about Alma's emotional state. It begins with Alma's bright eyes and wide smile, conveying a sense of delirious wonder. She quickly realizes that something is wrong, darting her eyes to the left and then opening her eyelids wide as she stares off into space, showing her confusion. This type of nuanced acting permeates throughout both seasons of *Undone*, allowing the viewer to relate and empathize easily with the characters' complicated emotions as the narrative unfolds.

Henry Bonsu (US)

instagram.com/ henrytheworst

Los Angeles-based Henry Bonsu is a cartoonist, GIF artist, and the creator of Adult Swim's *Lazor Wulf* animated series. His love for independent comics, manga, and psychedelic art is evident in his wacky and wild illustrations. Bonsu's career began with irreverent comic strips and GIFs, which he regularly posted to his Tumblr blog. This personal work led to Creative Director roles at Giphy and Fox ADHD, before developing the *Lazor Wulf* cartoon.

Created by Bonsu with animation by Bento Box for Season One and Six Point Harness for Season Two, *Lazor Wulf* (2019) builds on characters who originated in his webcomics. It follows the adventures of a group of anthropomorphic animal friends in the fictional town of Strongburg, who often interact with an irritable God (see the promotional artwork in Figure 4.53). The style of the show reflects Bonsu's mastery of the GIF format, cleverly integrating mesmerizing loops, such as the persistent flow of God's beard, with expressive character animation. *Lazor Wulf*'s neon universe references classic animation from the early twentieth century along with the random meme culture of our current moment.

Figure 4.53 A promotional image featuring the main characters from Henry Bonsu's *Lazor Wulf*.

A lover of drawing, Bonsu has been experimenting with animation to tell stories since the early 2010s. His extensive body of work explores different aesthetic styles with visual narratives that often depict paradox. In one of his early animated GIFs, for instance, he contrasts the effervescent happiness of a smiley face against the ennui of everyday life (Figure 4.54). In a continuous loop, the droopy smile melts to the ground over and over. Its electric color palette draws the viewer's attention, while the narrative's resigned smile serves as the perfect GIF response to so many text messages.

Some of his recent GIFs play with dabs of lineless color to illustrate the absurd, demonstrating Bonsu's curiosity with different aesthetic styles. For example, Figure 4.55 shows frames from a looping animation of a swimmer. He consumes a perpetual stream of energy drinks, infinitely stroking forward and never arriving at his destination. This contrast of strength versus futility is a reminder of the Greek myth of Sisyphus, and Bonsu's modern depiction of perseverance against overwhelming odds is immediately relatable to the viewer.

In his most recent personal projects, Bonsu has been playing with new characters who recur across many of his animated videos and GIFs. His no-nonsense granny has a dimensional personality; at once confident and terrified. She might ride her bike through the neighborhood while giving everyone the middle finger, or shiver with anxiety over fear of crime. One GIF shows her as a daring investigator, shining her flashlight to the left and right (see Figure 4.56). Her determined scowl morphs into an open-mouthed look of horror. What has she discovered?

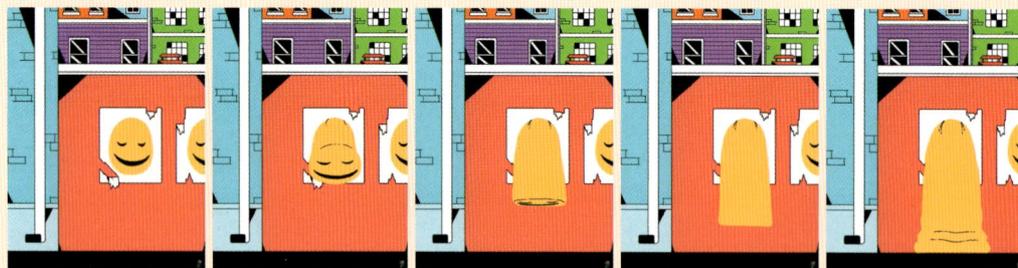

Figure 4.54 Five frames from a GIF made by Bonsu in 2014 show off the smooth hand-drawn animation of a smiley face drooping off its poster. This animation is representative of the strong conceptual contrasts in his work.

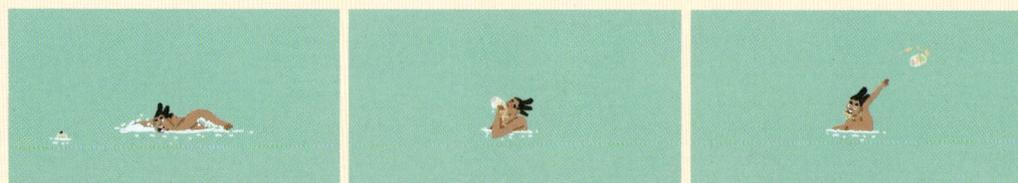

Figure 4.55 Three frames from Bonsu's GIF depict a swimmer's eternal struggle. The looping animation mesmerizes the viewer, who hopes the cartoon swimmer will eventually reach the end of the pool.

Another of Bonsu's recurring characters is Delmonte, a contemporary "daffy" duck intent on causing mayhem wherever he goes. In one animation, he ignites a stick of dynamite in the middle of a village (see Figure 4.57). Inspired by Golden Age slapstick, Delmonte isn't just an irresponsible rascal; he's a homicidal maniac. However, all hope is not lost, as the next GIF in the series shows a neighbor grabbing a fire extinguisher in response to Delmonte's dynamite. The visual style references the wacky distortions and bubbly shapes of early animation, but with sharp edges that support the perilous storytelling. Combining comics and cartoon animation, Bonsu is a modern Winsor McCay, creating dynamic GIFs for the social media audience.

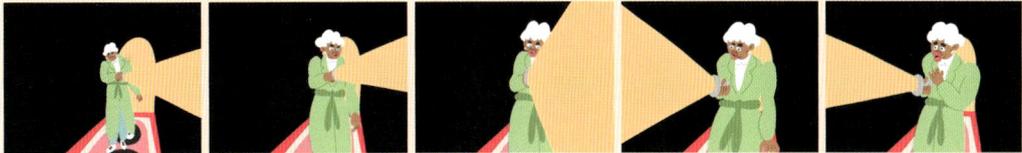

Figure 4.56 This fierce granny, one of Bonsu's recurring characters, shows up in many of his recent GIFs. She investigates a dark hallway with her flashlight. In just seconds, her body language goes from fearless to terrified, showing off Bonsu's expressive character animation.

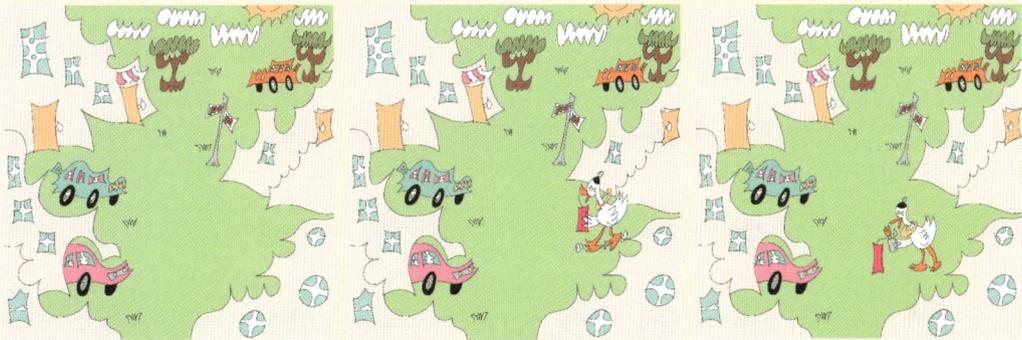

Figure 4.57 Three frames from a 2022 GIF show Bonsu's "Delmonte Duck" lighting a stick of dynamite in a residential area. The sharp-edged, warped drawing style supports the narrative of Delmonte's twisted behavior.

Tell us about your work. How do you describe your voice as an illustrator?

Baritone is how I would describe my voice as an illustrator. Honestly, I try not to take it seriously and draw what I enjoy.

Your background includes work closely associated with illustration, like comics and editorial, as well as the animation industry. How do you see the relationship between illustration and animation? Where do you see yourself within these disciplines?

It's so hard for me to separate the two. Whatever I illustrate is also something I must be able to animate.

Can you tell us about your show *Lazor Wulf* and how it came to be?

It's an 11-minute cartoon that's too aware that it's an 11-minute cartoon. The goal with *Lazor* was to create new mythology in the silliest way possible. It started on my Tumblr as a comic that I was drawing for fun, I was disrespectful to continuity, and the style would change every strip.

The visual and kinetic style behind *Lazor Wulf* is so inventive and doesn't feel quite like any other animated cartoon. In some ways, it reminds me of GIF art, such as the continuous flow of God's beard. What are some of the influences and intentions behind the show's aesthetic?

Those kind words are greatly appreciated! Well, I had a bunch of jobs making GIFs (FoxADHD, Giphy), so I can say that it's definitely a big inspiration. GIFs, UPA animation, and a bunch of obscure media.

Many illustrators work alone, communicating with their clients from a distance. However, the animation industry requires close collaboration. What have you enjoyed most about the collaborative nature of the animation industry? Do you think there is anything the independent illustrator can learn from this?

Most definitely! There's a lot I learned working with other talented artists. Trusting folks and allowing them to help make your ideas more digestible for an audience outside yourself is important to me.

What special powers do you think an illustrator can bring to an entertainment project vs. an animator?

Oh man, this one is difficult. For me, the goal is to make a cool product, and as I said earlier, I have trouble separating the two. To me, all illustrators are capable of being animators, and all animators are capable of being illustrators.

You've made a prolific number of animated GIFs over the years [on your Tumblr and Instagram]. What qualities do you think makes for a good GIF?

Fun. When you can tell the creator of the GIF had fun making it.

What tools do you use to create your animated work? Is there any technology you are experimenting with or eager to try?

I use Photoshop for personal work. I originally went to college for 3D and have been debating on messing around with Blender, but I don't know if I have the patience for it anymore.

Are there any motion illustrators or animators who inspire you?

Here's a couple, Jared D. Weiss, Natalie James, Cameron McClain, Abby Jo Turner, Jonny Payne, Sam Maurer, Jackie Snyder, Loveis Wise, and Rotimi Olowu.

Do you have any predictions for where the discipline of illustration is headed? What should illustrators be preparing for?

It's just going where it's going, and I'd make sure you're creating work that you enjoy and speaks to you. I mean, that's what I tell myself to keep from losing my mind.

Do you have any advice for illustrators looking to get started with motion?

First, get started, put the work out there, and then keep putting more work out there. Try really hard to get what's in your head on that paper, Cintiq … whatever you create with.

Figure 4.58 Various character designs for *Lazor Wulf* demonstrate Henry Bonsu's irreverent style.

Explorations

Boundary-breaking art challenges the norms
of traditional illustration through media play,
technological experimentation, and unconventional
applications.

Forms:
- Commercial works
- Social media posts
- Passion projects
- Technical experiments
- Fine art exhibitions

Features:
- Novel experiments with media or technology.
- Takes risks and embraces play.

The illustrators featured in this section aren't bound by traditional markets; rather, they create illustration and new-media artwork through playful, innovative, and novel experiments with media. Nevertheless, these artists continue a rich tradition, following in the footsteps of the groundbreaking artists who first experimented with film in the 1920s, the illustrators who invented cartoon animation in the 1900s, and the inventors who made early animation devices as far back as the 1600s.

These projects may be created for commercial purpose or simply to scratch an itch, using various techniques, from Rob Wilson's lo-fi cut-paper animation to Jakub Javora's advanced digital synthesis. They play for the sake of play, create new ways of using existing tools, combine media in surprising ways, and invent new technology that advances the field of computer graphics.

This section is meant to inspire you to try new ways of making while showcasing the breadth of outcomes, styles, techniques, and platforms that make up motion illustration.

Andy Potts (UK)

andy-potts.com

Andy Potts uses 3D animation and visual effects software to bring his dynamic illustrations to life with motion. He has produced work for clients internationally, including the BBC, *The Economist*, IBM, *Nature*, *Science*, and Universal Music Group. His colorful work combines CG visual effects, photography, and 3D models to create images and videos that are both surreal and photorealistic. His conceptual approach is well suited for scientific illustration, where he uses abstract, symbolic imagery to represent complex topics.

Potts has illustrated several covers for *BBC Science Focus* magazine, using Adobe After Effects and Cinema 4D to create animated videos for the digital editions. In his utopian cover illustration "A Cure for Everything," he uses a simple camera movement to follow a stream of colorful rectangles, through gates of monumental human heads, towards an all-knowing light (see Figure 4.59). Representing DNA, the stream of color blinks in and out, with an elegant animation reminding of visual effects in big-budget films. This conceptual illustration is thoughtfully designed to show off the best features of the animation software, employing a keyframed camera movement to show the depth of space and form of the 3D models. Created to function both in print and in the digital Apple News edition, Potts carefully composed the illustration with room for the masthead and headlines.

His cover illustration for "The Great Moon Rush" also uses 3D animation and visual effects to take the viewer on an epic journey (see Figure 4.60). As lunar landers rotate in orbit, the camera dynamically shoots toward the moon, giving viewers the sensation that they are rocketing through space. Potts combines a photoreal 3D moon, graphic shapes, and a paint-splatter star field. The limited color palette of purple, red, and gold unifies the collaged elements into a complex and sophisticated visual style. Potts directly references the graphic spiral design of *Time*'s "To the Moon" cover (1969), stretching his spiral dimensionally through the depth of space. As in "A Cure for Everything," the camera movement is cleverly used to create the primary animation in this video. In a marketplace dominated by painters, Potts distinctively uses 3D animation software to create exciting conceptual imagery.

Figure 4.59 Frames from an illustrated cover by Andy Potts for *BBC Science Focus*, titled "A Cure for Everything." Inspired by the surrealism of progressive rock album art, he uses 3D animation software to conceptually illustrate the sub-headline, "We can now alter our DNA quickly, cheaply, and accurately. Will it mean a future without illness?" His explorative use of 3D and visual effects software is distinctive in the illustration market.

Figure 4.60 Frames from "The Great Moon Rush" by Andy Potts for *BBC Science Focus*. This cover illustration video transports the viewer through space, using Potts's signature collage of media and texture.

Rob Wilson (US)

robwilsonwork.com

Living in New York, Texas-native Rob Wilson is known for instilling his sly sense of humor into witty illustrations. He produces work for advertising, editorial, and publishing purposes, with a client list that includes Vespa, Todd Snyder NY, Design Within Reach, and Valentino. He also created the surreal imagery for the popular podcast *Welcome to Night Vale* and its associated merchandise. When producing illustrations for commercial clients, Wilson mainly works in two visual styles: a geometric vector approach and a humanist Sharpie-marker look. However, he is a prolifically curious illustrator who continues investigating new tools and methods.

An active social media user, Wilson uses Instagram to promote his latest commissions and share clever doodles. While he typically collaborates with animator Sam Toerper of Freehand Studio for his commercial projects, Wilson plays with motion in

Figure 4.61 In these frames, Rob Wilson uses cut-paper to animate an ocean wave hilariously sweeping away a sunbather's shorts. Filmed with an iPhone, Wilson uses his wood desk as a stand-in for sand.

his personal explorations. For example, he filmed cut-paper animations with the camera on his iPhone in a series of experiments from 2018.

Figure 4.61 shows several frames from his short video, "Rising Tide," which illustrate the legs of a figure sunbathing on the beach. Wilson manipulates the "ocean" with his hands, bringing the wave over a figure's legs. As the tide recedes, it comically pulls the figure's swimming trunks away. The magic in Wilson's work comes from his clever ideas. Using simple tools, he not only tells a story, but makes a joke with a punchline. His handmade doodles and DIY approach have an effervescent charm, demonstrating how accessible animation can be.

Aubrey Longley-Cook (US)

aubreylongley-cook.com

Aubrey Longley-Cook is a Los Angeles-based artist who uses hand-stitched embroidery to create stop-motion animations. His work has been shown at LA's The LODGE, the Leslie-Lohman Museum in New York, and the Museum of Quilts and Textiles in San José. He often recreates images from pop culture, such as detective Jessica Fletcher from the television show *Murder She Wrote*, drag superstar RuPaul, and scenes from movies. While he does not identify as an illustrator, his GIFs function similarly, transfixing the viewer with a novel combination of traditional craft, pop culture, and digital media.

Longley-Cook trained as an animator during his undergrad studies and took up stitching as a personal outlet. In an interview with *mr x stitch*, Longley-Cook describes the "soothing, calming, meditative" process and pace of embroidery, a sharp contrast to the demands of the animation field (Chalmers n.d.).

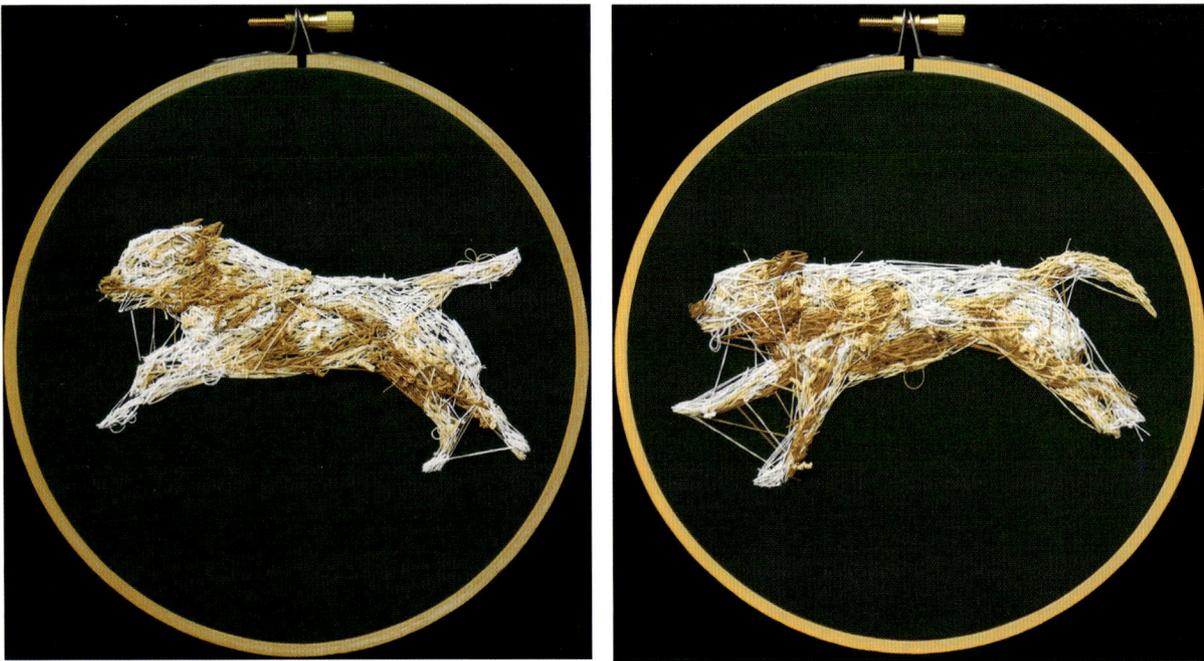

Figure 4.62 Four frames from Aubrey Longley-Cook's *Runaway (back view)* GIF show the artist's hand through the tangled threads used to create his delicately crafted embroidery. The unexpected combination of handmade craft with digital animation piques the viewer's interest.

His animations are typically made by assembling photographs from hand-stitched images into GIFs. In *Runaway*, he hand-stitches a dog's run cycle, each image framed in an embroidery hoop. His beautifully crafted imagery uses organized stitches that flow with the dog's body, sewn with only a few thread colors to create a tight color palette. In Figure 4.62, *Runaway* is pictured from the back, revealing the gorgeous chaos of its hand-stitched threads. Longley-Cook leaves the connecting threads intact, which hint at his process. The contrast of hand-stitching with digital animation is delectable, giving the viewer an entirely new aesthetic while creating connections between different worlds of art.

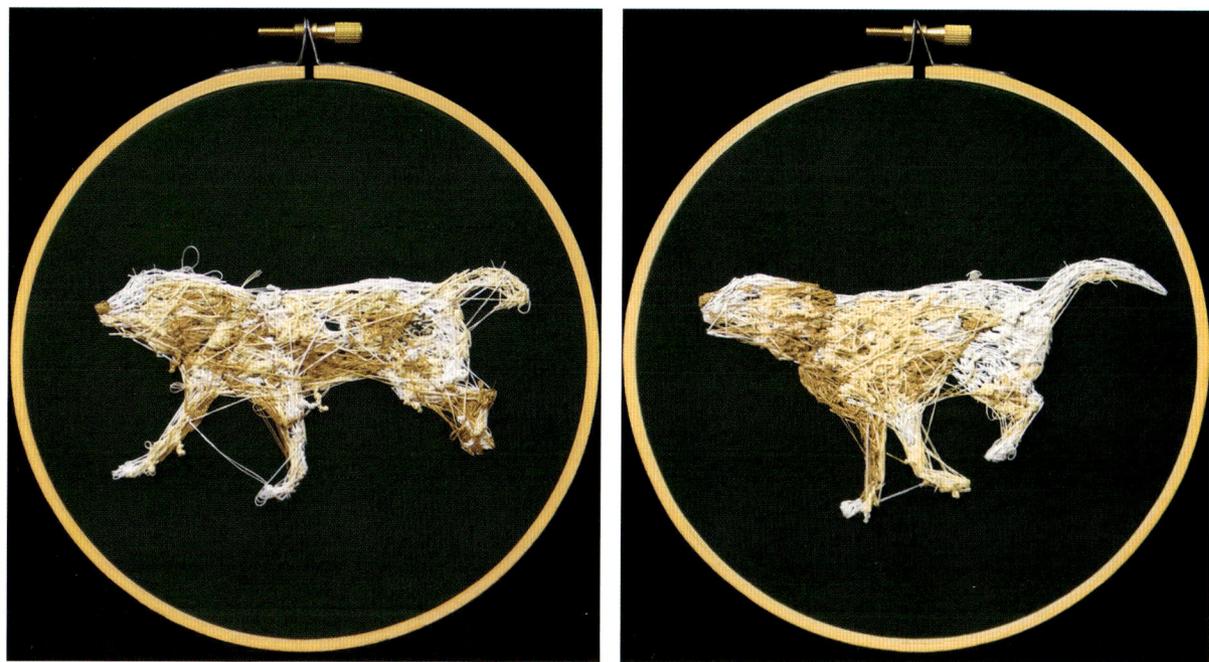

Ardhira Putra (Indonesia/Malaysia)

lynkfire.com/ArdhiraPutra

Ardhira Putra is an Indonesian illustrator and motion designer based in Singapore. He specializes in illustration for the independent music scene, creating illustrations and animations for global artists, including Epik High, Macross 82-99, and DJ Didilong. One of his best-known projects is his collaboration with TikTok music star Englewood, in which he created visualizers for each song on the *Yacht World* album, along with a complete music video for its track "Crystal Dolphin." Inspired by vintage game consoles and cartoons like *Astro Boy* and *The Adventures of Tintin*, Putra's colorful work uses dynamic 3D camera movements to visualize a retro animation style.

Putra has recently explored the non-fungible tokens (NFT) marketplace through platforms like SuperRare and Foundation. With NFTs, artists can "mint" unique cryptocurrency and sell them digitally. In 2022, he was invited to collaborate with Samsung on a promotional NFT for the brand, demonstrating how advertisers experiment with new technology to reach their audience.

His nostalgic visual voice creates a delightful contrast with cutting-edge crypto. For instance, his "Dazzle" NFT animated video references vintage equipment like gaming consoles, CD players, Tube TVs, and VHS tapes. Like Andy Potts, Putra uses simple camera movements that show off the depth and form of his 3D models (see Figure 4.63). An array of secondary animations overlay fantastical moving patterns and graphics in a transfixing loop. His referential work is a pastiche of the cartoon and computer history that enabled motion illustration in the first place, experimenting with new media to explore what else illustration might become.

Figure 4.63 Two frames from Ardhira Putra's "Dazzle" NFT show the most extreme camera keyframes. The point of interest loops from left to right, showing off the depth of the 3D models.

Jakub Javora (Czech Republic)

javoraj.com

Jakub Javora is a Czech artist and animator based in Prague. He is the founder of Paranormal Studio, specializing in concept art, illustration, animation, VFX, and matte painting. Javora's experimental work explores how to bring a painterly approach to video, savoring in chewy brush strokes and impressionistic dabs of color.

He also initiated the company Secret Weapons and the development of its innovative EbSynth software, which can restyle video footage based on artist-made keyframes. EbSynth has a variety of potential applications, like photorealistic de-aging or quick "cartoon animation" from live-action film. Javora and his team at Paranormal use EbSynth, along with other proprietary tools and techniques, as part of a robust workflow to create animations that feel like fantasy paintings come to life.

Figure 4.64 shows frames from an input video of an actor playing a caveman, along with output animation where every frame feels hand-rendered. Javora's lush painting imagines an environment for the caveman while also bringing a sophisticated visual style to the figure. Applied to footage, Paranormal's workflow brings to life what illustrators do best: illustrating stories with evocative style and mood. The process could potentially be used

Figure 4.64 In *Caveman* (2020), Paranormal's workflow generates a fully painted animation from a live-action video. These are the input video frames and the output animation frames that are "synthed" from Javora's paintings.

to create a fully "painted" movie by tracking illustrations onto footage of live actors.

As part of Paranormal's workflow, the team plays with the possibilities within industry-standard animation software to create motion illustrations. For example, their *Medieval Knights* experiment places layers of illustrated figures in a 3D space, creating the illusion of depth as the camera moves forward. This is emphasized as the rays of sunlight and falling snow dynamically follow the camera movement for an exciting parallax effect (see Figure 4.65 and Figure 4.66).

Paranormal's experiment, "Jungle Woman" (2020), is an excellent example of the variety of techniques used in their workflow, which combines live-action footage, digital painting, and 3D environments (see Figure 4.67). Here, footage of a live actor was repainted into a fantasy creature and placed into a dimensional space. Beyond restyling footage of people, the process can also be used to adjust backgrounds. The base for this environment was rendered in 3D, and then a style transfer was completed to produce the final look. Paranormal Studio's innovative research with digital graphics and technology brings a rich, tactile painting style to life through animation.

Figure 4.65 From a collection of experimental shots titled *Medieval Knights* (2022), this animation frame is created with a combination of hand-painted art, 3D software, and dynamic simulation.

Figure 4.66 This behind-the-scenes look at *Medieval Knights* shows how the layers of painting and 3D models are arranged in the animation software Blender. With this setup, it is possible to keyframe multiple camera movements to render many different shots.

Tell us about your work. How do you describe your voice as an illustrator?

I started as a concept artist and matte painter for movies and games. I was very industry-driven, focusing mostly on design for these media without a strong individual message. Design is a great discipline, and I even founded a studio for this art service. Now, though, I am trying to focus more on topics that interest me, like evolution, relationships, sex, religion, science, or violence …

Your work blends elements of illustration, animation, cinema, motion design, special effects, and more. How do you identify as an artist within these disciplines?

Based on the ideas developed in the Renaissance, I think the spirit of classical fine art disciplines is still living in movie and game industries. In contemporary fine art, you don't need to be "good" at drawing perspective to succeed there. But in the entertainment industry, you are still aiming for pleasing or beautiful results from a classical point of view. You would still use knowledge of anatomy, perspective, composition, staging, lighting, color theory, storytelling, etc. … all the Renaissance, Baroque, classical stuff. It's based on beautifully executed, highly skilled art craft. I always respected this craft, so I think these people from all these disciplines you've mentioned identify, at least subliminally, with this kind of Renaissance art and technology spirit.

What qualities do you think make for a compelling motion illustration?

I am still searching for an ideal look and feel in this area. I am personally trying to find a balance between a totally "handmade" approach, which is basically frame-by-frame animation, but for me, it usually looks too chaotic.

The opposite style, which would be a typical 3D scene with a painting style mapped onto models, usually looks too stiff and rigid. I believe the answer for me would be somewhere in the middle, like a hybrid between.

Where did the idea to create EbSynth come from? Has your experience with this technology influenced you as an artist? If so, how?

My work and inspiration have always been cinema driven, but at the same time, I wanted to stay in the realm of painting and drawing. Animated movies would seem like an option, but for that, I would need to conform and introduce some sort of heavy stylization to deal with the workload of this medium. So, to keep the complexity of style, I am searching for and developing strategies to animate it without conforming. "Synthing" is one of them. I got the idea to transfer motion into a painting, directly from video. My friend, a CG scientist, helped me create the first prototype of the tool, which later developed into the EbSynth app.

You've done much experimentation with converting live-action video into a painterly animated style. What type of projects do you imagine being created with this technique?

I see myself as a big experimenter in the CGI field, always trying to find some new approach and technique. Sometimes it's even contradictory because I'll do lots of experiments but won't produce anything … I do that for a purpose, though, as I am trying to move into film work. This technique was basically my personal approach how to achieve a painted style of film. The best type of project to use this technique would be something very imaginative, where you can paint almost anything.

▶

Besides EbSynth, what other tools do you use to create your animated work? Is there any technology you are experimenting with or eager to try?

I'm always trying to experiment with things that capture my interest, like photogrammetry, for example. At the same time, I try to keep my core toolset as limited as possible, i.e., one 3D app, one 2D app, and one compositor. It would be cool to try some neuro-generated stuff based on prompts. There is always something new and interesting.

Your studio, Paranormal, brings together the talents of several artists. What benefits have you experienced from working with a team?

Working with a team is about responsibility. You basically entrust your hard-earned reputation in someone else's hands. So, it's not only about your art skills, but also about social skills and good leadership. The benefit is that if you work together to build a strong team, all the members benefit significantly, as opposed to a solo approach.

Do you have any predictions for the future of illustration? What should illustrators be preparing for?

Well, I am sort of curious because I'm seeing the first results from new neuro networks that make pictures based on written text. My friend from the CG scientific community, who I really respect, believes this technology could transform the industry in a big way. So, I am curious about what will happen. Is it the future? Certainly it is, but I thought it would come much later. Illustrators should prepare to receive briefs full of neuro-generated ideas, with a request to remake or polish them.

Are there any animators who inspire you?

I get artistic inspiration from creators like Karel Zeman, Andy Warhol, Stanley Kubrick, and Craig Mullins …

Figure 4.67 Created as a proof of concept for a workflow to create moving concept art or cinematic previsualization, Paranormal's "Jungle Woman" (2020) synthesizes live-action footage of an actor, as well as a 3D modeled environment, into a fantastical painting style.

More Illustrators to Discover

Here are more amazing illustrators creating boundary-smashing work with their unique visual voices. Check out their portfolios online to see their illustrations move:

- Carlos Alegria (Spain): **alegriamotion.com**
- Minju An (Korea): **minjuan.work**
- Igor Bastidas (Venezuela/US): **igorbastidas.com** (see Figure 4.68)
- Chi Birmingham (US): **chibirmingham.com**
- Lilli Carre (US): **carreillustration.com**
- Brandon Celi (Canada): **brandonceli.com**
- Karolin Chen (Sweden): **karolinchen.com**
- Andrea Chronopoulos (Greece/Italy): **andreachronopoulos.com** (see Figure 4.70)
- Mark Conlan (Ireland/Australia): **markconlan.com**
- Owen Davey (UK): **owendavey.com**
- Christopher DeLorenzo (US): **chrisdelorenzo.com**
- Xoana Herrera (Argentina/US): **xoanaherrera.com**
- Stephanie Hofmann (Germany/UK): **stephaniehofmann.co.uk** (see Figure 4.69)
- Tara Jacoby (US): **tarajacoby.com**
- Allison Kerek (US): **allisonkerek.com**
- Manshen Lo (UK): **manshenlo.com**
- Christina Lu (US): **cplu.tumblr.com**
- Jeca Martinez (Philippines/Canada): **jecamartinez.com**
- Uno Moralez: (Russia): **unomoralez.com**
- Alyssa Nassner (US): **alyssanassner.com**
- Cole Ott (US): **coleottart.com**
- Lara Paulussen (Germany): **larapaulussen.de**

Figure 4.68 Frames from "Outdoor Voices" animated GIF for *The New Yorker* by Igor Bastidas.

- Chris Piascik (US): **chrispiascik.com**
- Yoshi Sodeoka (Japan) **sodeoka.com** (see Figure 5.1)
- Raul Soria (Spain/Germany): **raulsoria.de**
- Otto Steininger (Germany/US): **ottosteininger.com**
- Sachin Teng (Taiwan/US): **sachinteng.com**
- Rafael Varona (Peru/Germany): **rafael-varona.com**
- Juliana Vido (Argentina): **julianavido.com** (see Figure 5.2)
- Zhong Xian (Taiwan/UK): **zhong–xian.com**
- Jennifer Zheng (UK): **jenniferzheng.co.uk**

Many more illustrators produce work for these agents, studios, and collectives:

- Agent Pekka: **agentpekka.com**
- BUCK: **buck.co**
- The Jacky Winter Group: **jackywinter.com**
- The Line: **thelineanimation.com**
- Moth Studio: **moth.studio**
- Nomint: **nomint.com**
- Remembers: **remembers.fr**

Figure 4.69 Frames from "The Pet" animated GIF by Stephanie Hofmann.

Figure 4.70 Frames from "Welcome to the YOLO Economy" animated GIF for *The New York Times* by Andrea Chronopoulos.

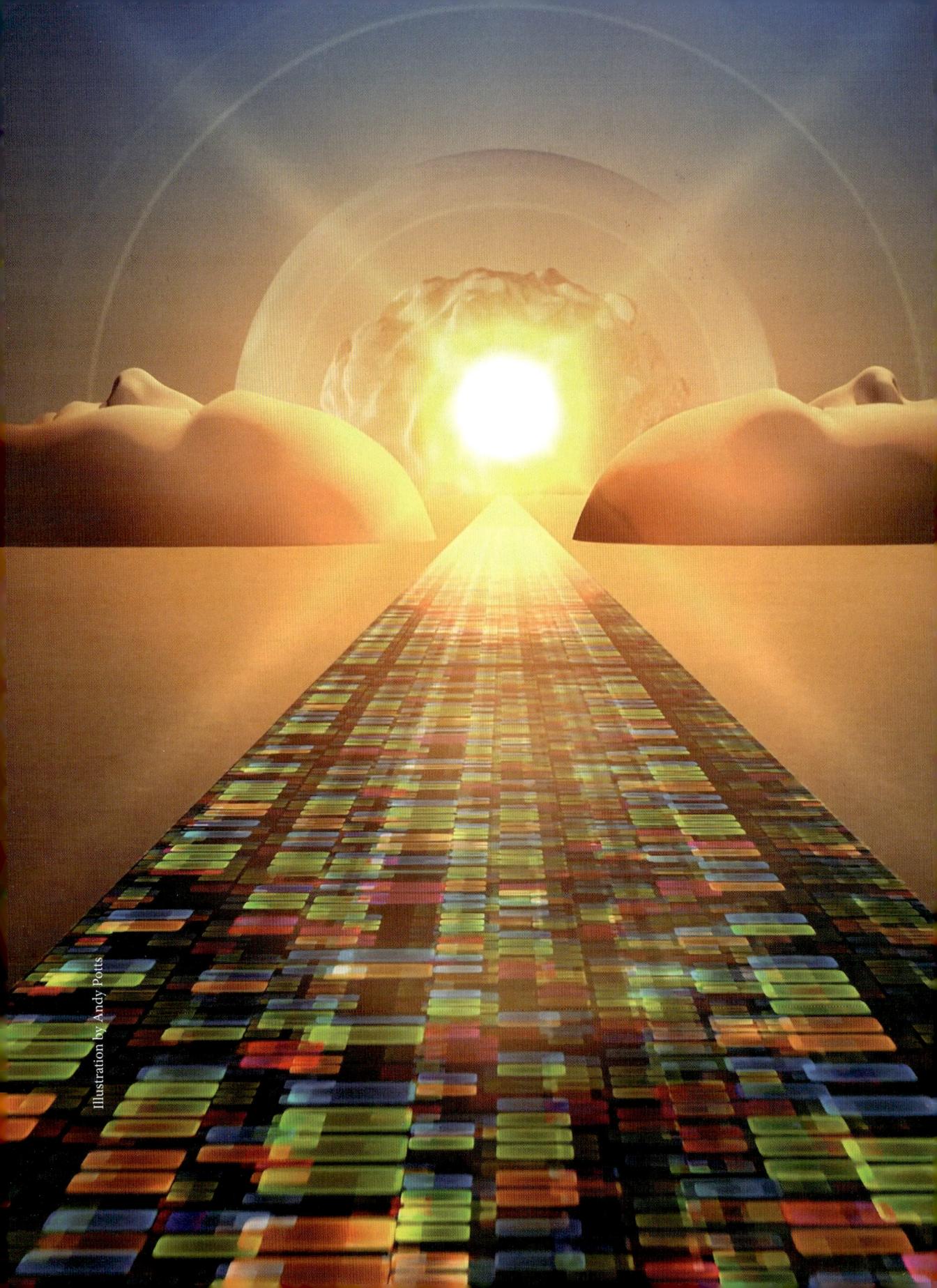

CHAPTER 5

Technical Considerations

This chapter provides general information about tools, materials, software, and file formats that will be referred to in the next chapter, **Exercises and Projects**.

Analog Tools

Sketchbook

Great images start with great ideas. Use your sketchbook as the first step with every illustration to brainstorm concepts and experiment with visual compositions. Resolve your idea as a sketch before you jump into the time-consuming animation process.

Traditional Media

Traditional drawing and painting media can be used to make motion illustrations. Animation techniques, like cut-paper and stop-motion, can be created entirely with your phone's camera and handmade imagery. You may also wish to integrate dimensional media like clay, fabric, or collage materials. Animators have long been experimenting with non-traditional materials like sand to create stop-motion animation; don't be afraid to try new things.

Digital Hardware

Computer + Graphics Tablet

The time-honored approach to digital illustration uses a personal computer with a graphics tablet. This is the most powerful and versatile setup for digital animation because you can choose from many full-featured software packages to suit your needs. Wacom is the leader in graphics tablets, which allow you to "draw" on a pad, which is translated to your computer screen. They offer models to fit most budgets, but keep in mind that the introductory models often don't have the deep levels of pressure sensitivity that allow for sophisticated mark-making. (Other manufacturers produce graphics tablets at a more competitive price, so it's worth shopping around.)

Tablet Computer

Tablet computers are popular among illustrators because they enable drawing directly on the screen, with a feel that is most similar to analog media. Many illustrators like working with Apple's iPad for its streamlined interface and intuitive graphics applications, like Procreate. The iPad's downside is that it has a limited choice of illustration and animation software, and it lacks the versatility and power of a computer. However, it is also possible to get a powerful PC in tablet form, like the Microsoft Surface, which allows the user to run the same software as a desktop PC.

Digital Software

2D Illustration and Animation

- **Adobe Photoshop:** One of the most robust bitmap painting applications available. Its easy-to-use "Timeline" feature can be used to create GIFs and work with video.
- **Procreate:** Only available on the iPad, illustrators love Procreate's intuitive interface and its tactile brushes that resemble traditional media. In addition, it has a simple frame-animation tool called "Animation Assist."
- **Clip Studio Paint:** Works similarly to Photoshop, but many illustrators prefer its drawing tools which were designed specifically for comics. It has a fully featured animation system accessible through its "Animation" menu.
- **Adobe Illustrator:** A vector drawing tool ideal for typography and shape-based images. It does not have native animation features, but its layered files can be imported into other animation software.

2D Animation

- **Adobe After Effects:** This keyframe animation software is popular among motion designers and visual effects artists, offering many great tools for the motion illustrator. Digital puppets prepared as layered PSD or AI files can be imported for keyframe animation. Its camera system allows 2D art to be placed as planes in a 3D space for dynamic camera movement and parallax effects.
- **Toon Boom Harmony, TV Paint, and Adobe Animate:** These hand-drawn frame-animation applications are used in the entertainment industry and should be considered for those serious about cartoon animation with multiple scenes. They have different strengths and price points.
- **Adobe Premiere:** Adobe's video-editing software can do some limited effects and text treatments. For the motion illustrator, it is helpful for editing longer projects.

3D Modeling and Animation

- **Autodesk Maya, Maxon Cinema4D, and Blender:** These powerful 3D packages offer robust tools for modeling, texturing, lighting, animation, and rendering. Each has different strengths and price points.

- **Pixologic Zbrush, Autodesk Mudbox, and Nomad Sculpt:** These 3D digital sculpting software platforms offer an organic modeling experience similar to traditional sculpting. Zbrush is the industry standard in gaming and visual effects, with the most robust toolset. Nomad Sculpt is made for tablets, with an iPad and Android version available.
- **Luxion Keyshot:** This rendering software is made for product visualization with photorealistic materials and lighting. It is not a modeling or animation software; rather, it is meant to be used along with other apps, like Zbrush, to render final illustrations.

File Setup

Bitmap vs. Vector

Digital images can be prepared as bitmap or vector files. Bitmap images are made of a grid of colored squares (pixels) that create an image. They are best used for detailed images that feature texture and gradation—they are excellent for artwork that mimics traditional media. Denser grids of pixels allow for larger images but increase file size.

Figure 5.1 Frame from "What Happens When Russian Hackers Come for the Electrical Grid" animated GIF by Yoshi Sodeoka for *Bloomberg Business*.

Figure 5.2 Frames from "Midsummer Night's Dream" animated GIF by Juliana Vido.

Vector images, on the other hand, are made of mathematical equations that define the image's shapes and lines. Their best assets are precise shapes and infinite scalability—they can be enlarged or reduced without losing quality. The ability to scale is handy for close-up "zooms" and for re-using digital puppets in many scenes.

File Size

The size of a file refers to how many bytes of storage it takes up. Smaller files will transfer across the web more quickly, so keeping file sizes small through optimization is an important step.

Image Dimensions and DPI

Not to be confused with file size, dimensions are the width and height of an image, measured in units like inches, centimeters, and pixels. In print media, the relationship between a physical unit (inches or cm) and dots per inch (DPI) creates the appropriate pixel density for a high-quality print. In digital media, however, pixels are all that matter. Full HD video is 1920×1080 pixels, so any art produced larger than this will generally appear sharp in digital animation. Newer screens support greater pixel density, with 4K (3840×2160) and 8K (7,680×4,320) becoming more popular.

Different software use various terms for dimensions, including image size, canvas size, composition size, and so on.

Aspect Ratio

Aspect ratio is the proportion of the width to height of an image, written as W:H.

- 16:9 is the most common aspect ratio in digital media and is a widescreen format. It is used for TVs, most computer monitors, and many smartphones and tablets. Most content for streaming platforms is 16:9 to maximize the screen space.

- 3:2 and 4:3 are rectangular aspect ratios common in photos and film.
- 1:1 is a square format popularized by Instagram.

When making an animation to be shared across multiple networks, it is worth considering how your video will crop in different use cases. Major advertisers often design images to fit several aspect ratios—starting with the largest format and identifying smaller active areas within it to be used for other aspect ratios.

Frame Rate

Measured in frames per second (fps), frame rate refers to the number of frames or images displayed per second in an animation or video. Historically, frame-by-frame cartoon animation was made at 24fps, which is considered the minimum number of frames required to fool the eye into seeing fluid motion. Digital media is often recorded at 30fps and is advised for most digital animation projects. High frame rates, such as 60fps, have come into vogue for sports and video games to capture every bit of action, but this often requires more work and results in larger file sizes, making it unsuitable for most animation. Low frame rates, like 6fps or 12fps, give video a choppy look which some animators prefer because it feels more like moving illustrations.

File Formats

Working Formats for Digital Art and Asset Creation

- **PSD (Photoshop Document)** is a versatile bitmap file format widely used in image-editing software as a working file. They support transparent backgrounds and may contain multiple layers, making them suitable for digital puppets with many pieces or parallax backgrounds with different layers of depth.
- **TIFF (Tagged Image File Format)** is a bitmap file format that is lossless, meaning that it preserves all data in the original image without any loss of quality. TIFF can support layers, but they are best used for flattened hi-res artwork, like background paintings. Additionally, they can store color profiles, which makes them excellent for delivery of final artwork to clients, like the print version of an illustration for a magazine.
- **PNG (Portable Network Graphics)** this file format is a lossless bitmap format, like TIFF. It is designed for the web and supports transparency. In digital animation, layers from a working file can be exported into individual PNGs for use as sprites.
- **AI (Adobe Illustrator)** is the default vector file format for Adobe Illustrator. These files can hold different layers, which can be imported into animation software, like After Effects, for use in digital puppetry.
- **SVG (Scalable Vector Graphic)** is a vector file format that can hold layers of artwork that can be animated. They can be displayed by web browsers and are useful for interactive applications.
- **MOV** and **AVI** are standard video files that can save lossless video and are good intermediary files to render final animated videos. However, the files tend to be

too big to share online and have limited support in web browsers. They should be compressed as a web-friendly video file for delivery, like an MP4.

Final Formats and Optimization for Delivery and Publishing

- **GIF (Graphics Interchange Format)** is a web-friendly image format that may contain animation frames played in a loop. Some file specifics:
 - **Limited color palette:** They can only display a maximum of 256 colors. It is best to design around limited color palettes to circumvent compression issues during the export process.
 - **Dithering:** To create tonal variation and gradation, GIFs use dithering patterns where patterns of colored pixels are optically mixed in the viewer's eye. "Diffusion" dithering is the most organic and imperceptible, while "pattern" dithering gives a retro vibe with an ordered arrangement of pixels.
 - **Transparency:** Transparency is supported, allowing GIFs to be layered in web designs to create complex animations.
 - **Optimization:** GIFs can quickly balloon to gigantic file sizes unsuitable for web-sharing. Photoshop's "Save for Web" feature allows fine-tuned optimization and is advised as a final processing step for all GIF animations (navigate to "Export > Save for Web" in Photoshop). Optimize each animation carefully, balancing the dimensions, frame count, and color palette. Try to get the exported file below 1MB in size, starting by decreasing the image dimensions to 800 pixels or smaller on the longest side. You may also need to reduce the color count or consider removing animation frames. (The file size can technically be larger, but anything more than about 5MB is going to lag during download—aim for the smallest possible.)
- **MP4 (MPEG-4)** is a multimedia container format for video and audio that is widely supported by animation software, video players, and web platforms. They can be optimized according to several variables, like dimensions, codec, and bitrate, to produce high-quality video at a small file size.
 - **Optimization**: Videos should be compressed before sharing them online. The H.264 codec is one of the most popular compression methods because it can produce small file sizes without significant loss in video quality. Adobe Media Encoder is recommended for video compression—it has presets for most popular streaming services.

Working Tips

- **Stay organized.** Many animation packages can integrate multimedia assets like sound, layered illustrations, and video. You will need to keep all of these together to avoid file errors. When starting a new project, create a fresh folder with the project title. Inside that folder, make three more folders: "Assets," "Animation Files," and "Renders." Save all project components here.

- **Illustrate large and animate small.** When preparing illustrated assets and digital puppets, work 2 to 3 times larger than the final planned video output for greater flexibility and freedom during the animation process—such as cropping in closer without losing image quality. When painting, many digital brushes also work better at a larger size. You can import these large assets into smaller compositions for the animation phase. This tip also supports client work that will be printed and animated in two editions—the print version will almost always need to be created larger to achieve the correct DPI.
- **Size of canvas vs. computing power.** Larger image dimensions require greater computing power, especially when using CG animation tools like After Effects. Use trial and error to find the right balance of image dimensions that work best for your computer setup while satisfying your project's needs.

Online Distribution

Everyday social media channels like Instagram, Facebook, Tumblr, Twitter, and TikTok are commonly used by artists to share their work. Instagram is the most popular format for art directors seeking illustrators. Longer videos and animated shorts can be posted to YouTube and Vimeo for maximum exposure. Additionally, these art-specific channels may be helpful for sharing work and communicating with potential clients:

- **ArtStation.com:** This online community is favored by concept artists and 3D modelers.
- **Behance.net:** Adobe's portfolio platform mixes elements of social networking, allowing other creatives to search for artwork across the whole site. Local clients can search by the illustrator's city.
- **Dribbble.com:** This social platform for professional designers requires an approved application or invitation to share work, which suggests a higher quality of portfolios to potential clients searching for collaborators.
- **GIPHY.com:** A searchable online database of GIFs. Artists may create profiles and upload their work, ensuring their images are credited when shared across the web.

Illustration by Adam Osgood

CHAPTER 6

Exercises and Projects

This chapter offers activities to experiment with animation techniques and build a motion illustration portfolio. This sequence of exercises is designed to give broad experience with different animation techniques that could be used in motion illustration, arranged from least complex to most sophisticated, with something to offer both the beginner and experienced animator. Each exercise has multiple variations with dozens of potential outcomes. For the sake of simplification, the exercises are written for 2D animation, but most could be adapted for 3D animation. The chapter closes with project ideas to make motion illustrations that tell compelling stories with clear visual communication.

Digital Fluency

While software is suggested for each exercise, they are written with the understanding that technology changes quickly and digital tools will come in and out of fashion. Multiple software packages are listed wherever possible, with emphasis on the needs of each exercise, so that you may use preferred or available tools. Because of this, the steps in each exercise do not walk through detailed software training but rather the larger ideas behind the digital animation process. Many free resources and video tutorials online go in-depth on specific techniques, and this book provides terminology to use when searching for help.

If you are a beginner with digital illustration or animation, that's okay! Adobe Photoshop has approachable animation tools, and Adobe offers detailed, step-by-step training for its software at **helpx.adobe.com**; just search for "animation." Procreate also features intuitive animation tools with comprehensive instruction available at **procreate.art.** If you are looking for extensive, in-depth software training, **LinkedIn Learning** and **Pluralsight** both offer high-quality online courses for most popular animation packages.

Animated samples and downloadable files for each exercise are available on the online resource **motillu.com/book**. Use the password **dynamite** to view these exclusive resources.

Ideation before Illustration

Start each exercise and project in your sketchbook by writing and sketching ideas. Brainstorm multiple solutions and choose the strongest to move forward with. Here are some suggestions to guide the ideation process:

- **Write a word cloud** of every idea you can think of relating to the theme of your project.
- **Prepare thumbnails** or storyboards before making any final art (see Figure 6.1). With a single GIF, you may be able to convey your entire idea within a single thumbnail sketch. Prepare a storyboard if you are working on a project with multiple shots and camera movements. Make template sheets with a grid of rectangles in your chosen aspect ratio. Indicate motion with arrows and notations.
- **Choose an aspect ratio** and develop strong compositions that maximize the final image dimensions.
- **Experiment with quick color studies** to support the illustration's mood, theme, and idea (see Figure 6.2).
- **Make a "tight sketch"** before moving to final art (see Figure 6.3). This is a line drawing at full-size that shows all the details you intend to include in your final illustration. Use this step to refine shapes, resolve tangents, and reassess compositional issues. It won't be seen, so don't worry about mark-making; you can refine that later in the final art.

Work "Smart" with Reverse Engineering

It is essential to consider the animation technique when developing illustration concepts. Like any art medium, animation has its strengths and weaknesses, and some animation techniques are better suited for certain concepts than others. For example, digital puppets can be reused in multiple scenes but have a limited range of motion, while frame-by-frame animation allows for any kind of motion but is very time-consuming to create. Work backward and clarify in writing what your chosen animation technique is best at doing. Then, use this information to determine what you will illustrate. Each exercise in this book is designed around a specific animation technique and will offer suggestions to reverse-engineer concepts best suited to the approach.

Figure 6.1 This page shows process steps from the production of the music video "Lord Only Knows" by Big Black Delta (2020), animated by Adam Osgood. These thumbnails were drawn in pencil to quickly establish the visual narrative. In this scene, an archaeologist looks on as a missile explodes in the distance.

Figure 6.2 Color studies are a fantastic opportunity to experiment with color relationships before moving into final rendering. Because this art doesn't appear in the final animation, this step can be quick and dirty; the main goal is to establish a conceptual mood.

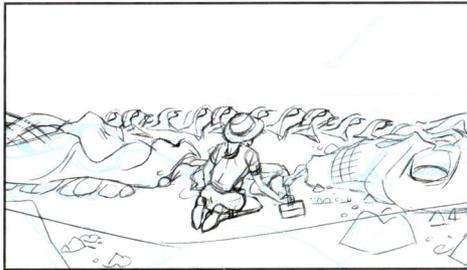

Figure 6.3 The tight sketch phase, which might also be called "rough animation" in the cartoon animation industry, is when the final composition and shape-language is established and refined.

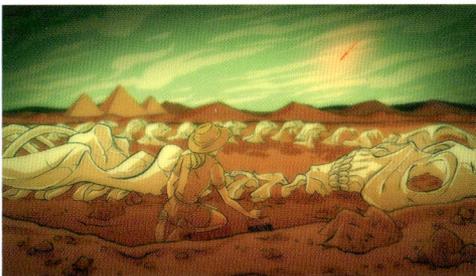

Figure 6.4 These two frames from the finished animated video show how the idea slowly becomes clearer at each step in the illustration process. While many ideas carry through into the final art, some will evolve to become stronger.

EXERCISE 1: CUT-PAPER ANIMATION

Use physical puppets to create motion with video.

Cut-paper animation is one of the most approachable techniques for an illustrator because the tools can be as simple as paper, scissors, and a camera. You don't need any animation software; just one hand to hold the camera and the other to move the puppet. The outcome won't be slick and polished, but that is part of its charm. Embrace imperfection and have fun.

Figure 6.5 This photo shows a cut-paper "stage" illustrating a galaxy and a spaceship "puppet" on a separate piece of paper, with a stick attached for the animator to hold while filming. This paper has been tinted with watercolor, but the creative options are infinite. For example, you might use colored paper and/or other traditional media to illustrate or create texture.

Tools Needed
- Paper, scissors, and your favorite traditional media.
- A camera that can take video (your smartphone is perfect).

Process Steps

Illustrate a spaceship navigating the galaxy with a cut-paper stage and puppet.

1. Illustrate a cut-paper spaceship (puppet) and a galaxy (stage) with paper, scissors, and drawing/painting tools.
2. Using your smartphone's camera, take a few short videos where you move the puppet across the stage. If you don't want your hand visible, you might attach a stick or tab (as seen in Figure 6.5) that you can use to control the puppet from off-camera. Imagine that you are the pilot, steering the spaceship on a tour of space. What kind of stories can you tell through the puppet's movements?
3. Use the video-editing tools on your phone to trim the video, removing any excess start and end footage.

Variations

- **Use two or more puppets.** Add a second puppet and enlist a friend to be the actor. What new storytelling opportunities does this create?
- **Make it 3D.** Instead of paper, use clay and/or three-dimensional materials to build your puppets and set. For example, you could build puppets with wire armatures that you can use repeatedly. You could also modify a doll or action figure with clay and paint.
- **Represent your scene with unconventional materials**. A well-chosen object can add additional context to an image, a sensation of tactility, or suggest an imaginative tone. For instance, a cotton ball might become a cloud, a lemon slice might become the sun, or bowtie pasta could represent a butterfly.
- **Use stop-motion instead of filming video.** Stop-motion will enable you to build multi-part puppets with joints and hinges that can be moved separately for each animation frame. Instead of filming a video, one photo is taken at a time and assembled in video-editing software. For inspiration, refer to Lotte Reiniger's *The Adventures of Prince Achmed* (1926).

Reverse-Engineer

This technique centers around two elements—a puppet and a stage. What ideas, narratives, and concepts can you think of that could be illustrated with this simple setup? Write down as many puppet/stage pairs as you can think of.

EXERCISE 2: FLIPBOOK ANIMATION

Draw a quick animation with traditional materials.

Flipbooks are a fantastic introductory animation method because the setup only takes a few minutes, and you can start experimenting with animation immediately without a computer. This technique is often used in classrooms with children, so it is possible you have already drawn in a flipbook at some point.

This exercise uses the "straight-ahead" approach to animation; this means you will draw the frames sequentially from the beginning, organically feeling out the pace of the animation. Straight-ahead animation can lead to exciting and whimsical discoveries along the way because there is no clear plan for the end.

Figure 6.6 Flipbook animations can be shared online by taking videos with your smartphone's camera.

Tools Needed

- Index cards (4 × 6 inch)
- Binder clip
- Scissors
- Pencil
- Light-table or window

Process Steps

Animate a flower growing from seed to bloom in a flipbook made from index cards.

1. Cut the index cards in half to be 4×3 inches each.
2. Create a stack of 25 to 30 cards, and number them sequentially in the bottom corner. There isn't a right or wrong number of cards; however, you will need enough cards to flip through them easily, but not so many that they don't fit in the binder clip.
3. Begin drawing using only the 3×3 inch area on the right-hand side of the card stack. Start by illustrating a seed on the first card. Then, progressively work card-by-card to illustrate the growth into a sapling, mature plant, and bloom. Don't worry about perfection; just have fun and enjoy the process of drawing.
4. Flip back and forth to earlier cards as you work to ensure that the placement of imagery from card to card is visually connected. A light-table (or sunny window) is helpful to see through the drawings of multiple cards at once.
5. When you are finished, check that the cards are in the correct numbered order, then secure a binder clip on the left-hand side of the stack.
6. Holding the stack by the binder clip, flip through the cards to see the motion you have illustrated.

Variations

- **Animate with in-betweens**. Instead of "straight-ahead," you could also use a "keyframe/in-between" process. Start by drawing the seed on the first card and the blooming flower on the last card. Then insert a blank card between them and draw the "in-between" middle state of the plant. Continue inserting blank cards "in-between" the finished cards to draw the middle states until you have fluid animation. This method can help to create a smoother animation because you have your destination mapped out from the start.
- **Experiment with other media.** Try making your book out of artist-quality paper to play with other media and mark-making techniques. What might the introduction of color allow?

Reverse-Engineer

What can you animate with a flip book? Make a list of ideas that only take a few seconds to show a complete action. Consider the small drawing area. Metamorphosis and dynamic looping actions work well in this format.

EXERCISE 3: THREE-PANEL COMIC

Tell a story with an animated GIF using only three frames.

In this exercise, three static illustrations will cycle in a looping GIF to tell a story with a clear beginning, middle, and end—the result will feel like a brief slideshow. For the beginner, this is an accessible way to experiment with digital tools and learn about the software features without the fear of a complicated animation. If you are more experienced, this exercise is also great practice to strengthen your visual communication skills. Lean on your illustration skills to develop a sequence of three images that tells a complete story.

Figure 6.7 This story illustrates a common dream where the sleeper believes they are falling. When these three images are assembled as a GIF, the viewer imagines the unseen action in between the frames.

Tools Needed
- Digital illustration software that includes basic animation functions, like Adobe Photoshop or Procreate.

Process Steps

Make a simple GIF that tells a surprising story with three frames representing the beginning, middle, and end. If you can embed a natural loop in the story, the GIF will have a mesmerizing effect.

1. Create a 3000×3000 pixel document in your preferred illustration software.
2. Using the animation toolset (e.g., "Timeline" in Photoshop or "Animation Assist" in Procreate), create tight sketches of all three illustrations on separate frames.
3. By default, the animation will be extremely fast. Play the animation, adjusting the duration of each frame and making any necessary corrections to improve the visual communication of the illustrations. In the sample, each frame is set to hold for 0.8 seconds.
4. Finalize the illustrations in your desired style.
5. Export the animation as a 600×600 pixel GIF.

Variations

- **Hand-rendered illustrations.** If you prefer to illustrate your GIF with traditional media, you can scan the three images and import them into the animation software as the final step.
- **Macro and micro.** A story can be epic, starting at the beginning of time and ending far into the future. It can also happen in just a moment, like a reaction to a strange sound. What kind of story do you want to tell?

Reverse-Engineer

This animation's success hinges on its idea. Make a list of surprising things. How can these situations be plotted over three images to tell a story that is funny, scary, exciting, or unexpected?

EXERCISE 4: DIGITAL ROTOSCOPING

Use footage as a reference tool for digital animation.

Rotoscoping is a wonderful way to learn digital animation tools without the pressure of inventing the action. The magic of rotoscoping is the ability to apply your unique visual vocabulary to a video segment while capturing a nuanced and believable performance.

Figure 6.8 This example shows a selection of frames from a live-action reference video and their corresponding rotoscoped drawings.

Tools Needed

- A camera that can take video.
- Digital drawing software that can import video and includes animation functions, like Adobe Photoshop.

Process Steps

Make an animated video by tracing over footage of a face, capturing the nuances of human movement and expression.

1. Take a selfie video where you transition through a few different facial expressions. Change the angle of your head and body for dynamic motion. (You may also enlist a friend to be your actor.)
2. Create a new file in the animation software, choosing an appropriate aspect ratio (3:4 works well for a vertical portrait) and pixel dimensions (2400×3200 pixels would work well).
3. Import the selfie video. In Photoshop, the "Video Timeline" function is recommended, which allows sophisticated frame-by-frame animation and supports video import.
4. Reduce the video layer's opacity to 10–30 percent. It should look like you are viewing the video on a light-table with a sheet of fresh paper on top.
5. Create new layers above the video and trace the frames, one at a time. Use expressive mark-making and tactile brushes to play up the illustrated quality. Most digital videos will have 30 frames per second. You do not need to trace every frame—you could work with a low frame rate, skipping every 2–3 frames for a choppier animation style. (The sample animation skips every three frames.)
6. Turn off the video layer's visibility and play the animation. Is there anything that could be improved for greater fluidity or clarity? Make adjustments.
7. Render a video file.

Variations

- **Draw animals from reference.** Search for Eadweard Muybridge's photo strips of animals. Rotoscope from one of these.
- **Tell a story with lip-synced dialogue.** Film a friend narrating a personal anecdote. Keep it short— each second of animation will require at least ten frames of drawing.
- **Advanced digital tools.** Try out Secret Weapon's free EbSynth software, which automatically applies your art style to video.

Reverse-Engineer

- Rotoscoping requires live-action footage. What people, spaces, and animals would make good subjects to film reference? Are there copyright-free videos you could use as a starting point?

EXERCISE 5: DIGITAL FRAME-BY-FRAME ANIMATION

Animate a special effect with hand-drawn frames.

This exercise provides a low-stakes experience with frame-by-frame animation by adding ambient animation to a still illustration. There are many possibilities to explore, like fire, water, precipitation, wind, explosions, pixie dust, or rays of light. How can ambient animation aid the viewer's understanding of an image and add additional context?

Figure 6.9 In this example, a glittering effect is achieved by drawing a random array of sparkles on each animation frame. Three frames are typically sufficient for a natural-looking loop.

Tools Needed

- Digital illustration software that includes basic animation functions, like Adobe Photoshop or Procreate.

Process Steps

Make a looping GIF with special effects animation integrated within a static illustration.

1. Brainstorm ideas based on an environmental effect or ambient animation. Then, compose your image within a square aspect ratio for easy social media posting.
2. Create a 3000×3000 pixel document in your preferred illustration software.
3. Make a tight sketch of your entire composition.
4. Using the animation toolset (e.g., "Timeline" in Photoshop, "Animation Assist" in Procreate), create a **pencil test** for the animated effect—don't worry about your line quality; focus on mapping out the motion. Three frames are enough for most effects; you shouldn't need more than ten.
5. Play the animation and adjust each frame's duration to improve the timing. Make any necessary corrections to the visuals.
6. Finalize the illustration and animated effect in your desired style.
7. Export the animation as a 600×600 pixel GIF.

Variations

- **Living illustration.** Instead of animating an ambient effect, use the line-boil technique, tracing over the same image three times and looping. The subtle variations in the traced drawings will make the illustration feel like it has come to life.
- **Metamorphosis.** Animate two to three objects morphing into one another. Choose a theme, like breakfast foods or modes of transportation, to create a cohesive animation.

Reverse-Engineer

Make a word cloud, starting with different ambient effects (e.g., fire, rain, magic). Add new branches for environments and situations that could be illustrated with each. For instance, fire could be depicted as a campfire, candlelight, a rising phoenix, or a burning building. Come up with as many ideas as you can.

EXERCISE 6: TWEENING BASIC TRANSFORMATIONS

Use keyframes to create simple motion in digital animation software.

Digital animation software, such as Adobe After Effects, are built around keyframe systems that allow the artist to automatically generate a smooth animation by indicating a starting and ending parameter for an individual layer of art. Depending on the software package, these parameters may be specific and complex; however, most include the four **basic transformations** that control a single layer's *position*, *rotation*, *scale*, or *opacity*. By indicating a starting and ending keyframe for a basic transformation, the illustrator can generate a sophisticated animation with very minimal effort.

Figure 6.10 The Ghost "puppet" has only two keyframes that control its movement across the stage; one at the beginning and one at the end of the animation. What details can you add to your illustrated environment to suggest a deeper story to the viewer?

Tools Needed

- Digital drawing software, like Adobe Photoshop or Procreate, to create a .PSD file.
- Digital animation software which allows for keyframing on a timeline. Adobe After Effects is referenced directly in the exercise. Photoshop's video timeline can keyframe *position* and *opacity*, but unfortunately cannot *scale* or *rotate*.

Process Steps

Illustrate a spooky ghost who haunts the halls of a mysterious mansion. (This is essentially a digital approach to the **Cut-Paper Animation** exercise, at the beginning of this chapter.)

1. Create a 3000×3000 pixel document in your preferred illustration software.
2. Make a digital illustration with two layers: a ghost on the top layer and a haunted mansion on the bottom layer.
3. Name both layers appropriately and save the file as a PSD.
4. Import the layered PSD into After Effects. Set the composition's duration to 3 seconds, framerate to 10 frames/second, and dimensions to 1080×1080 pixels.
5. At the beginning of the timeline, move the ghost layer off the left side of the composition and add a keyframe on the position parameter.
6. Now, set the playhead to the end of the timeline. Move the ghost layer off the right side of the composition and add another keyframe on the position parameter. Your animation only needs two keyframes at the start and end of the timeline to create the left-to-right motion.
7. Test the animation by pressing "play." It should appear as though the ghost is "floating" horizontally across the mansion.
8. Render the video. Convert to a GIF in Photoshop if desired.

Variations

- **Animate opacity.** Instead of the *position* parameter, animate keyframes with the *opacity* parameter, changing it from 0 to 100 to 0. This will create the illusion that the ghost is appearing and disappearing.
- **Create a more complex animation.** Place keyframes for both the position *and* opacity so that the ghost is floating *and* appearing simultaneously.
- **What other simple two-layer illustrations could you animate with this formula?** What about a pirate ship sailing the seas (position), fireflies glowing by a campfire (opacity), or turbines on a wind farm (rotation)?

Reverse-Engineer

Make a list of anything you can think of that can move, rotate, scale, and appear/disappear. Here are a few ideas to begin. Brainstorm more in your sketchbook and use these possibilities as catalysts for future illustration projects.

Position: Things that move up and down or left and right.	**Rotation:** Things that spin or turn on an axis.	**Scale:** Things that get bigger and smaller.	**Opacity:** Things that disappear/appear or fade-in/fade-out.
• Vehicles • Shooting star • Fish swimming • Elevator	• Fan blades • Clock hands • Washer cycle • Earth spinning	• Balloon • Growing flower • Shrink ray • Extreme zoom	• Spooky ghost • Fireflies • Traffic lights • Steeping tea

EXERCISE 7: MASKING AND MATTING

Use digital animation software to mask moving elements to specific shapes.

Masks are a non-destructive way to hide part of a layer without deleting the pixels. "Clipping masks" are a particular form of masking that allows a layer to be "clipped" to the opaque pixels of the layer below it. In animation, clipping masks can be combined with position keyframes to move a pattern or texture within an isolated shape. In video-editing, similar techniques are described as "traveling mattes" or "track mattes," and are used extensively in visual effects for film.

Figure 6.11 You will make three layers: the main illustration, a mask (shown in green), and a pattern. The last image shown is a composite with the pattern masked to the shape of the man's coat.

Tools Needed
- Digital drawing software, like Adobe Photoshop or Procreate, to create a layered .PSD file.
- Digital animation software that has clipping mask functions and allows for keyframing on a timeline. Adobe Photoshop's tweening function is referenced directly for this exercise. If you want greater control, Adobe After Effects can do more sophisticated keyframing and layering using their **matte** feature set.

Process Steps
Make a fashion illustration with a pattern in one of the garments. Through animation, the pattern will appear to move perpetually leftward.

1. Create a 10×10 inch, 300 DPI document in your preferred illustration software.
2. Illustrate three layers:
 a. A fully colored fashion illustration. Consider how the costume and pose can maximize the pattern's visibility.
 b. A layer with a solid fill of the garment that you will use as a clipping mask. Choose a bright color that is not in your final illustration.
 c. A repeating pattern (the right and left sides should be seamless).
3. Duplicate the pattern layer and move the copy to the right of the original. Their edges should line up perfectly. The duplicate will be hidden off the right side of the canvas.

4. Select "Create Frame Animation" in the Animation Timeline and add a second frame.
5. On Frame 2, select both pattern layers and move them to the left, so the duplicate pattern is in the exact position where the original pattern was. The image should look the same as Frame 1; however, the original pattern will now be hidden off the left side of the canvas (see Figure 6.12).
6. Select both animation frames and press the "Tween" button. Add 29 frames. Delete the last frame (this is visually the same as Frame 1 and creates a pause in the flow). You will be left with 30 frames. Play the animation—it should appear as though the pattern is traveling continuously to the left. If you feel this is too fast or too slow, you can redo this step with more or fewer added frames.
7. In the layer stack, the patterns should be just above the mask layer. Right-click each pattern layer and select "Create Clipping Mask." The patterns should now be clipped to the mask layer, revealing the final look of your illustration.

Export the animation as a 600×600 pixel GIF.

Figure 6.12 This looping animation technique replaces one image layer with an identical duplicate via horizontal movement. After in-betweens are added, the viewer perceives a perpetually moving pattern.

Variations

- **Direction.** This exercise asks you to move the pattern from right to left, creating a sensation of forward movement in the figure. What if the pattern moves up or down instead? How can intentional choice with directional motion support your story?
- **Typography.** Use a word or phrase to mask a moving pattern. How can combinations of words and images create a clever or humorous experience for the viewer?

Reverse-Engineer

While this exercise's premise is built around decorative illustration, animating with masks is a versatile technique that could be used for narrative purpose. The basic function of masking is its ability to hide and reveal. Instead of animating a pattern, animate the position of the mask. Use it like a flashlight, searching the image. What can you reveal to the viewer?

EXERCISE 8: RIGGING DIGITAL PUPPETS

Use digital animation software to create puppets with movable joints.

Digital puppets are an excellent alternative to frame-by-frame animation. Similar to a paper puppet connected with hinges, a digital puppet allows the animator to move and rotate the separate elements. The puppet's main advantage is that it can be reused in different shots and placed over different backgrounds. It is a versatile format that works just as well for humans, animals, and inanimate objects with moving parts.

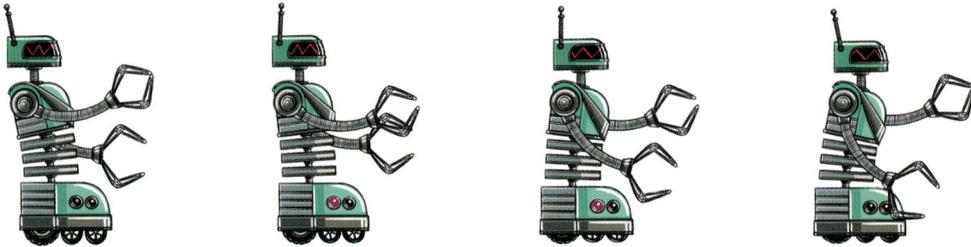

Figure 6.13 These frames demonstrate how many moving parts can be built into a single puppet. Examine the flexible spine, blinking lights, and clamping hands for examples of how you can make your puppet move.

Tools Needed
- Digital illustration software that can create a layered PSD. (You could also make an AI file if you prefer to work with vectors.)
- Animation software with rigging capability like Adobe After Effects. Adobe Animate and Toon Boom Harmony could also do this.

Process Steps
Animate a video of a rigid-body robot.

1. Create a 3000×3000 pixel document in your preferred illustration software.
2. On the first layer, design your puppet as a tight sketch. Think carefully about which parts will move and where you will place the digital "joints." See the exploded view in Figure 6.14.
3. Illustrate the robot. Each movable part needs to be on its own layer. Consider which layers need to be in front of others. Name all layers descriptively (i.e., "right arm") and save.
4. Import the PSD in After Effects. Change the "Composition Settings" to 30 fps, with a duration of 30 seconds, and set the composition dimensions to 1080×1080 pixels. The long duration will give you enough room on the Timeline to experiment, but you will likely only create two to four seconds of

animation. (You will need to scale down the layered artwork to fit the smaller image dimensions. This can be done easily by selecting all layers, pressing "s" and keying in a smaller value, like 30%.)

5. In the composition panel, use the Anchor Point Tool to move the anchor point on each layer to its joint location (i.e., the axis where it can rotate).
6. Set up the rig by creating parent-child relationships for each layer. For instance, the body is the parent of the arm, the arm is the parent of the hand, and the hand is the parent of the finger.
7. Animate the puppet by setting keyframes on the "rotation," "position," and "opacity" parameters of each layer. To create a looping animation, each layer's first and last keyframes should be set to the same value.
8. Render the video. You may convert this into a looping GIF by importing it into Photoshop and exporting with the "Save for Web" tool.

Variations

- **Use reference for naturalistic movement.** Puppets work well for humanoid and animal characters. When animating a walk cycle, it is helpful to examine key poses from video footage. Eadweard Muybridge's photography is a valuable resource for this.
- **Organic movement.** After Effects' "Puppet Pin" toolset allows individual layers to be warped and bent, enabling flexible, rubber hose-type movements. This toolset can be used alone or in combination with parent-child chains to create complex puppets.

Reverse-Engineer

While digital puppets are versatile, they have a limited range of motion that cannot show depth. This lends itself best to graphic, stylized approaches. What objects can you think of that could be illustrated with parts that move and rotate? What characters might work with this technique?

Figure 6.14 An exploded view of the sample robot shows the different parts of the puppet. Each moving part must be illustrated on its own layer to allow for animation.

EXERCISE 9: PARALLAX ENVIRONMENT

Use digital software to animate spaces with the illusion of depth.

With parallax scrolling, objects in the distance move slower than objects in the foreground, creating an immersive illusion of depth for the viewer. This technique has been used throughout animation history via Ub Iwerks's multiplane camera (1933) and seen in the layered backgrounds of side-scrolling 2D video games like *Moon Patrol* (1982).

Figure 6.15 This is the first and last frame from a parallax animation of an underwater fantasy environment, showing how the layers of animation move at different rates. Note how the deep background is in the same position in both frames while the nearest layer has moved all the way to the left.

Tools Needed
- Digital drawing software, like Adobe Photoshop or Procreate, to create a layered .PSD file.
- Digital animation software that allows for keyframing on a timeline. Adobe Photoshop's tweening function is referenced directly for this exercise.

Process Steps

Illustrate a panoramic environment with four layers that each depict a different level of depth, then animate a parallax scrolling effect.

1. Create a 6000×1800 pixel document in your preferred software and illustrate an environmental scene with four distinct layers. Since the layer nearest the camera will move the fastest, you should paint the full 6000-pixel width. The furthest level of the background won't move at all, so you only need to illustrate a 2400-pixel width. The two middle layers should be about 3600-pixels and 5400-pixels wide, respectively (see Figure 6.16).
2. In your preferred 2D animation software, make a new document that is 2400×1800 pixels (this is a 4:3 aspect ratio).
3. Import each background illustration layer. In Photoshop, you can simply drag the layers from the original document into the new canvas. Then, align them all to the left edge of the canvas.
4. Open the Timeline and click "Create Frame Animation."
5. Add a new animation frame. On Frame 2, reposition each background layer to be aligned with the right edge of the canvas.
6. Select both animation frames and press the "Tween" button. Add 118 frames—this will give you 120 frames in total, resulting in 4 seconds of animation at 30fps. If you feel this is too slow or too fast, you can redo this step with more or fewer added frames.
7. Render the animation as a video at 1620×1080 pixels.

Variations

- **Looping GIF.** With some extra planning, this process can create extremely satisfying looping GIFs. To create a loop, the first and last frames of the animation must be the same. Therefore, you will have to design each background layer as a seamless tile and animate with the same replacement technique from the **Masking and Matting** exercise.
- **3D Camera.** You can achieve incredible results with software that has 3D cameras. For instance, After Effects's 3D layer toolset allows 2D planes to be placed in a dimensional space. By animating a virtual camera, you can automate a parallax effect. This allows for more complex scenes; for instance, you could duplicate the same tree asset dozens of times and stagger them in space to create a dense forest.
- **Z-Axis.** 3D toolsets also enable the camera to move forward and backward dimensionally into a scene. You can create exciting tracking shots moving through an illustrated space.
- **Parallax for Interactive.** Parallax effects can be incorporated into games, apps, and web experiences. For instance, consider how a webcomic might use a parallax animation to convey an epic journey.

Reverse-Engineer

This technique requires multiple distinct layers of the space to create the illusion. Think of spaces with a variety of architecture, environmental features, plants, animals, vehicles, and so on. Greater depth will be achieved with layers near the camera and extremely far away.

Figure 6.16 The parallax animation effect results from these four layers traveling at different speeds. The layer nearest the camera must move the fastest, so it must be drawn extra wide. Progressively, as the layers go into the distance, they will move slower and don't need as much width.

Bringing It All Together

Here are ideas for complete projects that center on narrative and conceptual ideas, with multiple variations to help build a motion illustration portfolio. Consider how techniques from the exercises can be modified and remixed for use with these projects.

Project 1: Looping GIF Made for a Specific Market

Illustrators know that a single image is powerful. What types of narratives and concepts can you create with one looping GIF? Optimize the design of your GIF for its native viewing formats on the web and in social media feeds. What aspect ratio, subject matter, color palette, and compositional choices will make your image stand out?

Variations

- **Visualize a metaphor for editorial purpose.** Choose a headline from your favorite news source. Reverse-engineer at least three different concepts. How can the animation call attention to the metaphor?
- **Advertise a product with humor.** Make a social media ad for your favorite beverage. Develop a humorous idea to promote the drink's most unique qualities.
- **Tell a narrative that relies on a simple animation.** Illustrate a scene from a classic fairy tale. Use the animation to highlight an essential part of the story.

Project 2: Series of Looping GIFs

Create a series of illustrations with a strong group impact. Multiple images can tell in-depth visual stories through sequencing and repetition. Consider where these animated GIFs might live—on a specific website or social media platform—and develop an idea suitable for the audience.

Variations

- **Illustrate a multi-panel comic.** Use GIFs in place of the panels in a webcomic. How can animation support storytelling?
- **Animate an anthology.** Make a list of things that could be illustrated as a series, like an alphabet, the periodic table of elements, and astrological signs. Use these as prompts for a series of GIFs.
- **Make a multi-part social-awareness campaign.** Choose a social issue with personal meaning. Make a series of three to five GIFs with a call to action that could be shared on social media

Project 3: A Short Film in Five Scenes

Tell a cohesive narrative with five unique shots edited together into a single video. Think of each shot like a complete illustration and use a variety of camera angles to serve your subject matter best. Use audio to complement your imagery.

Variations

- **Tell a classic fairy tale, folktale, fable, or legend.** Embrace the challenge of creating a strong story arc with just five shots. Use a classic narrative sequence as the setup for each shot: exposition (1), conflict (2), action (3), climax (4), and resolution (5).
- **Visualize a non-fiction audio clip.** Ask a friend or family member to tell a brief story from their life and record the audio as your starting point. Work with them on a script with five sentences—one to pair with each shot.
- **Explain a complex subject.** Choose a topic in science, business, politics, or technology that you can simplify for the viewer. Write a script with five key points and record yourself as the narrator.

Glossary

3D model: A digital representation of a three-dimensional object or scene made from a mesh of polygons with vertices mapped to x, y, z coordinates.

Animation: A sequence of images creating the illusion of movement that may be used in different formats like cartoons, games, illustrations, and motion graphics.

Aspect ratio: The ratio of the width to height of an image, video, or screen, represented as two numbers separated by a colon, like 16:9.

Basic transformations: Most keyframe animation software allows the transformation of position, opacity, rotation, and scale. Altering these four attributes can create a wide range of movement with digital puppets.

Bitmap: A type of digital image file using pixels to represent pictures that excels at displaying gradation, tonality, and texture.

Cartoon animation: Animated content with a narrative framework where characters perform a story. Typically made for entertainment or advertising purposes.

CGI or CG (Computer-Generated Imagery): Creation of imagery using computer software. CGI tools are used frequently in cartoon animation and visual effects for television and film.

Claymation: Animation with clay figures or models shot using stop-motion techniques.

Complementary colors: Pairs of colors opposite each other on the color wheel that have strong contrast, used to create dynamic images.

Cutout animation: A type of animation in which 2D puppets are moved and posed to create the illusion of movement (whether with traditional materials or digital software).

Digital puppets: Computer-controlled, animated characters rigged with a virtual skeleton used in the animation and video game industries.

Dithering: Pixel patterns created in computer graphics to represent gradations in tone with limited color palettes.

Frame animation: A traditional animation technique where each frame is drawn by hand for control and polished results.

GIF (Graphics Interchange Format): A web-friendly file format that can store multiple images and play them back as a looping animation.

In-between: The process of drawing frames "in-between" keyframes to create smooth movement in animation.

Keyframe: The important poses in an animation. In digital animation, the software can automatically generate the in-between frames.

Limited animation: Efficient animation techniques using a low frame rate or looping stock animations, common in television cartoons.

Line boil: A hand-drawn animation technique where the same image is redrawn on multiple frames to create a living image effect through subtle variations in line or paint application.

Mask: A non-destructive image-editing technique that hides part of a layer without deleting the pixels.

Matte: An animation layer that can be used as a masking shape for another layer without deleting any pixels.

Modernist art: Art and design produced during the Modernist period (late nineteenth to

mid-twentieth century) that rejected traditional forms and emphasized experimentation, abstraction, and new techniques.

Motion graphics (sometimes called "motion design"): A specialization within graphic design that creates animated content for film, TV, and digital media using graphics, typography, and film.

Motion illustration: Animated content created for an illustration purpose that visualizes an idea or narrative where the motion plays a supporting role to the imagery.

Parallax: The visual effect of depth in an environment where objects nearest the camera move faster than objects in the distance. Used often in animation and gaming.

Pencil test: Like a rough sketch for animation, the pencil test is the first pass at a hand-drawn animation that helps refine the movement, timing, and flow.

Pixel: The smallest unit of a digital image, represented as a colored square in a grid forming a bitmap image.

Principles of animation: Guidelines for believable movement/action in animated characters or objects, emphasizing believability, timing, and weight.

Raytracing: A light-simulation technique used to render photorealistic lighting and shadows in CGI.

Rotoscoping: Animation technique where live-action reference is traced to create the illusion of realistic movement.

Rough sketch: An intermediary drawing made at full size after the thumbnail and before the tight sketch. This step can help work out general object placement, perspective, and anatomy with sketched volumes.

Rubber hose animation: A style of animation with non-realistic, rubbery character design and motion, popular in the early decades of cartoons.

Stop-motion: A technique of animation where physical objects are moved incrementally and photographed one frame at a time.

Thumbnail: A small sketch created during the conception phase of an illustration to test visual ideas. In professional practice, multiple thumbnails are often presented to a client for direction.

Tight sketch: A preliminary drawing made at full size to work out shapes, design, and composition before beginning any final artwork. This step may require client approval on professional projects.

Timeline: A linear representation of the duration of an animated project that shows the location of keyframes.

Transition: A visual effect or animation used to switch between scenes or shots.

Tweening: Term used in digital animation software for computer-generated in-betweens.

UI: The visual system users interact with on devices and software (e.g., icons, buttons, and windows).

Visual effects: Use of CGI to create or enhance visual elements on a project for film or TV, typically to produce photorealistic special effects like explosions, fire, or characters.

Visual novel: A format for interactive fiction games using static images, text, and voice acting to tell a story.

Resources

Further Reading

For readers who would like to explore motion illustration further, these books cover the fundamentals in illustration, animation, motion design, and computer graphics:

- *The Animator's Survival Kit* by Richard Williams (Faber and Faber, 2009)
- *Design for Motion* by Austin Shaw (Routledge, 2015)
- *The Moving Image Workshop* by Heather D. Freeman (Fairchild Books, 2015)
- *History of Illustration* by Susan Doyle, Jaleen Grove, and Whitney Sherman (Fairchild Books, 2019)
- *Illustration: Meeting the Brief* by Alan Male (Bloomsbury Visual Arts, 2014)
- *Understanding Comics* by Scott McCloud (William Morrow Paperbacks, 1994)
- *The Language of New Media* by Lev Manovich (Leonardo Books, 2002)
- *Computer Graphics and Computer Animation: A Retrospective Overview* by Wayne E. Carlson (The Ohio State University, 2017)

Organizations

- **Society of Illustrators (SOI):** Illustration's most prestigious competition; accepts GIFs and animated videos. societyillustrators.org
- **American Illustration (AI):** The long-running illustration competition added an animation category via its "International Motion Art Awards." ai-ap.com/cfe/motion
- **The Illustration Conference (ICON):** Biennial conference with an animation showcase called *Motion Commotion*. Animation and motion workshops are typically offered. theillustration-conference.org

- **SIGGRAPH (ACM):** Annual conference celebrating the latest in computer graphics. Their film festival and Dailies programming allow independent animators to show their work alongside major studios. siggraph.org

Online Learning Hubs

YouTube is a great starting point for free tips and tricks with digital animation software. However, the subscription services listed here offer comprehensive online training. For beginners, following a complete "essentials" course in the selected software is recommended to avoid frustration before starting any larger projects.

- **LinkedIn Learning:** Offers comprehensive, well-produced tutorials for design software, excelling in training for Adobe's suite of applications.
- **Pluralsight:** Specializes in CGI software and is recommended to new learners interested in visual effects and 3D animation.
- **Skillshare:** A project-based site with à la carte tutorials from working illustrators. Search for Jamie Bartlett, Libby VanderPloeg, Melissa Lee, and Abbey Lossing.
- **Domestika:** Another à la carte service with video courses made by industry professionals. Search for Yukai Du and Carlos Alegría.

Journals and Directories

- **Animation Obsessive:** animationobsessive.substack.com
- **Animation World Network (AWN):** awn.com
- **Cartoon Brew:** cartoonbrew.com
- **Motionographer:** motionographer.com
- **Screendiver:** screendiver.com

Bibliography

Aguilar, Carlos. 2019. "Henry Bonsu on Transforming His Online Comics into Adult Swim's Newest Series 'Lazor Wulf.'" *Cartoon Brew*. April 19. https://www.cartoonbrew.com/tv/henry-bonsu-on-transforming-his-online-comics-into-adult-swims-newest-series-lazor-wulf-172883.html. Accessed December 23, 2022.

Animation Obsessive. 2021. "What the 'UPA Style' Actually Is." *Animation Obsessive*. September 5. https://animationobsessive.substack.com/p/what-the-upa-style-actually-is. Accessed December 20, 2022.

ASME. 2019. "Johannes Gutenberg's System of Movable Type." February 3. https://www.asme.org/getmedia/4e9d6576-020f-4e74-a00c-27e11a250f09/gutenberg-and-mass-production.pdf. Accessed February 9, 2023.

Azéma, Marc. n.d. "Was the Chauvet-Pont d'Arc Cave the First Movie Theater?" *Google Arts & Culture*. https://artsandculture.google.com/story/was-the-chauvet-pont-d-39-arc-cave-the-first-movie-theater/XgWxpamuYC7XMw?hl=en. Accessed October 17, 2022.

Bacon, Bennett. 2023. "An Upper Palaeolithic Proto-writing System and Phenological Calendar." Cambridge University Press. January 5. https://www.cambridge.org/core/journals/cambridge-archaeological-journal/article/an-upper-palaeolithic-protowriting-system-and-phenological-calendar/6F2AD8A705888F2226FE857840B4FE19. Accessed February 9, 2023.

Baker Library Historical Collections. n.d. "The Art of American Advertising: Advertising Products." https://www.library.hbs.edu/hc/artadv/advertising-products.html. Accessed February 9, 2023.

Bellis, Mary. 2019. "The History of Spacewar: The First Computer Game." *ThoughtCo*. March 5. https://www.thoughtco.com/history-of-spacewar-1992412. Accessed August 24, 2022.

Bernstein, Richard. 2016. "Head Case: Why Has PBS Promoted Controversial Shrink Dr. Daniel Amen?" *Observer*. August 3. https://observer.com/2016/08/head-case-why-has-pbs-promoted-controversial-shrink-dr-daniel-amen/. Accessed December 13, 2022.

Boissoneault, Lorraine. 2017. "A Brief History of the GIF, from Early Internet Innovation to Ubiquitous Relic." *Smithsonian Magazine*. June 2. https://www.smithsonianmag.com/history/brief-history-gif-early-internet-innovation-ubiquitous-relic-180963543/. Accessed October 20, 2022.

Boissoneault, Lorraine. n.d. "Orbis sensualium pictus." British Library. https://www.bl.uk/collection-items/orbis-sensualium-pictus-animal-tales-space. Accessed December 16, 2022.

British Library. n.d. "Aesop's Fables printed by William Caxton, 1484." British Library. https://www.bl.uk/collection-items/aesops-fables-printed-by-william-caxton-1484. Accessed December 17, 2022.

Brown, Shelby. 2021. "Where Did Writing Come From?" *Getty*. April 27. https://www.getty.edu/news/where-did-writing-come-from/. Accessed December 15, 2022.

Bukatman, Scott. 2006. "Comics and the Critique of Chronophotography." *Animation—an Interdisciplinary Journal* 1(1): 83–103.

Carlson, Wayne. 2017. "6.2 Magi." *Computer Graphics and Computer Animation: A Retrospective Overview*. June 20. https://ohiostate.pressbooks.pub/graphicshistory/chapter/6-2-magi/. Accessed December 18, 2022.

CERN. n.d. *A Short History of the Web*. https://home.cern/science/computing/birth-web/short-history-web. Accessed November 28, 2022.

Chalmers, Jamie. n.d. "eMbroidery." *mr x stitch*. https://www.mrxstitch.com/aubrey-longley-cook-2/. Accessed December 30, 2022.

Chikhani, Riad. 2015. "The History of Gaming: An Evolving Community." *TechCrunch*. October 31. https://techcrunch.com/2015/10/31/the-history-of-gaming-an-evolving-community/. Accessed December 28, 2022.

Chiquimedia. 2017. *Mortimer and the Dinosaurs: Press Kit*. https://chiquimedia.org/en/apps/mortimer/press-kit. Accessed October 6, 2022.

The Coca-Cola Company. n.d. "Haddon Sundblom and the Coca-Cola Santas." *The Coca-Cola Company*. https://www.coca-colacompany.com/company/history/five-things-you-never-knew-about-santa-claus-and-coca-cola. Accessed December 16, 2022.

Disney Facts and Figment. 2020. "Who Came First? The Dawn of Color in Disney Cartoons." June 26. https://factsandfigment.com/2020/06/26/who-came-first-the-dawn-of-color-in-disney-cartoons/. Accessed December 19, 2022.

Dobson, Terence. 2014. "Norman McLaren: A Late, Great Animator Now Drawing Applause." *The Conversation*. June 23. https://theconversation.com/norman-mclaren-a-late-great-animator-now-drawing-applause-27506. Accessed December 26, 2022.

Doyle, Susan, Jaleen Grove, and Whitney Sherman. 2019. *History of Illustration*. New York: Bloomsbury.

Dudok De Wit, Alex. 2020. "Vatroslav Mimica, Luminary of the Zagreb School of Animation, Dies at 96." *Cartoon Brew*. February 21. https://www.cartoonbrew.com/rip/vatroslav-mimica-luminary-of-the-zagreb-school-of-animation-dies-at-96-186548.html. Accessed December 21, 2022.

Eastern Arizona College. 2022. *Japanese Animation*. June 25. https://eac.libguides.com/c.php?g=723550&p=5215189. Accessed December 27, 2022.

Farley, Lloyd. 2022. "13 Early CGI Uses That Still Hold Up Today, From 'Westworld' to 'A New Hope.'" *Collider*. July 30. https://collider.com/best-early-cgi-westworld-star-wars-a-new-hope/. Accessed September 18, 2022.

Fichter, Adrienne. 2019. "Europe vs. Big Tech." *Republik*. May 3. https://www.republik.ch/2019/05/03/europa-vs-big-tech. Accessed December 13, 2022.

Finley, Klint. 2017. "The GIF Turns 30: How an Ancient Format Changed the Internet." *Wired*. May 28. https://www.wired.com/2017/05/gif-turns-30-ancient-format-changed-internet/. Accessed October 20, 2022.

Fletcher, Seth, Jen Schwartz, and Kate Wong. 2019. "Truth, Lies, & Uncertainty." *Scientific American*. September 1. https://www.scientificamerican.com/interactive/truth-lies-uncertainty1/. Accessed December 13, 2022.

Freeman, Heather. 2016. *The Moving Image Workshop*. New York: Bloomsbury.

Fulton, Wil. 2017. "I Found the World's First Meme with Help from Meme Historians." *Thrillist*. August 21. https://www.thrillist.com/entertainment/nation/first-meme-ever. Accessed December 28, 2022.

Furniss, Maureen. 2007. *Art in Motion: Animation Aesthetics*. Eastleigh: John Libbey Publishing.

Gallagher, William. 2020. "How Apple Owes Everything to its 1977 Apple II computer." *Apple Insider*. April 18. https://appleinsider.com/articles/20/04/18/how-apple-owes-everything-to-its-1977-apple-ii-computer. Accessed February 9, 2023.

Garland, Emma. 2018. "Happy Birthday, Salad Fingers." *VICE*. July 16. https://www.vice.com/en/article/ywkdzy/happy-birthday-salad-fingers. Accessed November 28, 2022.

Gennetian, Arpia. 2021. "WPA Posters: Art for the Common Good." *Objective*. https://adht.parsons.edu/historyofdesign/objectives/wpa-posters/. Accessed December 21, 2022.

Gregurec. n.d. "Web Animation in the Post-Flash Era." *Toptal*. https://www.toptal.com/designers/web/animating-the-web-in-the-post-flash-era. Accessed December 20, 2022.

Grgic, Velimir. 2009. "Vatroslav Mimica." *Diverse Croatia*. November 8. http://dicocroate2.over-blog.com/article-vatroslav-mimica-38984757.html. Accessed December 22, 2022.

Halas, John, and Roger Manvell. 1962. *Design in Motion*. New York: Hastings House.

Harry Ransom Center. n.d. "The Niépce Heliograph." https://www.hrc.utexas.edu/niepce-heliograph/. Accessed February 9, 2023.

Hayes, Lee. 2018. "The Three P's: Papyrus, Parchment and Paper." The University of Adelaide. May. https://www.adelaide.edu.au/library/special/exhibitions/cover-to-cover/papyrus/. Accessed December 15, 2022.

Hersey, Will. 2020. "Remembering Saul Bass: The Designer Who Changed Cinema." *Esquire*. September 30. https://www.esquire.com/uk/culture/film/a34169582/remembering-saul-bass-the-designer-who-changed-cinema/. Accessed December 21, 2022.

Hillegas, Laura. 2019. "Constructivism Brought the Russian Revolution to the Art World." *Artsy*. January 4. https://www.artsy.net/article/artsy-editorial-constructivism-brought-russian-revolution-art. Accessed August 29, 2022.

History.com Editors. 2017. "Video Game History." *History*. September 1. https://www.history.com/topics/inventions/history-of-video-games. Accessed December 28, 2022.

Japan House. 2019. "Drawn to Inspire | The Impact of Manga and Anime." August 16. https://www.japanhousela.com/articles/the-impact-of-manga-and-anime/. Accessed December 27, 2022.

Johnston, Ollie, and Frank Thomas. 1981. *The Illusion of Life*. New York: Disney Editions.

Kastrenakes, Jacob. 2014. "Twitter Now Supports GIFs." *The Verge*. June 18. https://www.theverge.com/2014/6/18/5821394/twitter-adds-gif-support. Accessed January 3, 2018.

Lemelson-MIT. n.d. "Roberta Williams: Graphic Adventure Games." https://lemelson.mit.edu/resources/roberta-williams. Accessed February 9, 2023.

Lemonade. 2020. "Headexplodie on Art as a Way of Making Your Own Friends." September 7. https://medium.com/ff0083/headexplodie-puts-clay-in-motion-b220725c440b. Accessed December 6, 2022.

Levin, Jo Ann Early. 1980. *The Golden Age of Illustration: Popular Art in American Magazines, 1850–1925*. Philadelphia: University of Pennsylvania.

Library of Congress. 2001. "The Floating World of Ukiyo-E." https://www.loc.gov/exhibits/ukiyo-e/intro.html. Accessed December 15, 2022.

Lloyd, Robert. 2020. "Meet the Mysterious Cartoonist behind 'the weirdest thing on Adult Swim.'" *Los Angeles Times*. December 13. https://www.latimes.com/entertainment-arts/tv/story/2020-12-13/lazor-wulf-henry-bonsu-adult-swim-interview. Accessed December 23, 2022.

Loveridge, Sam. 2021. "The 50 Most Important Games of All Time." *Games Radar*. August 18. https://www.gamesradar.com/50-most-important-games-all-time/. Accessed December 28, 2022.

Mak, Aaron. 2022. "A Reminder That GIFs Didn't Always Move." *Slate*. March 29. https://slate.com/technology/2022/03/the-history-of-gifs.html. Accessed October 20, 2022.

Male, Alan. 2014. *Illustration: Meeting the Brief*. London: Bloomsbury.

Matteson, Gary. 1993. "Looking Back: What is VersaWriter?" *Atari Classics*, June: 26. https://www.atarimagazines.com/atariclassics/v2n3/looking_back.php. Accessed December 18, 2022.

McCloud, Scott. 2006. "Making Comics." https://www.scottmccloud.com/makingcomics/. Accessed December 16, 2022.

McDonnell, Chris. 2013. "Artist of the Day: Stephen Vuillemin." *Cartoon Brew*. June 18. https://www.cartoonbrew.com/illustration/stephen-vuillemin-82039.html. Accessed May 6, 2022.

McHugh, Molly. 2015. "You Can Finally, Actually, Really, Truly Post Gifs on Facebook." *Wired*. May 29. https://www.wired.com/2015/05/real-gif-posting-on-facebook/. Accessed January 3, 2018.

Moodie, Jonathan. 2020. "Psychoactive Cinema: Sacred Animations." *Psychedelic Sangha*. February 5. https://psychedelicsangha.org/paisley-gate/2019/11/5/psychedelic-sacred-experimental-cinema. Accessed December 26, 2022.

Murphy, Mike. 2019. "From Dial-up to 5G: A Complete Guide to Logging on to the Internet." *Quartz*. October 29. https://qz.com/1705375/a-complete-guide-to-the-evolution-of-the-internet. Accessed November 28, 2022.

National Gallery of Art. n.d. "The Camera Obscura." https://www.nga.gov/press/exh/2866/camera-obscura.html#:~:text=A%20forerunner%20of%20the%20modern,image%20onto%20the%20opposite%20surface. Accessed February 9, 2023.

National Research Council of Canada. 1996. "Retired NRC Scientists Burtnyk and Wein Honoured as Fathers of Computer Animation Technology in Canada." *IEEE*. https://ewh.ieee.org/reg/7/millennium/computer_animation/animation_honoured.html. Accessed December 18, 2022.

Norman Rockwell Museum. 2020. "Advertising." *Illustration History*. https://www.illustrationhistory.org/genres/advertising. Accessed December 15, 2022.

O'Brien, Bennett. 2019. "Minju An – Giphy Arts at Nasdaq." *Nasdaq*. September 23. https://www.nasdaq.com/articles/minju-an-giphy-arts-at-nasdaq-2019-09-23. Accessed May 6, 2022.

Osgood, Adam. 2018. "The Blurry Intersection of Illustration and Animation." In *The Theory and Practice of Motion Design*, edited by R. Brian Stone and Leah Wahlin, 205–219. New York: Routledge.

Padula, Lily (dir.) 2018. *Maladaptive Daydreaming*. Produced by NPR.

Paranormal. 2022. *Paranormal*. https://javoraj.com/. Accessed May 6, 2022.

"PDP-1." 2022. *Wikipedia*. July 18. https://en.wikipedia.org/wiki/PDP-1. Accessed August 24, 2022.

Pinheiro, Tomas, and Lucas Tinoco. 2021. "The Heydays." *NeoCha*. September 28. https://neocha.com/magazine/the-heydays/. Accessed December 30, 2022.

Pollack, Michael. 2018. "If Market Volatility Is Back, Are You Ready?" *The Wall Street Journal*. March 4. https://www.wsj.com/articles/if-market-volatility-is-back-are-you-ready-1520219580. Accessed December 13, 2022.

Pope, Lucas. 2019. "How Lucas Pope Created the Unique 1-bit Art Style of *Return of the Obra Dinn*,

out this week on PS4." *PlayStation.Blog*. October 17. https://blog.playstation.com/archive/2019/10/17/lucas-pope-on-return-of-the-obra-dinns-art-style/. Accessed December 20, 2022.

Porteus, Ellen. 2015. "Quantcast Animated Brand Gifs." *Behance*. October 13. https://www.behance.net/gallery/28044313/Quantcast-Animated-Brand-Gifs?locale=en_US. Accessed December 11, 2022.

Quinn, Tony. 2022. "Digital Magazines: News and a History Timeline." *Magforum*. October 18. http://www.magforum.com/digital_history.htm. Accessed December 14, 2022.

Reed, Walt. 2001. *The Illustrator in America*. New York: Watson-Guptill Publications.

Rizzo, Meredith. 2018. "Invisibilia: When Daydreaming Gets in the Way of Real Life." *NPR*. April 5. https://www.npr.org/sections/health-shots/2018/04/05/598365217/invisibilia-when-daydreaming-gets-in-the-way-of-real-life. Accessed December 14, 2022.

Robertson, Adi. 2017. "Dear Angelica Might Be the Most Beautiful Virtual Reality I've Ever Seen." *The Verge*. January 23. https://www.theverge.com/2017/1/23/14345316/dear-angelica-oculus-vr-story-studio-sundance-2017-review. Accessed May 6, 2022.

Romano, Aja. 2017. "The GIF is 30 years old. It didn't just shape the internet—it grew up with the internet." *Vox*. June 15. https://www.vox.com/culture/2017/6/15/15802136/gif-turns-30-evolution-internet-history. Accessed October 20, 2022.

Roos, Dave. 2019. "7 Ways the Printing Press Changed the World." *History*. September 3. https://www.history.com/news/printing-press-renaissance. Accessed December 17, 2022.

Ross, Heather. 2022. "The History of the Sketchpad Computer Program – A Complete Guide." *History-Computer*. December 4. https://history-computer.com/sketchpad-guide/. Accessed December 18, 2022.

Science + Media Museum. 2020. *A Short History of the Internet*. December 3. https://www.scienceandmediamuseum.org.uk/objects-and-stories/short-history-internet#:~:text=Consequently%2C%20the%20number%20of%20websites,around%2010%20million%20global%20users. Accessed October 18, 2022.

SCRT WPNS. 2022. *Eb Synth*. https://ebsynth.com/. Accessed May 6, 2022.

Shaw, Austin. 2020. *Design for Motion*. New York: Routledge, Taylor & Francis Group.

Sirk, Christopher. 2020. "Xerox PARC and the Origins of GUI." *CRM.ORG*. June 12. https://crm.org/articles/xerox-parc-and-the-origins-of-gui. Accessed February 9, 2023.

Smith, Ernie. 2017. "An Early Touchpoint." *Tedium*. September 21. https://tedium.co/2017/09/21/wacom-tablet-history/. Accessed December 28, 2022.

Solomon, Dan. 2019. "The Creator of Amazon's 'Undone' on the Animation Style Born in Texas." *TexasMonthly*. October 17. https://www.texasmonthly.com/arts-entertainment/amazon-undone-kate-purdy/. Accessed September 25, 2022.

Stinson, Liz. 2013. "A Sweet Comic Book Made Entirely from GIFs." *Wired*. September 16. https://www.wired.com/2013/09/a-clever-comic-book-made-entirely-from-gifs. Accessed May 6, 2022.

Sullivan, Helen. 2018. "A Tiny Coral Paradise in the Great Barrier Reef Reckons with Climate Change." *The New Yorker*. February 3. https://www.newyorker.com/tech/annals-of-technology/tiny-coral-paradise-in-the-great-barrier-reef-reckons-with-climate-change. Accessed December 14, 2022.

Syam, Umi. 2017. "The Year in Illustration 2017." *The New York Times*. December 28.

Taggart, Emma, and Margherita Cole. 2022. "The History of Camera Obscura and How It Was Used as a Tool to Create Art in Perfect Perspective." *My Modern MET*. June 5. https://mymodernmet.com/camera-obscura/. Accessed February 9, 2023.

Ulanoff, Lance. 2016. "The Rise and Fall and Rise of the GIF." *Mashable*. August 10. https://mashable.com/article/history-of-the-gif#j2qgqWFbZ. Accessed October 20, 2022.

University of Pennsylvania Museum. n.d. "Writing: Scribes, Hierogrphys, and Papyri." *Egypt: A New Look @ an Ancient Culture*. https://www.penn.museum/sites/egypt/writing.shtml. Accessed December 12, 2022.

Vaughan-Nichols, Steven. 2015. "Before the Web: Online Services of Yesteryear." *ZDNET*. December 4. https://www.zdnet.com/home-and-office/networking/before-the-web-online-services/. Accessed November 28, 2022.

Visionary Media LLC. 2013. "Origins." *WhirlGirl*. https://whirlgirl.com/origins. Accessed December 28, 2022.

Vuillemin, Stephen. 2022. "Stephen Vuillemin." https://stephenvuillemin.com/. Accessed May 6, 2022.

Wagner, Daniel. 2021. "Limbo | Why I Love." *Games Industry.biz*. December 7. https://www.gamesindustry.biz/limbo-why-i-love. Accessed December 19, 2022.

Warren, Christina. 2013. "Instagram Adds Video." *Mashable*. June 20. http://mashable.com/2013/06/20/instagram-video/#dodg8rjbcSqb. Accessed January 3, 2018.

Wright, Steven. 2019. "Lucas Pope on the Challenge of Creating Obra Dinn's 1-bit Aesthetic." *PC Gamer*. December 23. https://www.pcgamer.com/lucas-pope-on-the-challenge-of-creating-obra-dinns-1-bit-aesthetic/. Accessed December 20, 2022.

Yamin, Nahum. 2016. "El Lissitzky in the Light of the Modernist Movement." *Medium*. October 10. https://medium.com/@nahumyamin/el-lissitzky-in-the-light-of-the-modernist-movement-cecdc4a74acd. Accessed December 21, 2022.

Zeegen, Lawrence. 2010. *Complete Digital Illustration*. Mies, Switzerland: RotoVision SA.

Zorich, Zach. 2014. "Early Humans Made Animated Art." *Nautilus*. February 28. https://nautil.us/early-humans-made-animated-art-234819/. Accessed December 12, 2022.

Figure Credits

0.1 Frames from "Ice Cream Bike Ride" GIF. © Cindy Suen

0.2 Frames from "The Optimist" video by Red Nose Studio

0.3 Frames from *Mortimer and the Dinosaurs* (suitcase) by Chiquimedia

1.1 Frames from "Fork Yeah" GIF. Illustration and animation by Chris Piascik

1.2 Frames from "Ghost Morph" GIF. Illustration and animation by Chris Piascik

1.3 "Rupert Murdoch" portrait by Wesley Bedrosian

1.4 Process image from "Rupert Murdoch" portrait by Wesley Bedrosian

1.5 Troupe de lionnes peintes sur les parois de la grotte Chauvet-Pont d'Arc. Photo © Bonnafe Jean-Paul

1.6 "'A Lovely Garland' (Tamakazura): Tamatori-ama," from the series Scenes amid Genji Clouds Matched with Ukiyo-e Pictures (Genji-gumo ukiyo e-awase). 1845–46. Utagawa Kuniyoshi. Japanese. Purchase, Alan and Barbara Medaugh Gift, 2019

1.7 Detail from "The Raven and the Fox," *Aesop's Fables*, printed by William Caxton, 1484. British Library

1.8 "Kenosha-Klosed-Krotch: The classiest garment made," page 165. Leyendecker, J. C. (Joseph Christian), 1874–1951 (Illustrator). General Research Division, The New York Public Library. (1916)

1.9 Detail of "Kenosha-Klosed-Krotch: The classiest garment made," page 165. Leyendecker, J. C. (Joseph Christian), 1874–1951 (Illustrator). General Research Division, The New York Public Library. (1916)

1.10 "Little Sammy Sneeze" comic strip by Winsor McCay for *The New York Herald* (1905)

1.11 "The Magic Lantern" by French engraver Jean Ouvrier (1725–1784). Harvard Art Museums/Fogg Museum, Gift of Belinda L. Randall from the collection of John Witt Randall, Photo ©President and Fellows of Harvard College, R9298

1.12 Optical Illusion Disc With Man and Frog. 1833. [Haymarket, London: Pubd. by T. McLean] Photograph. Library of Congress

1.13 *La Course Rapide* (published 1893). Étienne Jules Marey and photographer Michel Berthaud. Courtesy the J. Paul Getty Museum

1.14 Frames from *Little Nemo* (1911). Dir. Winsor McCay

1.15 Frame from *The Adventures of Prince Achmed* (1926). Dir. Lotte Reiniger. ©Christel Strobel/Primrose Productions

1.16 "Der Prolog" (1923) by El Lissitzky. Courtesy the J. Paul Getty Museum. Gift of Samuel J. Wagstaff, Jr

1.17 "WPA Women Painters" poster, Federal Art Gallery (~1936–1938). Library of Congress

1.18 "Las Vegas—fly TWA" poster by David Klein. Library of Congress, Prints and Photographs Division, [LC-DIG-ppmsca-42772]

1.19 Frame from *Gerald McBoing Boing*. © 1950, renewed 1978 Columbia Pictures Industries, Inc. All rights reserved. Courtesy of Columbia Pictures

1.20 Photograph of *Spacewar!* running on the Computer History Museum's PDP-1. Source photos © 2007 Joi Ito & © 2012 Jason Eppink. Composite photo by Adam Osgood

1.21 Screenshots from *The Man with the Golden Arm* (1959). Dir. Otto Preminger

1.22 Frames from *La Faim* (1974). Dir. Peter Foldes. National Film Board of Canada

1.23 Screenshot from *King's Quest* (1984). © Sierra On-Line, Inc.

1.24 Frames from *WhirlGirl*. Images courtesy of David B. Williams © 2000 Visionary Media. All rights reserved

1.25 Frames from the "Dancing Baby" animated GIF. Used with permission from Autodesk, Inc

1.26 Frame from *Salad Fingers 3: Nettles*. © David Firth

1.27 "Spider" frame from *Limbo*. © 2022 Playdead. All rights reserved

1.28 Frames from *Emotional Weather* GIF Sticker Set by Annie Wong

1.29 Frames from *Yellow Cosmic* video. Images © Ardhira Putra

1.30 Frames from "Toasty Cat" GIF. © Cindy Suen

1.31 Frames from "Sushi Cat" GIF. © Cindy Suen

1.32 Frames from "Barber Cat" Video. © Cindy Suen

1.33 Frame from "Tamago Cat" GIF and Photo of "Tamago Cat" Plush. © Cindy Suen

1.34 Frames from *Night Sushi* Video. © Cindy Suen

2.1 Frames from "Volume of P2P Loans" for *Bloomberg Business* by Stephen Vuillemin

2.2 Frames from *Contagion* video ("Energetic Talker") by Lily Padula

2.3 Frames from *Fake News* ("great job everyone"). Illustration © Mark Kaufman for *The Nib*

2.4 Frames from *Mortimer and the Dinosaurs* (spaceship) by Chiquimedia

2.5 Screenshots from *Margot's Room*, shown in a web browser. Illustrations © Emily Carroll

2.6 Frames from *Lynx* EbSynth Motion Painting. © Jakub Javora, Paranormal s.r.o

2.7 Frames from "Tea" GIF. © Aubrey Longley-Cook

2.8 Frames from "Flow" GIF by Yukai Du

2.9 Frames from "The New American Dream Home Is One You Never Have to Leave" GIF for *The New York Times*. © Igor Bastidas

3.1 Frames from "Chain E-Mail" GIF for *The New Yorker*. © Igor Bastidas

3.2 Frames from "Strong Dollar" GIF for *The Wall Street Journal* by Richard Borge

3.3 Frames from "Lies" GIF for *Scientific American* by Red Nose Studio

3.4 "Tree" frame from *Limbo*. © 2022 Playdead. All rights reserved

3.5 Frames from *Watermelon Smoothie Video*. © Cindy Suen

3.6 Screenshot from *Return of the Obra Dinn*. © Copyright 3909 LLC. Used with permission

3.7 Frames from "Finger Flame" GIF by Henry Bonsu

3.8 Frames from *Floating* video. © 2018 Rob Wilson

3.9 Frames from "Drinking Bird" GIF by Luis Mazón

3.10 Frames from "Medieval Knights" video. © Jakub Javora, Paranormal s.r.o

3.11 Frames from "Ping Pong" GIF. © Andrea Chronopoulos

3.12 Frames from "Bird Lady" GIF by Stephanie Hofmann

3.13 Frames from "PBS Toaster" GIF. Artwork from PBS FM Radio Festival 2018 by Ellen Porteus

3.14 Frames from *Morning Breeze* video. © Ardhira Putra

3.15 Frames from *Animated Comics—EP 3* ("Staircase") by Stephen Vuillemin

3.16 Frames from "DeBruyne" GIF by Wesley Bedrosian

3.17 Frames from "Turning Leaves" video. © coffeecakescafe

3.18 Frames from *Thunderpaw* GIF depicting swimming. © Benji Lee

3.19 Frames from *A Good Wife* by W. Scott Forbes

3.20 Frames from "Quarantine Mood" GIF. © Juliana Vido

3.21 Frames from "Violet Hum" Music Video (Paint On-Top of Face). © Tribambuka. Illustration, Animation, Direction by Tribambuka (Anastasia Beltyukova). Choreography: Kirill Burlov. Band: The

6.2	Frames from "Lord Only Knows" colorscript. © 2020 Adam Osgood	6.10	Frames from "Haunted Mansion" GIF. Illustration © Adam Osgood
6.3	Frames from "Lord Only Knows" animatic. © 2020 Adam Osgood	6.11	Layers and Composite from "Trench Coat Fashion Illustration." Illustration © Adam Osgood
6.4	Frames from "Lord Only Knows" music video. © 2020 Adam Osgood	6.12	Diagram of moving pattern from "Trench Coat Fashion Illustration." Illustration © Adam Osgood
6.5	Photograph of cut-paper animation stage and puppet from "Dog Astronaut." Illustration © Adam Osgood	6.13	Frames from "Robot Digital Puppet" animation. Illustration © Adam Osgood
6.6	Frames from flipbook video. Illustration © Adam Osgood	6.14	Exploded view of "Robot Digital Puppet." Illustration © Adam Osgood
6.7	Frames from "Falling Dream" GIF. Illustration © Adam Osgood	6.15	Frames from "Undersea Fantasy Parallax Environment." Illustration © Adam Osgood
6.8	Frames from rotoscoped animation "Shocked Head Turn." Animation © Adam Osgood. Photos by Erin Campbell	6.16	Layers from "Undersea Fantasy Parallax Environment." Illustration © Adam Osgood
6.9	Frames from "Silver Shoes" GIF. Illustration © Adam Osgood		

Index

Italic page numbers indicate figures.

Acknowledgments

Thank you to my editor Louise Baird-Smith and Olivia Davies, Hattie Morrison, Darcy Ahl, Amy Jordan, and the team at Bloomsbury for seeing value in motion illustration and guiding this book through the publishing process. To Susan Kwas and Dale Shidler, I am so grateful for your friendship and mentorship. Your experience, advice, and enthusiasm informed the decisions that shaped this text. To my friends and colleagues at MIAD, thank you for the informal conversations that made me rethink my assumptions about illustration and animation. To Christiane Grauert, Chris Szczesny-Adams, and Lou Morton—thank you, especially for your time and expertise in reviewing the historical portion of the text—it is greatly improved because of your critical feedback and recommendations. I would also like to acknowledge Ralph Giguere, whose effervescent curiosity and love for the arts are inspirational.

My eternal gratitude is due to the artists who agreed to share their work for this book: Cindy Suen, Chris Piascik, Red Nose Studio, Wesley Bedrosian, David Firth, Ardhira Putra, Stephen Vuillemin, Lily Padula, Mark Kaufman, Màriam Ben-Arab, Emily Carroll, Jakub Javora, Aubrey Longley-Cook, Yukai Du, Igor Bastidas, Andrea Chronopoulos, Richard Borge, Lucas Pope, Henry Bonsu, Rob Wilson, Luis Mazón, Stephanie Hofmann, Ellen Porteus, Juliana Vido, Coffeecakescafe, Benji Lee, W. Scott Forbes, Anastasia Beltyukova, Yoshi Sodeoka, Annie Wong, Emory Allen at Foreign Fauna, and Andy Potts. Thank you for agreeing to allow your images to be reproduced here as documentation of an exciting new path for illustration.

And finally, to the agents, studios, producers, and curators that helped arrange print permissions, thank you so much: Bianca Bramham at Jacky Winter, Sari Rowe at Snyder, Rosie Paine and Tim Coates at Bliink, Patrick Metcalf and David Shall at Tornante Television, Steph Swope at Minnow Mountain, Harrison Gish at Sony, Leighton Grey and Katie Darnall at Game Grumps, David Rodríguez at Chiquimedia, Grace Liu at Autodesk, Michael Mrak, Diane McGarvey, and Lisa Pallatroni at *Scientific American*, Alexandra Hubert at the National Film Board of Canada, David Rozelle at SFMoma, and Jeff Steward at Harvard Art Museums.

Author Credit

Adam Osgood is an Associate Professor in Illustration at the Milwaukee Institute of Art & Design, USA. His teaching focuses on how illustrators can use animation tools in their work. He has illustrated for clients including Hyundai, Lionsgate Films, and Yahoo, and his animated shorts have screened at festivals, including Siggraph and the London International Animation Festival.